IN/
SEARCH
RE/
SEARCH

IN/
SEARCH
RE/
SEARCH

IMAGINING SCENARIOS
THROUGH ART AND DESIGN

Gabrielle Kennedy (ed.)

Valiz

Gerrit Rietveld Academie
Sandberg Instituut

CONTENTS

BREAKING THE SHACKLES
OF RESEARCH
Gabrielle Kennedy

Truth is a funny thing. How it is defined and lauded changes depending on place and time. Right now we are in a peculiar era where a more pluralistic epistemology looks possible; where no single elite is allowed to hold a monopoly on the creation of knowledge. Specialists, whether they are economists, statisticians, engineers, architects, lawyers or scientists, are no longer extolled as the only authors of truth. Over the past decades the experts retreated into a bubble; into institutes that are not and probably never were objective incubators of knowledge, there to churn out truth based on clean, reliable and consistent methodologies. New stories emerged revealing that the culture-of-truth borne out of the Enlightenment is often disorganized, lacking in transparency and is rife with inconsistencies, and perhaps even a little bit of cheating. Experts are often beholden to corporate interests, partisan politics, and corrupt funding opportunities. The more this story spread, the more people started to dismiss the expert as irrelevant. It's a dangerous trajectory.

Enter the growing gang of thugs who aggressively ripped at this scenario, gnashing their teeth at any vulnerability. The defining title of this era is neoliberalism and it threatens accepted standards of truth, leading to a suspicion of and contempt for expertise in general.

Parts of the American media currently do their bit to counter some of the more public and obvious effects of this—turning spotting their president's lies, for example, into a credible sport. In April 2020, *The Washington Post* ran the headline that Trump had made 13,435 false or misleading claims over 993 days.

Bogged down in this post-truth milieu, the ante on bullshit bombardment has been dialled up to brash. And one consequence of the neoliberal's very deliberate attempt to shift the locus of power is how it starts to feel almost intellectually suicidal to sit on the side of a more flexible approach to epistemology. So is the time right to be challenging our most deeply held notions about how knowledge is made? Despite the risks, the answer is surely yes, and besides, the tide seems unstoppable—even science is being repositioned amongst some of the most serious commentators as more the product of scientific enquiry than a specific and consistent method leading to hard facts. This is a point that French philosopher Bruno Latour has been arguing for decades—that science should be understood as a social practice. It does depend, after all, on the bringing together of a complex combination of humans and objects to decode the world. He found the division between facts and values a bit dodgy, preferring to expand

on the idea of a networked reality, defining a clear connect between, as he put it: 'both the history of humans' involvement in the making of scientific facts and the sciences' involvement in the making of human history'. Of course not all scientists agree. Physicist Alan Sokal once famously responded to Latour's stance, inviting anyone who thinks that the laws of physics are 'mere social conventions' to jump out of their twenty-first storey apartment window to test for themselves.

Nevertheless, this idea that facts are networked makes beautiful sense. Facts survive based as much on their legitimacy as on the culture that produced them. Institutes, their directors and teachers, as well as the systems, values, evaluations and communication that stems from its existence gives knowledge life, and if this network breaks, the facts go with them.

How art and design fits into this evolving epistemological shift is an enthralling and open question. The time is ripe for creatives to be conducting and communicating research, to be testing its own theories, and using this antagonism with its more traditional disciplines to both contribute to and advance knowledge in a networked and transdisciplinary environment. Interpreting the world through the lens of culture does not, as its detractors might assert, land in fake news territory, but rather in recognition of how art and design can contribute to a more nuanced public discourse.

Many of the projects presented in this publication confront and even confound the traditional academic stance of what is relevant in research. It changes the angle, alters the understanding, and opens up new possibilities in the hunt to discover what is not yet known or understood. In art and design it is advantageous to consider research more as an attitude than a function. Research does not necessarily have to be a high-end, or specialist pursuit. Nor is it only for trained experts working in the fields of education, science or research & development. It does not have to be linear or even logical—attributes rarely, if ever, associated with art. Research in art and design entails exposing yourself, embracing change, and asking uncomfortable questions. Yet similar to more academic research, it should be rigorous and tight. It should begin with a disciplined investigation and end in knowledge—knowledge that strives to interpret twenty-first century realities. Because economically, environmentally, politically and socially so much is failing, no single discipline can possibly pretend to have an adequate explanation or solution anymore. Again it comes down to this idea of networked knowledge stemming from a more collective fraternity, which is why research being

carried out by artists and designers—although woefully underfunded and rarely recognized—must play a role. Designers and artists think radically, which is needed when faced with massive global challenges like economic rationalism, neoliberalism, climate change, migration, and poverty.

And thus this book—a repositioning of where research in the Rietveld Sandberg environment is right now. It has been put together for the purpose of giving more credence to the results. For it's only by gaining more attention that ideas developed within an institute can garner the necessary momentum for confrontation with society and the world at large. And at the moment there is no official system of peer review or publication for these disciplines to enjoy.

These pages are divided into twelve chapters or topics that regularly reappear as core themes in a lot of student work at the Gerrit Rietveld Academie and Sandberg Instituut. Importantly, these issues are not only specific to art and design students, but reach across age, nation, race, and political borders—they transcend narrow or isolated group interests.

The projects follow on from a recent news story that positions how that topic is being discussed in the mainstream press. Each chapter ends with a response from an academic who was invited to reflect on how the research fits with their own academic thinking. They were all given free reign to reply, only encouraged to respect the difference between data-driven collective knowledge and a more embodied form of artistic knowledge.

Here it is important to emphasize the conscious decision in this publication to steer away from the evolving and complex discourse surrounding the meaning of and methodologies common to artistic research. Over the past two decades much has been written about artistic research, which focuses on building connections with academic research. It is interesting, relevant and exciting, but often esoteric and buried deep in process rather than topic. This obfuscation tends to limit the potential of design and art research to contribute to the broader discourse we are aiming for.

To overcome this I have looked length-wise at Bachelor's and Master's work plus some extra internal research and special projects to see how artists and designers are using their thinking to understand social, political, scientific and economic topics. With that as my guiding rationale, I found a more editorial approach to research—research that builds connections back to the real world of culture, industry, housing, education, politics, public space, advertising, and

science. This embrace of research strives for a more transdisciplinary way forward, outside the bubble of graduation shows, gallery openings, peer feedback, and funding cycles.

The projects I selected for inclusion, therefore, were necessarily more topical than self-reflective. They all sat well with questions like: Was the research clear and reliable? Can the results be of benefit to others? Their vision was for a research-driven inquiry with an artistic output. I did discover that when more attention was placed on the inquiry than the process, strong topical voices emerged that hitherto might have received less attention. In this vein, common to all the included projects is thinking that has the potential to penetrate not just the artistic community but further afield. Accuracy mattered, rumour and trend were avoided, and flexibility was embraced—even admired.

This isn't as easy as it sounds. Creative research-ers pursue a path that is personal and ordered bur rarely systematic. Their start point and perspective is freer and less structured; it isn't dogmatic but leaves space for the unknown, the indeterminate, and the plurality of what it means to be right. At Rietveld Sandberg this more creative approach to research liberates it from the strangles of academic norms. Especially in design, research can move in different directions and at a different speed to science, which is more about collecting facts and evaluating risks. Designers gather information, analyse statistics, use documentation and design thinking as a method to create a solution then check if it works. If it doesn't, the design is re-evaluated. The pace can be fast and the goal can simply be a result.

And in art it is much the same because if art is understood as giving form to ideas that oppose the expected, a force against let's call them 'dominant perceptions', then how can research in art operate inside the status quo's limited structures?

If we learnt anything from the 2020 Covid-19 pandemic, it's that these dominant perceptions while not necessarily wrong, can be somewhat irrelevant. Like in that moment when nurses matter more than doctors, when care is more important than science. Art has always pushed for and celebrated the alternative, which in a hierarchical occidental framework is rarely recognized—since it does after-all too often oppose the dominant form.

Solid research skills are crucial for art and design graduates if the cultural sector is to be able to contribute viable alternative ways of thinking to counter the dangerous and pervasive neoliberal forces influencing the globe.

Another explanation for paying more attention to graduates with more research-based projects is a worsening economic outlook for art and design graduates. What sort of business model can a researcher embrace post-graduation? And what sort of economy can support art and design research? The only way these questions can be answered is if the topics, methods and results of the research are better positioned and communicated.

It should also be pointed out that across the Rietveld Sandberg community students have been busy thinking about issues, unaware that so many others were similarly engaged. Many I spoke with voiced disappointment that they had not known, met with or had the opportunity to share their inquiries and findings with peers working on the same topic. It is hoped, therefore, that a resource like this publication will not only be of interest outside the institute but also internally across different departments and interests.

But of course the overwhelming objective of this publication is to have art and design research more broadly recognized and incorporated in academic discourse and thinking. We want the conversation to move away from what is research to how better acceptance for the subjective stances explored in the included works can be established. So while design often claims to be in search of solutions, and art exists to provide perspectives, how can research in art academies find a wider context? This will impact on how students select their topics, their processes and results, but also how nuance in what's called knowledge is positioned and fêted.

The timing of this publication connects to the sorts of confrontations Rietveld Sandberg has experienced both internally and externally of late. The biggest challenge for culture now is that in a neoliberal system, nothing survives outside of it—all responses must exist within its framework or become irrelevant. In this context, art is the act of manufacturing content and culture becomes an industry like any other. There is little to no recognition of the impossible-to-monetize aesthetic, or the cultural and transcendent values art plays in a complex urban environment—its symbiotic relationship with society, identity, education, mores, and values.

A cynic might connect the recent upsurge in interest in artistic research to newly available funding opportunities. A more purist explanation is the core role art and design can and indeed must play in Latour's networked environment. Art and design research needs recognition—not for how it's done, or what the rules and procedures are, but for how more flexible

and nuanced thinking can provide a different way of knowing and perceiving.

So as this publication is indeed part of the push for an epistemological shift in how knowledge is created, it seems only appropriate to end with a quote from Latour himself. 'The social sciences are obsessed by epistemological questioning in a way that no science, no real science is. You never have a chemistry class that starts with the methodology of chemistry; you start by doing chemistry. And the problem is that since the social sciences don't know what it is to be scientific, because they know nothing about the real sciences, they imagine that they have to be listing endless numbers of criteria and precautions before doing anything. And they usually miss precisely what is interesting in natural sciences which is a laboratory situation and the experimental protocol!'*

* Bruno Latour, Graham Harman and Peter Erdélyi, eds., *The Prince and the Wolf: Latour and Harman at the LSE* (London: Zero Books, 2011).

Gabrielle Kennedy is an Amsterdam-based design journalist. She is currently editor-in-chief of *DAMN°* magazine and has contributed to many books and publications on design, and education. She sits on design juries and contributes an editorial voice to projects that explore the broader definition of design and the impact it can have on a contemporary cultural attitude. Previously she was the Asia editor of *POL Oxygen* magazine, editor-in-chief of Design.nl, and in-house journalist at Design Academy Eindhoven. In all of her books, exhibitions and projects she explores how current events and 'real life' are not just shaped by, but can be better understood through the prism of design.

For this publication she was invited by the Gerrit Rietveld Academie and Sandberg Instituut to look at how research is currently addressed. The project will continue as a core component of the development of research at the Rietveld Academie / Sandberg Instituut.

www.damnmagazine.net; @gabriellekennedy_design

POSTPONED INEVITABILITY
Jeroen Boomgaard

Research is a key term in art schools today. But, as this book shows, it still has a wide range of possible meanings. And it is not so much the question 'What is research?' that has to be answered, but rather 'When is it research?' Of course there is an element of research involved in every design, every work of art. They never come into existence in complete instantaneity and spontaneity. The whole purpose of an art school is about finding things out, practising, a lot of trial and even more error, looking, trying to understand, elaborating, and experimenting. All these aspects of training can be called research but usually we do not use that work in this way. Research seems to be implying something extra, an extra effort, more steps, more method maybe. An extra that is often confused with rigour and discipline, with dogma and dead knowledge, a pool of stagnant stinking water that art should avoid at all cost. But what is regarded as the 'what' of research is not its 'when'.

Yes, methods matter in research, just as brushes do in painting and a camera does in photography. But just as we should not take the brush to be the painting, so we should not make method the hallmark of research. In the research for the Lectoraat Art & Public Space (LAPS) at the Gerrit Rietveld Academie we sometimes discuss methods of working, means of research. But it never leads us to the conclusion that there is a method called artistic research. The members of this research group—mostly teachers from the Academie and some externals, including those from Sandberg Instituut—usually present and discuss their research process in terms of experiments, sources, reflections and doubts, but hardly ever in terms of a clear method because that is implicit in what they present. The main point is that what they show, what they offer for debate and discussion, is not a work of art or a result, but an effort to find something out. And this process of sharing and reflection results in suggestions and comments that lead to more research and a postponing of production. Research takes time because the researcher is not just working towards a result, but is exploring an existing terrain of theories, works of art and data that build the platform for their work to rest upon. Of course there is always a conclusive presentation in which outcomes are shared, but we usually do that in a format open to everyone: a publication, an exhibition, or a symposium. But it is exactly this period before, this situation of not yet there, of looking into other ways and other possibilities, the postponing of a final result, that we call research.

LAPS stimulates and organizes research on art and public domain, but in the work done in the research

group this mainly means thinking about the ways art can become public not just as end result, as a work of art or design, but also as an outcome of research. It's about how to share the process of research with a wider public, not to involve them in this process or to state that the process is the core of things, but to lift the outcome out of its destination as statement and open it up for a discussion on urgency and relevance.

This needs some explaining. The strength of research is not so much that it manages to establish certain truths, convinces us because it explains how the world functions. It is strong because it shows how it came to establish this truth, what its sources, arguments, relations and experiments have been—in short, how it has built up this construction that you can find convincing. A construction that at the same time invites you to take a closer look to see if you find points where it seems unstable, faults in its design, missing stones, doors that in the end do not open or lead to dead ends. In other words, it invites you to try to refute it with your own research, with counter arguments.

The power of good works of art is that they seem inevitable. They have to be like this: a statement that cannot be denied. A presence that creates something that was not there before, the opening up of a new possibility, a vision of something that does not have to rely on reality. We can dislike a work of art, think it false or insincere, badly executed, old-fashioned, too much following the latest trend, but it is very hard to disagree with it. And if it touches us, fascinates us, moves us in any way, it is not because we find its arguments convincing. And although we might not 'agree' with everything it shows us, if we do find some parts less convincing, it is usually based on the fact that some kind of internal, expected coherence, seems to be missing. The 'truth' of a work of art is not an external truth, a construction that can be verified by comparing it with other data, given facts. It does not want to be or have to be true in this sense. But it has to be true to itself, imply a certain intention, an art argument, that is followed to its utter consequences.

Or, so it seems. There is a catch however. Although academic research is supposed to be an open sharing of information, a potential public debate, as opposed to the hermetic procedures of art and its elitist inaccessibility, in practice it is a specialized form of discourse only for insiders to be understood—you have to be a specialist to be able to undermine the argument construction. On the other hand, art might seem elitist but artworks have the capacity to reach and touch people with quite different cultural backgrounds or levels

of education. In a certain way, they speak several languages at the same time. More and more art seems to be expected to use its aesthetic and emotional possibilities to bring people together in an general feeling of understanding, even when this is at the cost of the complexity of its layered languages.

It is not only the art world, however, that today feels the pressure to reach out and unite. Academic research is also expected to contribute to society in a more open, direct way, probably to take away growing distrust and counter all kind of conspiracy theories. And it is exactly under this pressure to give up nuance for understanding that art and science can find common ground. Academic research is turning towards art as an embodied method of research and as a more sensuous form of representation. Art in its turn tries to establish itself as research, opening up in references, considerations, decisions and doubts, to safeguard its more fundamental ways of understanding the world against a somewhat popularizing utilitarianism.

Postponing inevitability not only means that the moment of final production and presentation is shifted forward to give research more space and time. It also means that the fatal moment in which the work of art becomes mainly an object to be seen, to be sold, stored or placed is postponed, because it emphatically offers itself as an argument, an incentive to debate, as something that also speaks about the world and not only to it.

Jeroen Boomgaard is Professor of Art & Public Space at Gerrit Rietveld Academie. He is also Programme Manager of ARIAS, a collaborative platform for research through the arts, set up by UvA, HvA, AHK, VU, and Gerrit Rietveld Academie. On behalf of Rietveld he is in charge of a new third cycle trajectory for artists, called Creator Doctus. He also supervises a NWO/SIA funded research project at Zeeburgereiland in Amsterdam on Contemporary Commoning.

www.rietveldacademie.nl; arias.amsterdam; www.creatordoctus.eu; @followrietveld

CREATIVE AND CREDIBLE
Aiora Zabala

The intersection between art, design and research has several faces. The most obvious one is art and design improving communication of conventional science. This role is far from ancillary; effective communication is a lifeline to jump the science-policy gap—something most scientists are eager to do. Careful information design can ease understanding, like a visualization of differently sized black holes colliding. It can also reduce biased interpretation of facts (c.f. statistician and artist Edward Tufte), increase awareness or inspire unexpected thoughts. Artists could also contribute to define new language or boundary objects (those that help people with different views to start a conversation). After all, scientists use their own judgement to choose names for discoveries and ideas, and these names can have impact.

Getting the artistic tone right can make the difference between a groundbreaking proposal and a foolish one that stays in the drawer. For example, a graphical abstract about a new chemical synthesis could include a person to show it is human made. What if, instead of a person in a lab coat, it shows a magician? It will definitely make the research memorable, but perhaps not for the right reasons. It is not always that clear cut to delineate what level of creativity does not compromise research credibility. But the balance is achievable, as seen by the increasing number of cartoons published in high-level scientific papers.

An elusive face is that of art as an integral part of science. Several participatory research methods encourage creativity as a way to generate data and inspire new knowledge, for example, asking children to draw their experiences. Some professors use art, in the form of theatrical performance, to teach catchy lessons and boost student learning. In integrating art and science, the key question in the back of many researchers' mind is how they can maintain authority in a space where replicability and so-called objective evidence are badges for career progression. The way forward might be to align the artistic task to each part of the research process. For example, in one of the final stages—communicating outputs—art is certainly well received. At earlier research stages, it can enhance inspiration and imagination to develop research questions. Later, good design can provide effective or provocative ways to collect data, for example, by drawing synoptic illustrations to convey complicated surveys. In the analysis stage, an artist can devise unexpected possibilities, so that raw information is explored from further angles.

But not all research follows this linear process of inquiry. Research can also be about subjectivity,

people's opinions, feelings, emotions or perspectives. Art can be about these too. Like many of the projects in this book, art can help us think about antithetical situations, empathize with others—even with inanimate ones—or change the colour of our lens. Other projects question fundamental assumptions by imagining scenarios (possibilities of what could happen, independent of their probability). Envisioning scenarios is fundamental to prepare for the worst (like the event of a pandemic) and create hope for the best (like a transition to more sustainable societies). Both research and art are on par to perform these tasks, which are essential to understand our world and make it better.

A promising face is that of helping scholars think like an artist, either by practising creativity techniques or trying to do art by themselves. Working out both sides of the brain has clear benefits (think da Vinci), but academics often feel like lacking the time for pure imaginativeness. Instead, making mental space for artistic activity can unleash ideas that are latent under layers of daily rationality. Artists can guide such ventures. Artistic interaction, such as an audiovisual or image, also drives emotions, and emotions drive people. The urges to know more, to help others, to understand a problem, to give it a solution, are all motivations that drive scientists' work confronting adversities.

A growing face is research for art. For its recognition, the research method chosen is, I dare to say, almost irrelevant. What is key is to explain how this new output came about: Was it based on the artist's own theoretical reasoning? On a synthesis of other sources (literature, images, newspapers)? Inspired in photos, words or experiences—data—observed? More readers and viewers will appreciate this research if the research choices are understandable and clear. For example, they might ask why the artist-researcher chose this reasoning, these information sources or the subjects observed. It should not be judged as more or less rigorous whether the choice relied on a structured sampling method or with the aim of targeting specific subjects (e.g. the most interesting ones). But explaining these choices transparently and narrating how this information transformed into new knowledge, can help others recognize the research endeavour.

The crossing between design and research can be furnished in myriad ways. Benefits of doing so encompass increased diversity in science and the potential to unleash creative thinking in unprecedented ways. Caveats include whether subjective creativity could undermine credibility, or provide too biased angles of understanding (all knowledge is through a particular

lens, but some are more constructive and socially useful than others). Whether current science structures welcome this field is unclear; individual scholars may be excited to embrace new approaches, but they work within incentive systems that reward certain badges. It will take courage and confidence to break through. Science editors will still need to assess how the work is rigorous, well-regarded by disciplinary standards (whichever they are), of interest to a broad audience, and accessible also by experts in other specialities. These considerations need careful nurturing. Getting them right while keeping a groundbreaking spirit is fiddly, but the benefits are definitely worth it.

Aiora Zabala is an environmental scientist and economist, currently working as Scientific Editor at *Nature Sustainability*. She has lectured at the University of Cambridge, and studied at the University of Oxford and the Universitat Autònoma de Barcelona. Her research has taken her to remote areas in South Africa, Mexico, and Indonesia. She also studied Graphic Design at the Escola Massana Art and Design Centre in Barcelona and worked as a web developer for several years.

www.aiorazabala.net

THE ANT

EPOCH

Support The Guardian
Available for everyone, funded by readers
Contribute → | Subscribe →

Search jobs | Sign in Q Search ˅ | International edition ˅

The Guardian

News | Opinion | Sport | Culture | Lifestyle | More ˅

Environment ▶ Climate change Wildlife Energy Pollution

Science and nature books

Generation Anthropocene: How humans have altered the planet for ever

We are living in the Anthropocene age, in which human influence on the planet is so profound – and terrifying – it will leave its legacy for millennia. Politicians and scientists have had their say, but how are writers and artists responding to this crisis?

Robert Macfarlane
🖉 @RobGMacfarlane
Fri 1 Apr 2016 12.00 BST

f y ✉

'In 2003 the Australian philosopher Glenn Albrecht coined the term solastalgia to mean a "form of psychic or existential distress caused by environmental change". Albrecht was studying the effects of long-term drought and large-scale mining activity on communities in New South Wales, when he realised that no word existed to describe the unhappiness of people whose landscapes were being transformed about them by forces beyond their control. He proposed his new term to describe this distinctive kind of homesickness.'

▲ Illustration by Eric Petersen

I n 2003 the Australian philosopher Glenn Albrecht coined the term solastalgia to mean a "form of psychic or existential distress caused by environmental change". Albrecht was studying the effects of long-term drought and large-scale mining activity on communities in New South Wales, when he realised that no word existed to describe the unhappiness of people whose landscapes were being transformed about them by forces beyond their control. He proposed his new term to describe this distinctive kind of homesickness.

Where the pain of nostalgia arises from moving away, the pain of solastalgia arises from staying put. Where the pain of nostalgia tends to be borne of a hope of return, the pain of solastalgia tends to be irreversible. Solastalgia is not a malady specific to the present – we might think of John Clare as a solastalgic poet, witnessing his native Northamptonshire countryside disrupted by enclosure in the 1810s – but it has flourished recently. "A worldwide increase in ecosystem distress syndromes," wrote Albrecht, is "matched by a corresponding increase in human distress syndromes". Solastalgia speaks of a modern uncanny, in which a familiar place is rendered unrecognisable by climate change or corporate action: the home become suddenly unhomely around its inhabitants.

Robert Macfarlane, 'Generation Anthropocene: How Humans Have Altered the Planet for Ever', *The Guardian*, 1 April 2016

www.theguardian.com/books/2016/apr/01/generation-anthropocene-altered-planet-for-ever

'Where the pain of nostalgia arises from moving away, the pain of solastalgia arises from staying put. Where the pain of nostalgia can be mitigated by return, the pain of solastalgia tends to be irreversible. Solastalgia is not a malady specific to the present—we might think of John Clare as a solastalgic poet, witnessing his native Northamptonshire countryside disrupted by enclosure in the 1810s—but it has flourished recently. "A world-wide increase in ecosystem distress syndromes," wrote Albrecht, is "matched by a corresponding increase in human distress syndromes". Solastalgia speaks of a modern uncanny, in which a familiar place is rendered unrecognisable by climate change or corporate action (…).

Albrecht's coinage is part of an emerging lexis for what we are increasingly calling the "Anthropocene": the new epoch of geological time in which human activity is considered such a powerful influence on the environment, climate and ecology of the planet that it will leave a long-term signature in the strata record. We have bored 50 m kilometres of holes in our search for oil. We remove mountain tops to get at the coal they contain. The oceans dance with billions of tiny plastic beads. Weaponry tests have dispersed artificial radio-nuclides globally. The burning of rainforests for mono-culture production sends out killing smog-palls (…).

The idea of the Anthropocene asks hard questions of us. Temporally, it requires that we imagine ourselves inhabitants of "deep time"—the dizzyingly profound eras of Earth history that extend both behind and ahead of the present. Politically, it lays bare some of the complex cross-weaves of vulnerability and culpability that exist between us and other species, as well as between humans now and humans to come. Conceptually, it warrants us to consider once again whether—in Fredric Jameson's phrase—"the modernisation process is complete, and nature is gone for good", leaving nothing but us.

There are good reasons to be sceptical of the epitaphic impulse to declare "the end of nature". There are also good reasons to be sceptical of the Anthropocene's absolutism, the political presumptions it encodes, and the specific histories of power and violence that it masks. But the Anthropocene is a massively forceful concept, and as such it bears detailed thinking through. Though it has its origin in the Earth sciences and advanced computational technologies, its consequences have rippled across global culture during the last 15 years. Conservationists, environmentalists, policymakers, artists, activists, writers, historians, political and cultural theorists, as well as scientists and social scientists in many specialisms, are all responding to its implications.'

How does does metaphor function and how does it let us look at things differently? Can materials also be imbued with metaphor?

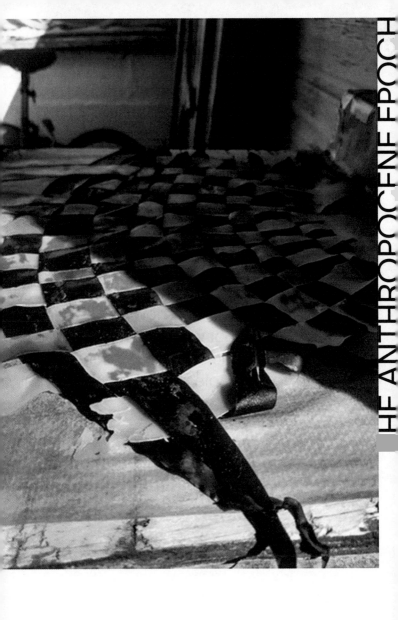

THE WARP & WEFT: METAPHOR AS MATERIAL AND THE MATERIALITY OF METAPHOR

41 Naomi Lamdin

I conducted a thorough research of the use and application of metaphor throughout history from thinkers like Aristotle to Nietzsche and George Lakoff & Mark Johnson.

Then I started my own thesis, which was a hunt to discover the right metaphor to weave throughout a text to help bring together experience, language, and materiality.

Weaving allows multiple threads from different angles. It permits different ideas, voices and knowledge—that may usually be considered unequal—to exist together.

Then I explored if and how one can understand metaphor without being restricted to the language generally used to describe it: red thread, for example.

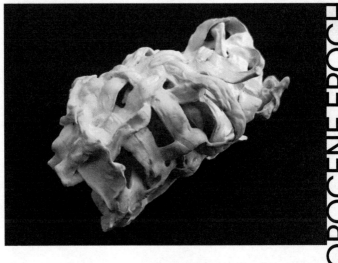

In *The Warp & Weft: Metaphor as Material and the Materiality of Metaphor*, I untangled the threads of written and spoken words to understand exactly what metaphor is and how it functions in a language.

Often things become so ingrained in daily life that we become almost unaware of them. And yet often these are the things that have most influence on us. Language is one of these things.

The process of making delves below the surface. It can give a maker the conceptual scope to weave together threads that run far beneath the level of aesthetics, far beneath the skin.

All art works—and therefore all the works that I will ever make—are essentially metaphorical constructions.

When we think about metaphor we usually think of it in terms of language. In this context it is used to bring together sometimes very distinct concepts, so as to understand one thing in terms of another—a writer can help the reader to make connections, evoke a certain mood or establish a theme.

'I'm running out of time.'

So to think of language as a kind of material that we use to string our thoughts together into some kind of sense, then as a material, it is one we all interweave throughout our daily life, metaphors included.

'When the hand strikes midnight, it's the end of the line.'

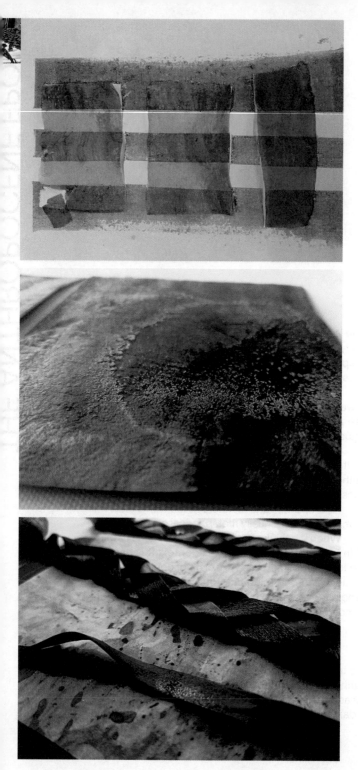

If language helps us to communicate our experiences in the world, it must also affect how we understand the world around us too.

If metaphor always seems to become a fundamental aspect to the artworks we make in one way or another (*this material in this form signifies this concept and this idea*), then how does our linguistic understanding and use of metaphor become a tangible (and formal) materialization?

To capture this I used seaweed. Taken home immediately, it becomes a tangible metaphor for the sea.

If this metaphorical value is established after only the simple gesture of removing a material from its original context, then how can this value be played with in order to understand how we put it there in the first place?

I may take washed up seaweed from the beach, but taking away the metaphor of the sea requires an exploration into its capabilities as a material.

As long as there have been oceans and seas there has always been algae and seaweed, coming into existence around three and a half billion years ago. Nowadays grown commercially on a large scale, seaweed and its extracts (agar, alginate, carrageenan) are harvested for their unique qualities.

The adaptability and wide-ranging use of this material somehow aligns itself with the adaptabilities of metaphor originating from a constantly shifting environment beneath the waves; the structure of seaweed shifts to and fro from malleable when wet to hard when dry, and back again.

How far can the metaphorical thread of the sea be pulled away from seaweed? If I try to take the weed from the sea and the sea from the seaweed, can I reintegrate it back into our awareness? How strong is our connection to the materiality of this particular metaphor?

THE ANTHROPOCENE EPOCH

Looking at the hidden value of problematic matter, I ask where does the border lie between natural objects and artefacts?

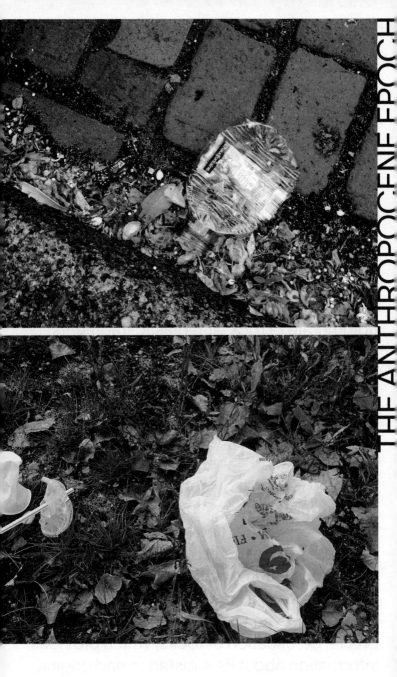

EVERYBODY NEEDS A ROCK
Sae Honda

Following the principle formation of plastiglomerate (a rock with plastic fragments) I created a unique, local artificial rock. To do this I collected plastic waste and small bits of discarded material, such as twigs and shells, in my own biotope or what you might call the environmental habitat where I live. First off, I melted down the stuff I had collected and then refined it by cutting and polishing.

A diary that contains information on date, time, weather and location accompanies the materials collected on the street, alongside short documentation of what was seen on the spot. This was then turned into a form of certificate for each rock. Contrary to official certification of rocks, which provides information about its substance and origins, these certificates give delineated information regarding when and where the materials have been collected, components, mined data, and surroundings.

This project takes it name from a picture book, *Everybody Needs a Rock*, written in 1974 by Byrd Baylor, an American author of children's books. In it she gives ten rules for finding our own special rock. The rules are highly sensuous and act as a kind of tool to change our way of looking at things surrounding us, inviting us to observe and value mundane and often neglected objects.

Inspiration for the project came from the discovery of a new kind of rock containing plastic fragments. The rock was found on Kamilo beach in Hawaii, which is known for its accumulation of plastic garbage. First discovered in 2006 by Charles J. Moore, a sea captain and oceanographer that founded the Algalita Marine Research Institute in Long Beach, California, what has become known as plastiglomerate was then researched by geologist Patricia Corcoran and sculptor Kelly Jazvac. The plastic debris had somehow melted and fused with natural beach sediment and formed a rock-plastic hybrid. It is said that the rock won't decompose but will remain in the ground forever. Therefore these rocks have been considered as a potential mark of humanity's time on Earth—our generation's rock.

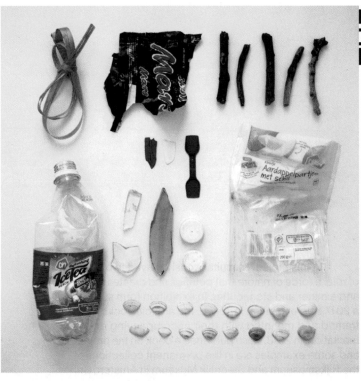

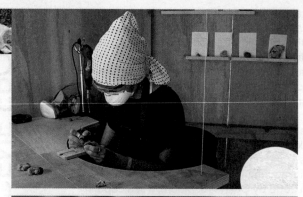

In this project I simultaneously played two types of role: a force of nature that petrifies and creates rocks, and a miner and stonecutter. In exhibition form such as a 2017 solo exhibition in Tokyo, the artificial rocks were framed and mounted with their accompanying documentation. In 2018, I also published a book on the project and some examples are in the permanent collections of the Rijksmuseum and Stedelijk Museum in Amsterdam.

When humankind dominates dualisms like nature/culture, how do we we define new modes of production and forms of knowledge?

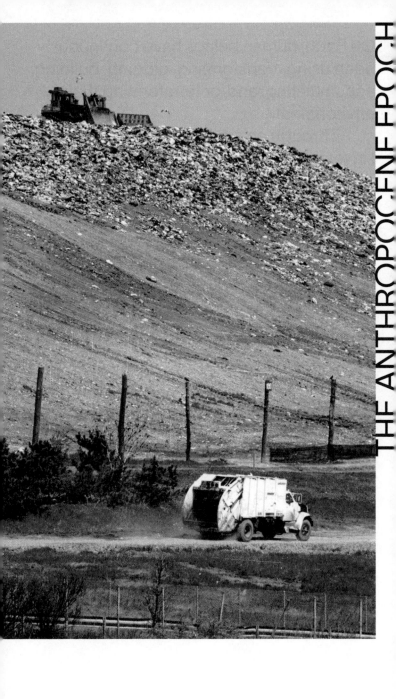

THE RAW, THE COOKED, AND THE
DECOOKED: A HISTORY OF WASTE
53 Cyril de Menouillard

On Earth, human beings have continuously been using, transforming, digging, building, accumulating, and/or terraforming their environment.

Through an artistic study of waste I investigated the way we process materials: in other words, how materiality is created and how this practice mirrors our knowledge production and accumulation. Observing waste disposal places informs us about the way a society envisioned its environment. Raw materials are more and more to be found in the 'cultural' domain of buildings rather than their quickly exhausting 'natural' environment.

I decided to focus on three distinct elements—earthenware, concrete, and garbage—to uncover this manufactured sedimentation of the landscape. The three strata were imposed by the site I worked on: earth as the common ground we live on, the concrete that covers it as a product of modernity, and garbage as the ultimate element of our material accumulation.

Claude Lévi-Strauss notices among other things that populations who do not know cooking have no word for 'cooked'. As a result, they do not have any word to say 'raw' because the concept itself cannot be characterized. His aim is then to show how empirical categories, such as those of raw and cooked, fresh and rotten, wet and burnt, may nevertheless serve as conceptual tools to generate abstract concepts.

Lévi-Strauss then introduces a series of *Ge* myths, in which the jaguar gives the secret of fire to men, but crucially, also that of cooking food. This notion is central insofar as it mediates the transition from nature to culture. It takes shape as an opposition to the rotting process by which food goes back to nature.*

However, looking upon the recent Anthropocenic view of our world, it becomes clear that 'nature' and 'culture' cannot be reduced to a binary system, nor can 'raw' and 'cooked' be considered limits. They are more ruptures of a transformational process: suddenly, they loose their dualistic aspect and open the possibility of a new state, the 'de-cooked'.

I applied my method to a *broedplaats* [warehouse] on the docks of Amsterdam. Used as an exhibition space, each material is mapped out in three distinct pieces. The idea was to produce objects of accumulation, corresponding to known architectural and cultural typologies: a ceramic arch, made of roof tiles; a bench dug out of the foundation slab of the exhibition building; and a garbage pile made of the rubble and any waste produced during the exhibition set-up.

In the words of artist and writer Robert Smithson, the objects each represent Non-Sites: Monte Testaccio (IT), Teufelsberg (DE), and Fresh Kills (US); three major historical dumps that transcended their cooked state to become 'natural' hills, decooked features of the landscape.

The Monte Testaccio is the ancient world's biggest garbage dump, layered with consumed amphoras throughout Rome's lifespan. Covered by crawling vegetation, very few residents are aware of its original function: in short, Monte Testaccio simply looks like a big hill. On the other hand, Teufelsberg was always envisioned as a manufactured landscape feature: it was formed from the remains of buildings destroyed in Berlin during the Second Word War and immediately covered with grass and trees as a geological monument to the war.

Our perception of the ground, predominantly horizontal, undermines the importance of its vertical composition. Due to our increasing pace of construction, we are neglecting the geological strata—anything but natural—produced by the mass movement of populations to cities. The Vertical Bench is a product of the extraction of the floor rather than an addition, revealing the accumulation of material we walk on daily. The rubble created during the digging is then disposed as a way to remove the former materiality of the floor of the exhibition space.

Commonly marginalized to the outskirts of the city, any large landfills should be considered as mirrors of human culture in the past, present, and what may constitute the future. They are central to an operational society struggling to face the by-products of its production. By-products to be hidden and embellished but not acknowledged as the results of its actions.

From a marginalized place, accumulating waste to an apparent natural feature of the landscape.

From dump to hill.

The decooking is complete.

* All references to Claude Lévi-Strauss come from translations by John and Doreen Weightman (1969 – 81) of his four-volume *Mythologiques: The Raw and Cooked, From Honey to Ashes, The Origin of Table Manners,* and *The Naked Man.*

Cyril de Menouillard

Given that our care for nature is negligible, which organism could survive the collapse of our planet's ecosystem?

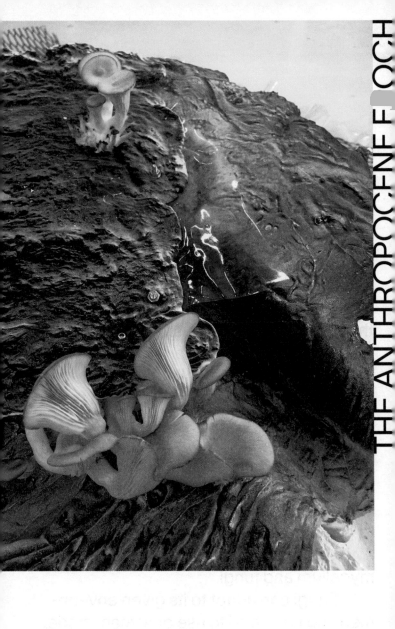

HYBRIS
Juliana Maurer

APPROACH

I chose a qualitative empirical approach for a project that mainly deals with mycelium, the 'underground' fungus. The research was divided into three parts: interviewing experts, reading and collecting theoretical information, and experimenting with the material itself.

Given their body of work, I interviewed experts like Maurizio Montalti and Studio Klarenbeek to get a better understanding of how to work with organic material and to get an insight of what is already possible. And yes, I taught myself how to grow mycelium and fungi.

Fungi can adapt to its given environment, so I decided to use only man-made, artificial materials found in construction sites, which are particularly bad for the environment. I built prototype habitats out of foam, PVC plastic and concrete, and let the mycelium grow. Which it did. It even makes its way through a laptop.

The Anthropocene puts man at the centre of what's happening on our globe. Although this era may appreciate the ingenuity and creative power of man, the term has increasingly become a symbol of man's exploitation of our planet.

Enter mycelium, a versatile and desirable material for every designer. Fast growing, its shape, size, texture and surface quality can be easily changed and processed. Mushrooms feed on agricultural waste and, in the end, quickly decompose into a natural cycle. This is an important advantage for a future material. The almost unsolvable problem of littering our planet with plastic waste can thus be mitigated.

One should not speak of nature or climate protection but of the protection of the human habitat. Nature has the ability to adapt to a multitude of conditions. While some species of animals will not survive the drastic environmental changes we may face, nature in itself is strong and will survive. Man is the weak link in the chain. Ultimately, we destroy our own existence through our ignorance and greed.

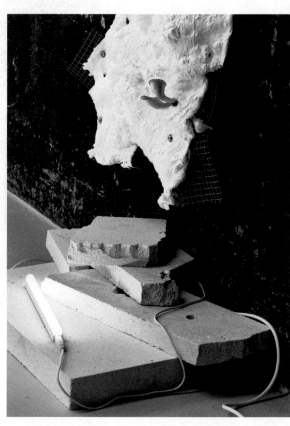

Juliana Maurer

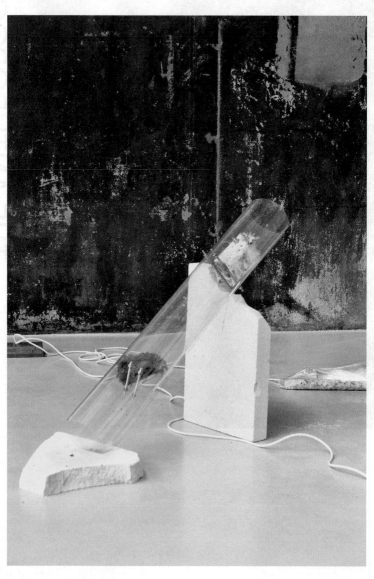

After my research, I decided to work with mycelium and fungi in an abstract and artistic way by showing a story about life and its decay.

The project's name is *Hybris*, a word from ancient Greek, and is often associated with a lack of humility. Sometimes a person's hubris is also associated with ignorance and arrogance.

In the current Anthropocene epoch, mankind no longer sees itself as part of nature but as a ruler of it. Man exploits and destroys nature for its own purposes. The tendency of mankind to dominate nature will eventually lead to nature dominating mankind. In this work, the materials manifest a contest between human work and nature's resilience: ubiquitous man-made materials come up against organic matter and high-tech materials confront the most primitive life forms.

The work shows a tension between the growth, the naturally grown, and the artificially created. The installation is formed out of man-made materials and objects. Light colours like grey and white dominate the overall image. It creates a cold, industrial feeling that is supported by several neon tubes that hang from the ceiling and lie on the ground. Its long cables are interwoven like roots spreading over the ground. The small scale of the sculptures makes you want to come close to discover what is hidden between the shiny, transparent surface of PVC plastic, and what is growing out of the undefined white sculpture hanging on the wall. It gives you a sense of intimacy. All the while the mushrooms (growing sculptures) are blazing their trail unnoticed through their given unnatural habitat within the sculpture.

The installation illustrates the arrogance of man in the Anthropocene. The light tubes stand for mankind's disregard for the natural law by inventing artificial light, so it is they who are in control of day and night. The chosen materials are all toxic for our environment. Once produced they are irreversible: plastic, foam, and concrete. Materials that are consciously chosen for being bad for the environment are paired with the fungus, the source of life.

Research is a fundamental tool for every artist and designer. But I would consider interdisciplinary collaboration as important as research. One of a designer's main functions is organizing communication, creating a message, and then making it understandable.

THE DANCE OF
TRIAL AND ERROR
Toby Kiers

Evolution is beautiful. It relies on chance (mutation) and selection (successful prototypes spreading more) to create the architecture of life. Evolution is the force that tests (and rejects) both the bold and the meek innovations. In its relentlessness, it carves out form and function from chaos. The beauty of evolution is its simplicity and its egalitarianism. Like design, it democratizes innovation as something accessible to all. It doesn't promise a straight route towards an end product, nor does it promise that the 'end' product is actually the end. It demands patience but guarantees refinement.

In the title of his 1973 essay, the evolutionary biologist Theodosius Dobzhansky makes the bold statement: '*Nothing in Biology Makes Sense Except in the Light of Evolution.*' Evolution provides a framework to understand life on Earth. It does this in three ways, all of which are relevant to the design projects here.

The first principle of evolution is in the process of failure. Evolution operates on a foundation of failure. Mutations are mistakes (failures in reading, writing or preserving genetic code). While the vast majority of these mutations are mistakes, it is the process of failure that generates change, leading to new and adapted forms of life. This concept is illustrated in the work of Cyril de Menouillard (*The Raw, the Cooked, and the Decooked: A History of Waste*). De Menouillard focuses on the process of failure by looking at landfills, and the idea that behind all advancement is waste. The concept is that landfills are like mirrors of human culture in the past, present, and the future. Evolutionary studies show us that we also carry these mirrors of our past in the form of so-called 'vestigial' organs. These structures, for example wisdom teeth, have lost all or most of their original function through evolution. But they remain with us. These are a functionless marker of our past. This concept is likewise explored in the work of Sae Honda (*Everybody Needs a Rock*),

where plastiglomerates (plastic-rock hybrids) are 'a mark of humanity's time on Earth'. The idea that our failures will be captured in *plastic* fossils shows we are not above the process of evolution.

The second principle is the idea of intention. Evolutionary change is not directed towards a goal. It rids itself of 'purpose'. It is free from the constraints of 'progress'. This is a concept that is even misunderstood by some scientists, most likely because organisms appear so 'well-designed' for certain tasks. But having a goal implies that there is a destination, one which life is moving towards. Naomi Lamdin (*The Warp & Weft: Metaphor as Material and the Materiality of Metaphor*) explores themes of the intentionality of language, using metaphors and seaweed. She asks how language must 'affect how we understand the world around us'. The word she uses is 'adaptability'. Juliana Maurer (*Hybris*) uses the same word in a project that asks us to marvel at the 'adaptability' of fungi. But what is adaptability— there is no intension or purpose. It just means that the dance of trial and error can lead to unintended results, which we call 'adaptability'. Evolution is powerful because it is both mindless, mechanistic, and without intension—and yet it has produced everything from tiny single-celled bacteria thriving in deep-sea vents to the muscular tongue of a giraffe. Given its ability to generate such massive innovative leaps, why is evolutionary theory not required curriculum for all design students?

The last principle is that evolution does not generate 'perfection'. No organism is perfectly adapted. Most are 'good enough' to pass their genes on to the next generation. This 'good enough' concept is refreshing in a world dominated by overly vocal winners. This is highlighted in Maurer's work: a fungus is 'good enough' at growing through computers and plastic. It is able to extract what it needs from the environment without being pampered. As she writes: 'nature in itself is strong and will survive'. Organisms do this by being OK, not perfect.

The power and principles of evolution are finally being recognized by diverse disciplines. Programmes in Darwinian medicine, agriculture and even robotics (whereby robots 'evolve' in unpredictable environments) are setting the stage for how evolution can be harnessed. Design students take note.

Toby Kiers is Professor of Evolutionary Biology and University Research Chair at the Vrije Universiteit Amsterdam.

www.tobykiers.com; research.vu.nl/en/persons/toby-kiers; @KiersToby

The Time Capsule That's as Big as Human History

When the apocalypse comes, survivors [...]

'When Martin Kunze was 13, he was on vacation with his parents in Spain, and at a beach next to the Mediterranean, did what kids sometimes do out of curiosity and boredom while their parents apply sunscreen and read and kibitz about the other tourists: He started digging a hole in the sand. The process intrigued him. About two feet down, fresh water started filling the hole from underneath. There was a plastic bottle his parents had brought with them, and on a childish lark, Martin took a piece of newspaper and jotted his name, number, and address on it in German with a message: *If you find this, please contact me.* (...)'

When Martin Kunze was 13, he was on vacation with his parents in Spain, and at a beach next to the Mediterranean, did what kids sometimes do out of curiosity and boredom while their parents apply sunscreen and read and kibitz about the other tourists. He started digging a hole in the sand. The process intrigued him. About two feet down, fresh water started filling the hole from underneath. There was a plastic bottle his parents had brought with them, and on a childish lark, Martin took a piece of newspaper and jotted his name, number, and address on it in German with a message: *If you find this, please contact me.* "I put this into the bottle, and put it into the ground, hoping that some beautiful girl would find it in the

BY MICHAEL PATERNITI VANITY FAIR October 30, 2018
PHOTOGRAPHY VIKTOR SCHANZ

'He waited and waited. "I never forgot this," he says. Years passed, then decades. No beautiful girl called out of the blue. Then, something astonishing happened. Three years ago, more than 30 years after Martin had buried the bottle, a dog-walking retiree from the area, after having the note translated for him, contacted Martin's parents, who were still at the same scribbled address, saying he'd found the bottle and read the note inside.

Martin, who is now 50, says it was probably the bottle's vintage and shape that helped it get found. What amazed Martin, though, was that someone had taken the time and effort to call after all those years, because of the jottings on a scrap of newspaper. It was all so simple, really, a naive impulse on a beach, a missive fired from the past to the future, and now from the future back to the past. And for Martin Kunze, who'd by then gone from being a scrappy boy with a curious mind to a shaggy university student with a passion for ceramics to a middle-aged father of five kids whose urgent mission these days has become the construction of an enormous time capsule meant to survive for thousands of years, it was also affirming. Who was the sender, and the receiver, and what was each looking for?

"Some communication through time," says Martin now, "some kind of contact."

If you were to build your own time capsule, what would you want people—or alien beings—a million years from now to know about us? That we were loving, or warmongering, or dopes strung out on memes and viral videos? That we flew to the moon and made great art, ate Cinnabons (that we measured at 880 astonishing calories), and committed atrocities? How could you begin to represent these times, as lived by nearly 8 billion people? And what would give you, of all people, the right to tell the story?

(...)

It's this very vision of an earth one million years from now that changed Martin Kunze's life forever. About ten years ago, he read a book called *The World Without Us*, by Alan Weisman, a thought experiment in how quickly things on our planet will deteriorate once humans have been eradicated. Weisman imagines New York City's Lexington Avenue as a sudden river, unmanaged petrochemical plants spewing toxins like Roman candle Most importantly, the book points out that ceramics, which are not unlike fossils, stand the greatest chance of living on as they already have from previous ancient civilizations.'

How can we provoke ourselves to see more with less—or more in less—to have a stronger awareness of limitation?

PERFECT TEMPTATION

Biyi Zhu

By trying to address the awareness of environmental challenges and food scarcity to people who live in countries with plenty is a challenge. In these places, scarcity is not easy to find at the physiological or social level. Only relative scarcity exists.

So how can we believe in climate change and resource scarcity when facing ubiquitous plenty?

For my research I attended all the usual climate conferences and read numerous articles, but the more I learn, the more I realize I don't know.

That is when documenting and filming takes over as the most important tool. This method gives me access to a complicated and vivid world through interviews, conversations, and engagement with another person's reality.

In my work, listening and experiencing creates knowledge. This knowledge transforms into a film to conduct a message.

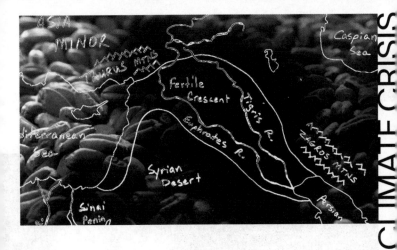

Scientific consensus about climate change prevails—temperatures are rising and public awareness is developing. However, the idea of scarcity is more complex. It is a dark and depressing topic, and difficult for people living with plenty to connect to.

My film *Perfect Temptation* is an installation based on my journey into the topic of food scarcity in Palestine and Cuba. Its content questions the ambiguous vision of food scarcity and environmental challenges using bread as a metaphor.

Bread has been a cultural symbol throughout history. Universally relatable, I used this quality to visually trigger a discussion about food scarcity in a world where there is, in principle, enough for everyone.

In my film, bread connects two different scenes of scarcity that I discovered during field trips to both Palestine and Cuba. And I reinvent some of my documentation with a body performance to portray scarcity via a poetic expression.

The opening scene shows a person standing in front of a corner, his hand touching the ashen wall softly, seemingly looking for something. His hand imitates the process of dough kneading and folding in the air; the emaciated body and an empty stomach indicating his need: a piece of shared bread. This scene recalls my vivid memory, sitting alone with a drowsy homeless guy in a street in Havana, sharing and documenting just one very small moment of his difficult life.

Havana is sunny and rainy and lush—an ideal environment for crops to thrive. There is no ready supply of imports. Most available products are produced domestically. Under communism food staples such as wheat, rice and potatoes were only regulated. Whereas salt, edible oil and sugar were properly centralised, meaning distribution was totally controlled according to the system. This situation has become more flexible in recent years, however, for ordinary people scarcity is reflected in the limited available choice and the uncertainty of supply.

This situation is completely different in Palestine. I met Palestinian craftsmen who only have access to limited resources to design products. This is a huge challenge for them and also really helped me to understand what limitation actually means. It is complicated because while available resources are limited, food supply is plentiful. The markets are full of vegetables and fruits and plenty of grains imported from around Europe, including Ukraine and Russia. But these are often at prices that many can't afford, with the situation being especially acute in the occupied Palestinian territories.

Does food scarcity exist?

In this part of the film I start by using a hand gesture: pushing grains aside and exposing the map of the current Fertile Crescent, now so barren and so unproductive, and represent the golden grains that surround the darkness of this desalinated natural landscape. The Fertile Crescent, an area that covers what are now southern Iraq, Syria, Lebanon, Jordan, Palestine, Israel, Egypt, and parts of Turkey and Iran, received its name from its tremendous grain harvest and impressive record of past human activity in ancient history. Today, it is mostly seen in terms of international geopolitics and diplomatic relations rather than any kind of poetical concept. With the huge difference between the past, the majority of these countries are facing inordinate suffering, war, civilization downfall, and turbulent political situations. Any or all, which may lead to a different level of tension about both food scarcity and food insecurity.

In the Middle East, staple foods are not only subject to politics but also large-scale environmental threats, and while those markets are full of grains now, what about the future? If overseas suppliers experience the same pressures and disasters of climate change, those exports could not only be extremely limited but in the worst-case scenario could come to a halt. Yield losses may happen more frequently due to unpredictable weather, but due to the speed of population growth the need for wheat will not slow down. Developing countries may not be able to avoid paying a higher price and emptying their wallets for wheat, a global grain strongly bound to the livelihoods of different people in different countries.

From lush lands where choice is limited to droughty lands that are not capable of gestating plants, spending time in these contrasting situations I learned that it is only when someone lacks basic daily food staples that they can really understand what scarcity means. It is something that needs to be experienced.

The project's goal became an experiment with how far feelings and emotions can go to really make people act differently, inviting the audience to engage with other people's experiences. They are encouraged to compare their own situations to the plight of others via viewing the film project on the ground with flour.

Perfect Temptation is a film about bread. It leads views into a better understanding of desire, inaccessibility, and scarcity. Bread appeals to the senses: it tempts us to eat, to strengthen our bodies, and to overcome fear. It starts from a single slice that we can see, but we cannot reach.

How to encourage people to act on urgent topics like climate change, food consumption, deforestation and inequality, without feeling direct or personally accused of blame?

A DIFFERENT PERSPECTIVE

Niels Albers

I wanted to use facts about man-made disasters to communicate their seriousness to an audience but avoiding any finger-pointing blame.

The premise was to focus this experiment on the audience's own future survival using an interesting narrative filled with well-researched facts. In my original research every fact listed comes with a clear footnote for reference.

Fundamental to the research question, method and project, I wanted to see if via just these facts it was possible to elicit sympathy and compassion from the audience.

At the moment I'm in the middle of the Atlantic Ocean. We left around three weeks ago from *Porto de Santos*, the biggest port of Brazil, heading for Rotterdam in the Netherlands.

During this long trip I have plenty of time to share my story with you.

I will talk in English and start by introducing myself. You call me Soy in North America or Soya in English-speaking Europe. I have bright green leaves, white purplish flowers, and later elongated spherical seed pods.

You see yourself as unique, but every species on this planet is unique so that is no way of distinguishing yourself. Why are you so prone to downplaying animal intelligence? Why do you routinely deny them capacities that you take for granted in yourself?

Here I like to quote philosopher and writer Timothy Morton:

> Maybe it would make it more obvious if we stopped calling it 'global warming' (and definitely stopped calling it 'climate change', which is really weak) and start calling it 'mass extinction', which is the net effect.*

Something I don't understand is why you don't seem to realize that my species only needs soil and sunlight to grow, while animals need food to grow. Since you cannot live from soil and sunlight you don't lose any food by letting us grow. To produce 650 kgs of edible parts of me and my family members (you call it plant-based food) you need zero kilogrammes of other food.

That is different with non-human animals. They need to eat before they can grow. For example, to let a cow grow to 650 kgs, you have to first feed it a few thousand kilogrammes of food—food that could be consumed directly by your species instead.

Non-human animals need to eat like you just to stay alive. They eat to stay warm, to let their heart beat, to breath, to keep their senses active, to keep their brain operational and even to digest their food. I would not call the meat industry a food production industry but an industry that transforms a lot of food into less food.

In other words, the expansion of my species' population resulted in the possibility of the growth of your population, which set off the rise of the non-human animal populations.

Logically all three of us need more space for this development, but there is only a limited amount of land mass sticking out of the big salty water shell, the main feature of the planet we've evolved on.

In the first instance, it seems very kind of you to make a lot of space for my species' development and expansion. From your point of view, it must be really nice for us to exist in huge populations. If we would have the same intentions as your species it would be disappointing to not yet have colonized the whole world and only be growing on six of the seven continents. But I'm not like you; I value variety.

Maybe you don't understand me, because after all I do speak another language, so let me explain with an example of how we communicate.

There are many ways we plants communicate with each other. We don't only use the wind as a messenger; it can also be via another species from another kingdom. I'm talking about fungi.

When you see a mushroom popping up from the ground that is just the tip of an iceberg. The toadstools above the surface of the land are just the fungi's reproductive organs. Underneath the land surface can be a huge network of threads, what you call mycelium. Fungi are the largest living organisms on this planet, and they can become more than a thousand years old.

To start a partnership a tree must be very open, literally, because the fungal threads grow into its soft root hairs. In exchange for sugars and other carbohydrates

that the tree can deliver, the fungi allow the tree to use its web to roam through the forest floor. In this way the tree extends its reach with it own roots towards other trees. It can even connect with other trees' fungal partners and roots.

You could compare it with your invention of the internet. Trees can communicate about insect attacks and even exchange vital nutrients via this forest-web. It shows that a forest can behave as a single organism. A tree is one, but a forest is also one. You call this 'flat ontology'. This means that a forest is not a bunch of trees that compete with each other; they are a large group of super co-operators. All this alienation produces the environmental dilemmas you call Anthropocene.

Another great example of Anthropocentrism, or an apex of insanity, is to call a geological epoch after your own species and proclaim yourselves as a geological force. Even if it is to accuse yourself of having trashed everything—the seas and the skies, the ground and what's underground—and even if it is to confess your guilt for the unprecedented extinction of plant and animal species, you assign yourself the main role.

You dare to speak of 'biodiversity' while you observe the dilution of species on Earth from space. You have the hubris to claim, paternally, to be 'protecting the environment', which certainly never asked for anything of the sort. All this has the look of a last bold move in a game that can't be won.

My destiny is pretty clear. I've been growing up with the notion that there is a big chance I will be eaten. That is fine, as it is part of the circle to fertilize the land for my brothers and sisters, cousins and other distant family members, to keep the balance for all involved. As a seed I was destined to travel away from my mother, hence this trip makes me generally excited.

* Morton Timothy, *Being Ecological* (London: Penguin, 2018).

Can garments become agents for change? What role can emotional connectivity play in creating alternative strategies for fashion production?

RES MATERIA
89 Sanne Karssenberg

While making an in-depth theoretical research about topics such as social sustainability, interdependency and politics of emotionality, I simultaneously started a practical textile research into the possibilities of transforming a used garment into a new one.

Contact with specialists and companies in the field of adhesives, airflows, flock and textile development, taught me about the existing technical possibilities. Analysis and reflection based on both my own tests and the information gathered from the industry shaped my imagination for future possibilities.

To engage with the theoretical framework, I fictionalized the theory. Books written by academics such as Bruno Latour, Zygmunt Bauman and Jonathan Crary, provided the base for envisaging alternative futures and the way current society could get there. By imagining these pathways to a possible dystopic future, I grounded the theory in contemporary society.

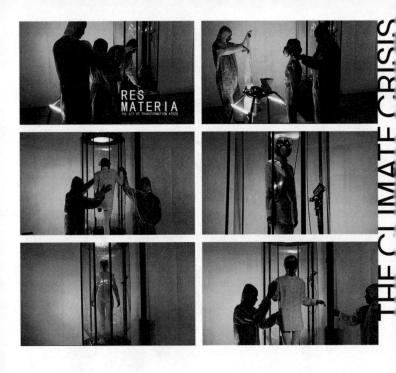

By altering the making process to explore the emotional value and connection of wearers with garments, and to see the possible effects, I invited different wearers. The garments were a starting point for a dialogue about the individual's relationship to the garment and fashion's societal impact. Both the material specifics of the garment, such as the brand and textile composition, and personal histories like the favourite place to wear the garment, are made visible as part of the production. To carefully interact with the object as an agent of change, these dialogues directly influenced my design process on an aesthetic and emotional level.

The title *Res Materia* is inspired by the Latin phrase *Res Publica*, meaning 'public affairs' or 'commonwealth'. *Res* is a Latin noun for a substance or a concrete thing. *Materia* is Latin for material. In this project the material and the thing, or in this case the textile and the garment, are the starting point for an embodied reproduction of garments. It is an attempt to bring change into the contemporary state of public affairs.

In times of increasing ecological, political and economical crises, a dystopic future doesn't seem far away. The current approach of the fashion industry to recycling is not an entirely fulfilling solution for the ecological crises. This project explores the possibility of change by redefining the relation between wearer, garment, and designer (facilitator). The base for this project is an imagined future of extreme ecological circumstances. Over-recycling has turned everything into dust, and all the resources are finished. This project attempts to offer solutions to tackle this possible dystopia.

Both the product and process involve the wearer. A person brings in a garment with a history, with a special emotional value or personal memory. This is a piece that one would not throw away but also no longer wants to wear. The garment is shredded in front of the eyes of the wearer, its remnants to be reused as a layer on another garment by the same wearer. The wearer then enters a man-sized cabin that resembles a fitting room, which hosts a dust storm of the shredded garment's fibres. The fibres stick to the clothes the person is already wearing.

The added, recycled layer provides a new aesthetic component and is a way to repair the torn or worn out pieces of the second garment. The added layer does not hide its recycled aesthetics; rather it turns recycling into an added value.

In the current fashion industry the production process of clothes mostly remains unknown. Those specifics are not part of the value of our clothes. In addition, it's difficult to engage with and value the making process of what we wear.

Res Materia proposes an almost physical experience: you hear, smell and feel the making process. It's a noisy, almost violent experience to be an equal actor within this reproduction process. By taking the history and the making process as the start to engage with our clothes, I try to value the interdependency between wearer, maker, and garment.

Humans, animals and other natural things are earning legal recognition and rights. Should artificial objects also be granted such rights?

THE RIGHTS OF OBJECTS
Marjanne van Helvert

APPROACH

I use speculative manifestos and fictional scenarios to explore ways of thinking outside of the constraints of current design ideologies. In the radically changing context of the Anthropocene, the Capitalocene and the climate crisis, with all of their social and environmental consequences, Western paradigms of progress, growth and modernity seem to be faltering. Our definition and reliance on notions of nature, wealth and solidarity within the neoliberal capitalist society are starting to crack, but we are struggling to commit to alternatives. We seem to be stuck in the exemplary quote by Fredric Jameson and/or Slavoj Žižek: 'It is easier to imagine the end of the world, than the end of capitalism.' But is it really? I intend to challenge this fatalistic, Western worldview by imagining all kinds of ends and beginnings.

For the longest time, in Western thinking at least, humankind has considered itself the master of nature. We imagined our influence on our surroundings to be negligible at most. And we imagined that 'nature' was so impassive and impregnable that its infinite resources would be at our disposal forever. This has turned out to be a paradoxical combination of megalomania and false modesty, and it is turning on us.

Now some of us humans have used too much, extracted too much, created too much, consumed too much, thrown away too much. Many of us did not realize that what we created would last forever, perhaps as garbage disintegrating at a glacial pace underground or in the oceans, or as carbon molecules being released *en masse* into the atmosphere after having been safely locked up in the Earth's crust for billions of years. Most of us did not think about the long-term effects of this irreversible reshuffle of materials.

As a consequence, we might need to consider the independence and rights of these non-living entities as much as living things. We need materials, eco-systems, weather patterns, waterways and other things to remain in that particular balance that supports life on Earth. We need them to have the right not to be disturbed and transformed by us, the right to be left in peace, as they once were, slowly having come to rest in relative stability after billions of years of violent formations.

WAARDEER HET
REPAREER HET

S|RE

Marjanne van Helvert

OBJECTOPHILIA,
A LOVE LETTER
TO THE
CONTAINER
VESSEL
CHRISTOPHER

Performed at Stroom, Den Haag, February 29th, 2020. Original photo by Naomi Moonlion.
Program curated by Lua Vollaard. Background design by The Rodina.

And once we create new entities, they necessarily deserve these rights as well. We might grant rights to the forest and the tree, but when we decide to build a chair out of that tree, we need that chair to have rights. It needs the right to serve its purpose and to survive, because if it doesn't it will go on to further disturb the balance of things. We need the chair, the jacket, the cup and the carpet to have the right to be taken care of, to be cherished and repaired, to be available to those who need it.

The right of a human-made object to survive is directly connected to our own chance of survival. These things in turn extend their rights to us: their sustainability by definition prolongs ours. The sustainability of objects, of consumer goods, of all of the things we surround ourselves within our daily lives, grants our own sustainability as a culture, and perhaps even as a species.

I have recited the above manifesto on multiple occasions and for various groups of people, ranging from art school students to designers, and mixed audiences. It has been received with an earnest enthusiasm that took me by surprise, as I had initially thought it was obviously a far-fetched concept that would not easily be taken seriously. Several times my readings led to fascinating discussions on how we could implement something like legal rights for objects, and how this could lead to both desirable and unintended consequences. For example: a lively and efficient repair culture would probably arise out of enforcing rights for objects, yet we might all become compulsive hoarders as well. The interactions resulting from the readings were the most valuable outcome of this project, planting new seeds in my own creative practice as well as in the minds of the audiences.

RADICAL EMPATHY
Will J. Grant

What changes are required of us, if we are to address
the key challenges we all now face? What must we do,
as the earth systems we rely on—and the biological sys-
tems, food systems, economic systems and political
systems—collapse around us? Is it as simple as enact-
ing minor tweaks to our day-to-day routines, or must
we modify deeply our relationship with everything
that has brought us to here? Do we even know what
that means? Must we modify who we are?

I write this response from the midst of the
Covid-19 pandemic: a global event striking fear in the
hearts of billions. But here in Australia this apoca-
lyptic threat has come hot on the heels of a series of
rolling existential disasters. We began the year with
drought and fires the likes of which we've never seen,
before hailstorms and pandemics wreaked other dys-
topian damage. We've been spared our usual floods
and cyclones so far, but there are no guarantees this
will hold.

As Niels Albers (*A Different Perspective*) reminds
us, the existential threat we face is talked about regu-
larly, but difficult to pin down. 'Climate change', he
contends, is a weak term, so too 'global warming'. For
him the adequate term is 'mass extinction'. Marjanne

van Helvert (*The Rights of Objects*) talks of the Anthropocene and the Capitalocene, and the delusion that we humans are the masters of nature. And for Biyi Zhu (*Perfect Temptation*), it's a crisis that remains difficult to see.

These terms and concepts all do something to evoke the crisis we're in. Yes, the climate is changing. Yes, it's humanity—and capitalism more precisely—that has caused it. Yes, it's our inability to think beyond short-term biases and needs, and yes, it's our wilful divorce from nature. Yes, we're living in the midst of the sixth great extinction.

Yes, and.

But it's difficult, with this crisis so multifaceted and vast, to exhaustively pin down one label. There is just so much that we are doing to the planet and ourselves that the politically and scientifically necessary reductionism cannot capture it all.

It is also difficult to know how much—and what—we must change. Must we eat differently, as Zhu and Albers ask? Ought we consider clothing, how we wear fabrics, and our bodies differently, as Sanne Karssenberg (*Res Materia*) offers? Or as Van Helvert proposes, must we start asking if the rights we hold dear for ourselves must be extended to the rest of the occupants of our biosphere?

Again, the answer can only be 'Yes, and.'

The key to grappling with this crisis is hinted at by all the artists in this chapter. At heart, we will get nowhere without a radical openness, without questioning all the assumptions of our social world, and without an empathetic approach that seeks to ask what we all truly need in this world. Karssenberg touches on something important here, when she asks participants in her project to bring 'garments with history', 'a special emotional value or personal memory' to then be shredded and made anew.

We are all from the world that has caused this rolling crisis; we are all—to some extent—complicit. This is not to apportion blame, as Albers warns us against, but to recognize that the world that has caused this crisis—as Van Helvert hints—is who we are. We cannot be that anymore, but we can only get to the new with empathy for the old.

Will J. Grant is Senior Lecturer at The Australian National Centre for the Public Awareness of Science at The Australian National University.

www.cpas.anu.edu.au/people/academics/dr-will-grant; @willozap; @WholesomeShow

THE COB
EX

THE
NEW YORKER

A CRITIC AT LARGE DECEMBER 23, 2019 ISSUE

THE FIELD GUIDE TO TYRANNY

Dictators tend to share the same ugly manner because all seek the same effect: not charm but intimidation.

By Adam Gopnik
December 16, 2019

'Dictatorship has, in one sense, been the default condition of humanity. The basic governmental setup since the dawn of civilization could be summarized as taking orders from the boss. Big chiefs, almost invariably male, tell their underlings what to do, and they do it, or they are killed. Sometimes this is costumed in communal decision-making, by a band of local bosses, but even the most collegial department must have a chairman: *a capo di tutti capi* respects the other *capi*, as kings in England were made to respect the lords, but the *capo* is still the *capo* and the king is still the king.'

From: Adam Gopnik, 'The Field Guide to Tyranny', *The New Yorker*, 23 December 2019

www.newyorker.com/magazine/2019/12/23/the-field-guide-to-tyranny

'Although the arrangement can be dressed up in impressive clothing and nice sets—triumphal Roman arches or the fountains of Versailles—the basic facts don't alter. Dropped down at random in history, we are all as likely as not to be members of the Soprano crew, waiting outside Satriale's Pork Store.

Only in the presence of an alternative—the various movements for shared self-government that descend from the Enlightenment—has any other arrangement really been imagined. As the counter-reaction to Enlightenment liberalism swept through the early decades of the twentieth century, dictators, properly so called, had to adopt rituals that were different from those of the kings and the emperors who preceded them. The absence of a plausible inherited myth and the need to create monuments and ceremonies that were both popular and intimidating led to new public styles of leadership. All these converged in a single cult style among dictators.

That, more or less, is the thesis of Frank Dikötter's new book, *How to Be a Dictator: The Cult of Personality in the Twentieth Century* (Bloomsbury). Dikötter—who, given his subject, has a wonderfully suggestive, Nabokovian name—is a Dutch-born professor of history at the University of Hong Kong; he has previously written about the history of China under Mao, debunking, at scholarly length and with a kind of testy impatience, the myth of Mao as an essentially benevolent leader. *How to Be a Dictator* takes off from a conviction, no doubt born of his Mao studies, that a tragic amnesia about what ideologues in power are like has taken hold of too many minds amid the current "crisis of liberalism." And so he attempts a sort of anatomy of authoritarianism, large and small, from Mao to Papa Doc Duvalier.

Each dictator's life is offered with neat, mordant compression. Dikötter's originality is that he counts crimes against civilization alongside crimes against humanity. Stalin is indicted for having more than 1.5 million people interrogated, tortured, and, in many cases, executed. ('At the campaign's height in 1937 and 1938 the execution rate was roughly a thousand per day," Dikötter writes.) But Stalin is also held responsible for a nightmarish cultural degradation that occurred at the same time—the insistence on replacing art with political instruction, and with the cult of the Leader, whose name was stamped on every possible surface. As one German historian notes, you could praise Stalin "during a meeting in the Stalin House of Culture of the Stalin Factory on Stalin Square in the city of Stalinsk."'

I investigated how architecture hosts ideology and space determines behaviour to pro-voke action within the current socio-political situation.

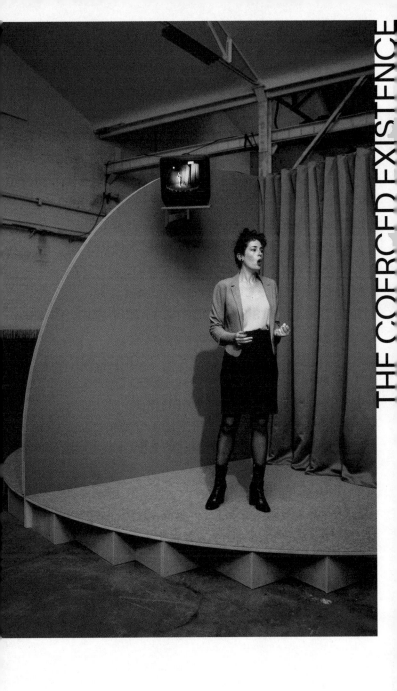

JELLY COASTS AND MILK RIVERS
Liene Pavlovska

To better understand the link between the responsibility of individual actions and the accountability of a collective body I used collaging as a tool. While valuing academic texts as well as information gained from leaflets, letters and tabloids, I also cherish my own and other's memories as much as written representations of history as part of the methodology.

In my research I also use theatrical modes of expression and experience of catharsis in the context of visual art. I look at catharsis as both an individual and collective phenomenon.

My research manifests in constructed situations, guided and revealed by architectural structures and spatial interventions. Work develops into collages, mixing various media and interventions by other artists and performers.

Making my research public and constructing situations that are experienced together with an audience is a cornerstone of my practice and the main objective I keep in mind whilst generating physical shape in my work.

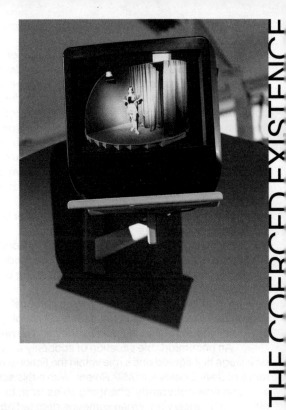

Jelly Coasts and Milk Rivers is an expression used in the Latvian language to describe a fictional place of wealth and happiness. Growing up in Latvia at a time when society shifted from a communist past towards a capitalist future, I often wonder about how the idea of a collective desire is represented and how narratives of the past, present and future are created whilst directed and hosted within the urban stage.

While working on *Jelly Coasts and Milk Rivers* I looked into a comparison between city planning and the creation of a theatre performance. I was focusing my gaze towards my personal history and linking what it has in common with, and how it is influenced by major historical events. I was looking to ideologies as a metaphorical stage director.

There is a blurred boundary between the role of the spectator and actor that I believe reflects a similar relation between an individual and society. In my scene the spectator becomes the actor via a sculpture, which is a circular route combining stage and backstage.

Approaching the installation one encounters an 'enter' sign that switches on and off in a random rhythm. The text board kindly asks you to wait, although it has no organizational logic.

Later, one finds oneself in a dark space where the voice of a man repeats:

Jelly Coasts and Milk Rivers. The place of true happiness and wealth. A place where all our dreams come true. Jelly Coasts and Milk Rivers. The place of true happiness and wealth. A place where all your dreams come true. Jelly Coasts and Milk Rivers. The terrain of freedom from work, the terrain of freedom from worries. The terrain where everything is organized for you. Jelly Coasts and Milk Rivers. The place that allows you to be the best version of yourself. Your dream. Our dream. Just enjoy it. Everything is made for you. Just be part of it.

While exiting the dark space, the spectator lands in a brightly lit stage area.

By collaging visual codes and gestures from the space of the theatre, I was creating a scale model of my own feelings and a spatial thought mapping of my thesis research.

When does the awareness of my personal privilege arise? How can I resist the scenario I am playing out? And where do I find my own agency and power?

An uncomfortable situation of suddenly arriving on a stage highlighted one's role within the fictional narrative of *Jelly Coasts and Milk Rivers*. Within this scenario one was constantly changing roles from being observed to observing. When someone decided not to step into a sculpture and not to be on stage, the logic of the installation still included the spectator within its narrative. My aim was to create the relationship between active/passive modes of participation as an exaggerated variation of constantly changing roles that I am experiencing and observing around me in daily life. The realization of being within a current socio-political and economical spectacle that is a well-oiled machine left me with a heavy burden, a feeling of being tied to the spot. I am interested in how to crack this position by disobeying the grand narrative bit by bit and by generating uncomfortable questions.

Can we question the politics of dying by reimagining the architecture of euthanasia?

Captain

Through conversations with UK based Pro-assisted dying campaigners *Dignity in Dying* and end of life counsellor Dr. Ton Vink...

TASKS

Read the Due Care Criteria

Sarah

A request for euthanasia or assisted suicide must be made by the patient concerned.

TASKS

Talk on the balcony

George

Now I can feel my body changing week by week, and I'm short of breath.

I'VE BEEN TO PARADISE

115 Joseph Pleass

I interviewed pro-assisted dying campaigners from the UK-based Dignity in Dying organization and spent time with end-of-life counsellor, Dr Ton Vink.

Using knowledge of computer programming, I created a game that aims to inform and educate players of the context surrounding euthanasia. The outline of the game script was discussed with Dr Vink and the game dialogues were influenced by accounts of patients and families going through the assisted-dying system.

Through the act of decision-making and role play, the game puts players in the position of making difficult decisions and confronting their own attitudes towards—imagined and real—end-of-life services and euthanasia.

I've Been to Paradise is a video game that allows a player to role play the experience of going through the process leading up to euthanasia of a loved one. The experience is set aboard a fictional euthanasia cruise ship.

By using the platform of a video game, I tried to create an empathetic encounter of the often difficult and conflicting sets of decisions and actions that play a part in the wider context.

The setting of the cruise ship acts as a kind of stage for speculating on future alternatives to the dying practices that we currently have established, for example hospices and hospitals. By choosing a setting that challenges our current association with the architecture of dying, a space is created for questioning that same dominant medical architecture, which itself is the result of cultural and political attitudes associated with 'how' and 'when' we should die. Alongside this sits our long-standing relationship to 'paradise', both as the notion of an afterlife and as the utopian ideal that cruise ships strive for, often mirroring notions of Christian paradise narratives of abundance and leisure.

The purpose of speculating about euthanasia is so that the taboo surrounding the discussion of dying practices can be lifted. Not only is it a matter of life and death, but an important interrogation of how our bodies are viewed by the state. The criminal status surrounding the decision to assist in someone's suicide reveals a complex interplay of ethics and subjugation that ultimately manifests in our laws and freedom. The fact that this plays out in such an emotionally wrought scenario requires speculation as a tool to approach the subject from a critical and emotional distance.

Working alongside Dignity in Dying, I designed the story that drives the game to include the personal accounts of families who have already been through the euthanasia experience as well as the legal ramifications of its criminal status in the United Kingdom.

Using the architecture and metaphor of the enclosure, how do physical and ideological walls build invisible enemies in our daily lives?

THE DOMESTICATED ENCLOSURE

Jonas Hejduk

I analysed sociological books and articles about the representation that people make of the idea of foreigners. The image is mostly built through filters like television, social networks, physical walls, and socio-cultural boundaries.

By blindly trusting sources, we easily end up judging a community (political, religious, social) without ever really encountering it.

I used the film *Jurassic Park* to trigger a nostalgic imagination in my audience and divert their attention to much more serious subjects: populism, security, and business.

This is the breeding ground of my *Domesticated Enclosure*, which via a series of tools (scary design, realistic details, real electric shocks) makes people believe the potential presence of danger. I try to echo the way some structures and media fuel fear in society.

I like to talk about sensitive subjects in an accessible way using humour, false naivety, and darkness.

Some people use fear to gain power, and sometimes it can take a pretty subtle form. For example, the French government declared a state of emergency following the Bataclan attack in 2015. By making certain laws more flexible France facilitated counter-terrorism actions, such as telephone tapping, and electronic and public surveillance. But Amnesty International has said the government used this tool (the state of emergency lasted until 2017) too broadly to strategically limit citizens' rights in the name of national defence.

In this way, the terrorist threat increased the government's power. So what if the government decided to permanently keep this power by inventing a radical Islamist ghost, making the public scared of something that might not exist?

When a wall is raised, it is then difficult to see what is really going on behind it. The architecture of enclosure is an architecture of terror. It indicates a monstrous danger with its details: towering fences, high voltage cables, raw concrete blocks, and a clear separation between what appears to be a high risk area and a so-called civilized side.

Jurassic Park taught us that the suggestion of danger in itself is already thrilling. No need to perceive a T-Rex to be convinced of its presence. But what if the dinosaurs hadn't come? Would we leave the island still convinced of the threat lurking behind the walls? Probably.

THE DOMESTICATED ENCLOSURE

The *Domesticated Enclosure* is first of all a manifestation of a child's fantasy: the act of being able to contemplate and get close to a space that is both hostile and nostalgic. Through facing the barrier, the position of the voyeur reveals that no embodiment of danger is needed to persuade us of its presence. Nearly two-metres high, the structure is composed of a thick concrete base bordered by an impressive yellow metal structure—reminiscent of the Auschwitz barriers.

Everything suggests that one must be wary: the electric wires give real shocks, the lights of the electric box are blinking, and noises emerge from the inside of a grim machine. The angle of the base prevents an audience from coming too close to observe clearly what the thick vegetation seems to hide. Facing the fence, a rug and a sofa allow the audience to enjoy an intimate atmosphere to sit and watch the huge monolith, just like watching television in your living room. Can a screen be seen as a type of enclosure when Fox News spreads stereotypes about the Muslim community?

Security convinces us that there is a distance between any given situation and us. On a political scale, is it enough to only strengthen borders to persuade people that a monster resides on the other side? All deportation migrant camps are private in the USA, and so is the surveillance industry in general. The lobbying of these companies succeeds in convincing the American government to harden the laws even more—in order to multiply the arrests—and thus to build more camps to make this business as profitable as possible.

As a citizen, it might feel safe or even pleasant to be on the 'right side' and to believe that there is something dangerous 'out there'.

But what does this say about the role we play in defining our reality and just how far do official enclosures affect our daily lives?

THE COERCED EXISTENCE

POWER PLAYS
Pedro Ramos Pinto

Jackboots, truncheons, and prison cells. Our imaginary of coercion and repression is often made visual and sensible in the direct exercise of violence. This is the *ultima ratio* of power but also the bluntest instrument of coercion. It works through pain and fear, that of the victim and its exemplary effect.

But how does power make us behave when it us who is the policeman? The critical point about philosopher and social theorist Jeremy Bentham's Panopticon was not so much that the prison guard could see everything. It was rather that the prisoners could not know if the guard was looking or not. Michel Foucault alerted us to the disciplinary nature of power, how uncertainty and fear make us work towards the aim of others, and to the role of space in disciplining us. This interplay between space, freedom and coercion runs through the three projects in this chapter.

In the installation of Liene Pavlovska (*Jelly Coasts and Milk Rivers*), the voice urges us to be the 'best version' of ourselves: '*Your dream. Our dream,*' whose dream? The disciplinary effect of capitalism works through its promises of freedom and plenty, even as we meander through its dark places. The arrival at the stage—as if in an anxiety dream—reminds us that such rewards will only come if we play the role assigned to us. When everything is commodified and packaged in an app, from our daily steps to our love lives, public and private spaces merge and literally, all the world is a stage upon which we must perform.

Jonas Hejduk (*The Domesticated Enclosure*) inverts the concept of the prison. The mysterious enemy is enclosed; we are kept safe from it. But its threat seeps out over the fence, through the viewing windows and infects us with its fear. We are mesmerized by the enclosure. Will it hold? Who is the prisoner? We can

wall in our fears, but in doing so do we risk becoming defined by them?

In the video game of Joseph Pleass (*I've Been to Paradise*) the issues of freedom, coercion and space take a further twist. The structure of the game, a tightly constrained environment guided by an algorithm as well as the confined space of the cruise ship, focuses our attention on a fundamental question: our freedom to choose our time of death. The association of the ship with death projects impacts us in a number of ways— it is impossible not to think of the countless Covid-19 ghost ships, unable to dock and threatened by a lethal virus. But this image also inhabits allegories of the 'good death', sailing into the sunset. Yet here too a critical instrument is separation, moving away from the society of the living. Pleass' avatars are on a ship because on-shore social mores coerce them to continue living in suffering. But why is it that to make our choice we have to remove ourselves from society? Are we coerced into facing death—even freely chosen—alone, or with only those willing to risk their own freedom to escort us?

Reflecting on these projects together brings out the intimate and contradictory interconnection between space and coercion. In both *Jelly Coasts and Milk Rivers* and *The Domesticated Enclosure*, freedom is eroded less by walling-in or internment than by the absolute openness of the stage, or by the power of that we enclose (or believe we have enclosed). In contrast, in *I've Been to Paradise* that very confinement is liberating.

Such thoughts resonate strangely during a time when so much of the world is under quarantine. The usual freedoms—to walk, to roam—have shifted dramatically. If we are coerced to quarantine, is that a worse loss of freedom than the obligation—driven by need— to go out to find work, being exposed to infection? In this moment Pleass and Pavlovksa remind us that the spaces of freedom are contingent and changeable. Yet Hejduk—but also Pleass, if we look behind the wall —remind us of the power of confinement: throughout history dictators have feared most what they separate and coerce. The power of prisoners of conscience, of those who refuse to be coerced, in house arrest or in any Robben Island, is a beacon for freedom.

Pedro Ramos Pinto is an historian at the University of Cambridge, working on the history of rights and inequality.

www.hist.cam.ac.uk/directory/dr-pedro-ramos-pinto;
@pedroramospinto; @ineqhist

LIMITATIO

OF LA

THE
NS

NGUAGE

The Atlantic

GLOBAL

What's a Language, Anyway?

The realities of speech are much more complicated than the words used to describe it.

JOHN MCWHORTER JANUARY 19, 2016

MORE STORIES

How Immigration Changes
Language

Hong Kong Is a Colony
Once More

TIMOTHY MCLAUGHLIN

Don't Build Roads, Open
Schools

'What's the difference between a language and a dialect? Is there some kind of technical distinction, the way there is between a rabbit and a hare? Faced with the question, linguists like to repeat the grand old observation of the linguist and Yiddishist Max Weinreich, that "a language is a dialect with an army and a navy." But surely the difference is deeper than a snappy aphorism suggests. The very fact that "language" and "dialect" persist as separate concepts implies that linguists can make tidy distinctions for speech varieties worldwide. But in fact, there is no objective difference between the two.'

A man writes Chinese characters on a footpath using water and a brush in central Beijing. (DAVID GRAY / REUTERS)

What's the difference between a language and a dialect? Is there some kind of technical distinction, the way there is between a quasar and a pulsar, between a rabbit and a hare? Faced with the question, linguists like to repeat the grand old observation of the linguist and Yiddishist Max Weinreich, that "a language is a dialect with an army and a navy."

But surely the difference is deeper than a snappy aphorism suggests. The very fact that "language" and "dialect" persist as separate concepts implies that linguists can make tidy distinctions for speech varieties worldwide. But in fact, there is no objective difference between the two: Any attempt you make to impose that kind of order on reality falls apart in the face of real evidence.

And yet it's hard not to try. An English-speaker might be tempted to think, for example, that a language is basically a collection of dialects, wherein speakers of different dialects within the same language can all understand each other, more or less. Cockney, South African, New Yorkese, Black, Yorkshire—all of these are mutually intelligible variations on a theme. Surely, then, these are "dialects" of some one thing that can be called a "language"? English as a whole, meanwhile, looks like a "language" that stands by itself; there's a clear boundary between it and its closest relative, Frisian, spoken in Northern Europe, which is unintelligible to an English-speaker.

As such, English tempts one with a tidy dialect-language distinction based on "intelligibility": If you can understand it without training, it's a dialect of your

From: John McWhorter, 'What's a Language, Anyway? The Realities of Speech are Much More Complicated Than the Words Used to Describe to', *The Atlantic*, 19 January 2016

www.theatlantic.com/international/archive/2016/01/difference-between-language-dialect/424704/

'And yet it's hard not to try. An English-speaker might be tempted to think, for example, that a language is basically a collection of dialects, where speakers of different dialects within the same language can all understand each other, more or less. Cockney, South African, New Yorkese, Black, Yorkshire—all of these are mutually intelligible variations on a theme. Surely, then, these are "dialects" of some one thing that can be called a "language"? English as a whole, meanwhile, looks like a "language" that stands by itself; there's a clear boundary between it and its closest relative, Frisian, spoken in Northern Europe, which is unintelligible to an English-speaker.

As such, English tempts one with a tidy dialect-language distinction based on "intelligibility": If you can understand it without training, it's a dialect of your own language; if you can't, it's a different language. But because of quirks of its history, English happens to lack very close relatives, and the intelligibility standard doesn't apply consistently beyond it. Worldwide, some mutually understandable ways of speaking, which one might think of as "dialects" of one language, are actually treated as separate languages. At the same time, some mutually incomprehensible tongues an outsider might view as separate "languages" are thought of locally as dialects.

I have a Swedish pal I see at conferences in Denmark. When we're out and about there, he is at no linguistic disadvantage. He casually orders food and asks directions in Swedish despite the fact that we are in a different country from his own, where supposedly a different "language"–Danish–is spoken. In fact, I've watched speakers of Swedish, Danish, and Norwegian conversing with each other, each in their own native tongues, as a cozy little trio over drinks. A Dane who moves to Sweden does not take Swedish lessons; she adjusts to a variation upon, and not an alternate to, her native speech. The speakers of these varieties of Scandinavian consider them distinct languages because they are spoken in distinct nations, and so be it. (...)

A Moroccan's colloquial "Arabic" is as different from the colloquial "Arabic" of Jordan as Czech is from Polish. In order to understand each other, a Moroccan and a Jordanian would have to communicate in Modern Standard Arabic, a version preserved roughly as it was when the Koran was written. The cultural unity of Arab nations makes the Moroccan and the Jordanian consider themselves to be speaking "kinds of Arabic," whereas speakers of Czech and Polish think of themselves as speaking different languages.'

What form(s) emerge when writing fiction by using the main character's thoughts and adventures as an actual research tool?

ARIADNE AND THE
INFLAMMATORY CHOIR
135 Manon Bachelier

APPROACH

This project is an editorial experiment,
a writing exercise, and a wide research for
themed artistic practices.

I used the methodology of Ariadne
herself, as defined by the Greek myth in
which she guards the maze of the Minotaur.
Her method is the only one that succeeds
in defying the architectural principle of the
maze, refusing any spectacular performance;
instead intuitively linking one step to the
other and placing markers: 'through an ex-
haustive application of logic to all available
routes. This process can take the form of
a mental record, a physical marking, or even
a philosophical debate; it is the process
itself that assumes the name.' (Wikipedia.)

I used archived documents specially
produced by artists I reached out to. The
story I was writing became the tool for gath-
ering the content, and the tool for ordering
and indexing it.

Ariadne and the Inflammatory Choir is 'an on-growing collection of dilated fluids delivered by burning lips'; encountered while researching the figure of Ariadne, known in Greek myth as the sister of the Minotaur, guard of Daedalus' maze, and helper-lover of Theseus.

I wrote two new chapters of Ariadne's story, starting from the existing mythical event of Theseus killing the Minotaur and assessing Ariadne's function as an eventually obsolete guard. As she evolves into a sea explorer, roaming the water and figuring out her own aspirations, I gathered content that echoed the story and the questions that arose. The collection became a magazine.

On the website, the main text is the fictional story of Ariadne, and all the collected contributions appear throughout as secondary hyperlinks. In contrast, in the printed magazines the story is spread out as small chapters, drowned in the thicker contributions and collected texts.

In this project I tried to experiment with editorial notions such as ranking, indexing, ordering, archiving, displaying, re-editing, and copying. It was challenging and exciting to throw these together in one piece of writing and to observe how they could nourish each other when read in a flow.

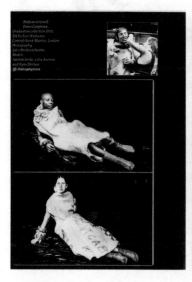

Visually, my graphic references came from self-made punk and feminist copied zines, which I tried to bring towards a more literary feeling, playing with rough scanning and experimenting with the depth of black inks on letters and on images. I wanted to keep the feeling of 'urgency' given by black and white zines as well as maintaining a cheap way of producing. Only the pages of the fictional story were printed on intense orange paper; and the illustrations drawn for the story (by artists Yunie Chae and Klara Graah) printed in full colour. Indicating the difference between the various types of content, the specifically produced contributions were printed as inverted (white text on black), while the collected archived material was copied as found, black text on white.

Considering the 'on-growing' character of the object, the booklets could easily be removed or added from the publication, copied and printed separately, then folded and bound together with metallic bolts.

The last step of the project was the spatial display of the research and its outcome (a printed magazine and a website). Because the research was about womxn artists defining their own practices and their own ways, I thought the physical components of the project shouldn't lean on anything already existing in the space (walls, floor or furniture). That's why I composed it by associating the thread Ariadne uses in the maze with a fantasy of her own pirate island. I wanted the space to grow intuitively, in a series of backs and forths, following Ariadne's thread principle. The installation then became a web of hanging black ropes knotted together; an ensemble linking all elements of the project as one wide constellation.

How can Western European citizens relate to a substantial crisis, when that crisis isn't in line with their own reality?

THE LIMITATIONS OF LANGUAGE

DID NOT TAKE PLACE

141 Rebekka Fries

In his essay *The Non-Existence of Norway* (2015), Slavoj Žižek explains the naive position of Europe and the United States' involvement in the affairs of the Africas and Middle East.

I decided to focus on reporting 'the refugee' by Western media and how the suffering of the 'other' is visualized in photography and media. I also watched movies such as Alfonso Cuarón's *Children of Men* (2006) and I had conversations with two Syrian refugees. I collaborated with a director, theatre maker, writer, and actors.

The six-screened video project *The Secret Agent* (2015) by Stan Douglas guided me on how to visualize a story from six angles. The inspiration for using a smartphone interface as a 'stage' was, *Your Phone Is Now a Refugee's Phone* (2016) made by BBC Media.

At the end of summer in 2015, Reuters, Aljazeera, *The Guardian*, *de Volkskrant* (NL) and *NRC Handelsblad* (NL) published numerous comments concerning Syrian refugees crossing the Mediterranean on Twitter. The Syrian civil war had been raging since 2011 and the harsh reality had taken some time to reach the headlines in Europe.

Due to the 140-character limit on Twitter, stigmatizing terms such as 'refugee crisis', 'closing borders', and 'migrant deals' became the way the crisis was framed. This type of language created a disconnect between the war and its reality.

The distorted relationship between language and image motivated me to address the disconnect.

The identity of the refugee becomes analogous with the other and all the uncertainties and fears surrounding 'a new way of living'. This is seen as potentially distorting the established European identity.

I read the essay *The Gulf War Did Not Take Place* (1991) by philosopher Jean Baudrillard, which provided insight into just how unaware the public was concerning the framing of the Gulf War in 1990–1991. He describes how CNN marked the introduction of live news broadcasts from the frontline while commercial breaks were programmed in between. Through this representation, the public's view was framed and thus distanced from the war and the actual damage taking place there. The role played by the individual was a narrative that this story-telling technique left behind.

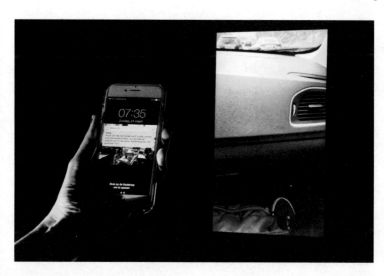

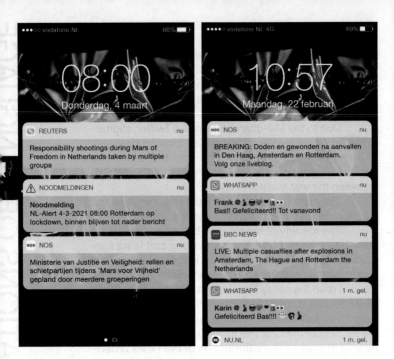

In contrast to this, the personal stories told to me directly by Syrian war refugees reveal the levels of anxiety and disbelief. These narratives emphasize how important it is to have everyday contact with family members.

Learning this made me better understand the importance of the mobile phone. A hand-held device defines how an individual experiences a crisis through the device.

The combination of inputs provides me with a format for storytelling using a familiar visual language.

I combined the perspective of the protagonist together with the position taken by the media and its political agenda to compose a suggestive scenario. The immersive experience of the video as it is taking place on our most intimate device, challenges West European citizens' worldview towards minorities.

To provide another layer in the disconnected experience of the storyline the project contains two screens that function together as a video installation. The video on the device leads the storyline, and on a second vertical screen the pursuits of what the video camera of the device could film is shown.

In the project, the viewer receives notifications on his or her personal device via the apps the protagonist is using on their own smartphone screen. At the same time, a second video is shown on another screen, which displays the recordings of the protagonist's camera.

The narrative takes place in 2021 and turns a Dutch citizen into a refugee. Certain events are causing numerous tensions in the Netherlands and as the protagonist feels threatened; she decides to leave.

The audience is given a perspective on how the life of the protagonist is lived metaphorically using her smartphone, but also, how important the smartphone is in urgent situations.

Furthermore, the audience is given a perspective of how their reality could also suddenly change. The smartphone user receives notifications and has a new reference on how a news notification can abruptly become part of a reality that isn't theirs.

How effective can art be when tasked with the responsibility of communicating the complex emotions inherent to the feminist struggle?

GIRLS' NIGHT OUT

I am searching for something—a language
or an expression.

Girls' Night Out is a sculptural environ-
ment. And I was drawn to the qualities of
foam, glass, and clay. The carved foam sculp-
tures carry the expression of something soft
and comforting, countered by the hardness
of the clay, and the sleekness of the mirrored
glass objects. With their combined materials,
the sculptures take on a different language.

Other peripheral influences from my
studio—sketches and music—fed into the
project. In the song *Fifteen Feet of Pure White
Snow*, Nick Cave shouts: 'Doctor, doctor,
am I going mad?' This line resonated with
me in the pursuit of building an environment
in which a sensitive viewer could catch
the work's atmosphere. I wanted people to
live and exist in the fiction I was creating
so made use of Cave's sentence in my text.

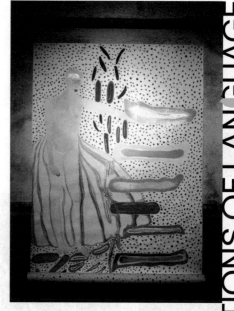

Girls' Night Out operated as an autonomous exhibition work, yet turned into a *Gesamtkunstwerk* during the times of the performative readings. For the performances I sat on top of one of the sculptures like a coach in her natural habitat.

The three sculptures and drawings of various sizes worked together across their contrasts. Playing with the qualities of surfaces (soft versus hard) and shapes (long and pointy versus rounder shapes) opened the work up for play. Experimenting with the degrees of contrast in colour and scale built tension and added to the ambiguous language within the work.

I believe coping with the realities of this contemporary era leaves people feeling fragmented. I think this makes us feel like we are almost living inside of a dream where nothing seems to make sense, where nothing really appears to hang together. While this is a state of mind, it is also an approach to the idea of being trapped. The mirrored glass objects standing on top of the grey foam together create repetitions of images. The thought of the mirror as something alienating instead of something merging, speculates on how one perceives oneself and our surroundings.

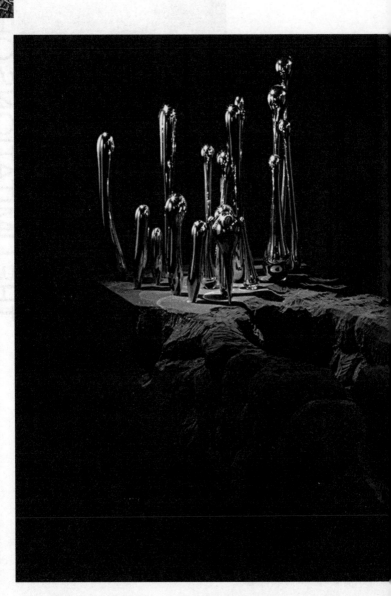

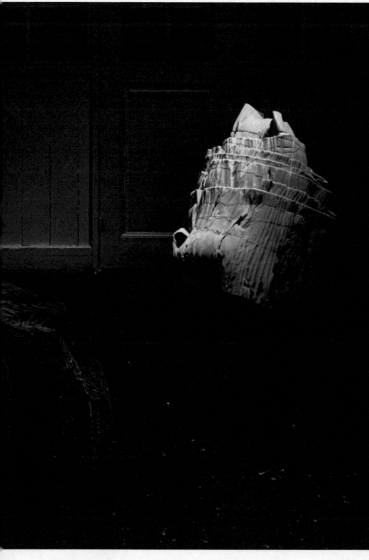

During the nearly one-year period I spent making *Girls' Night Out*, we witnessed a rising of the right wing in the Western world. I think what many experienced as a huge blow, was when Donald Trump won the election.

His infamous quote 'Grab'em by the pussy' seemed to respond to a drawing I made back in 2014. This A4 format drawing entitled *It is Naive to Believe That Men Don't Create HardCore Feminists* is interesting seen in relation to Trump's words. The choice of including this small drawing in my project was based on the very power it holds. The drawing depicts the title of the work across the paper. This statement is repeated in the fiction story readings, a line that gives an entrance into the work and offers the viewer a direction. Using this sentence was as much a way of launching out towards white patriarchy, as it was an attempt to speculate on power.

If the sculptures represent characters in *Girls' Night Out* and the enormous person seen in the largest drawing is understood as being one of the 'girls', then the viewer's imagination is given space to unfold. The title of the work suggests that there is a group of women together. Looking at the foam sculpture with ceramic fingers pointing out of its body in all directions, expresses attitude and even some aggression. But the colours used are soft, and the fingernails are mirrored. *She* is all made-up, ready to hit the streets for that night out.

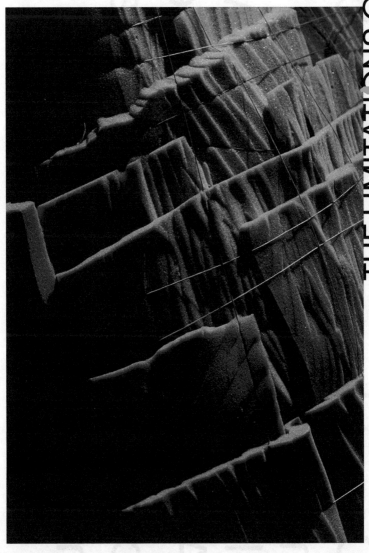

Do we know enough about human intelligence and the language through which AI advancements are being communicated, especially in mainstream media?

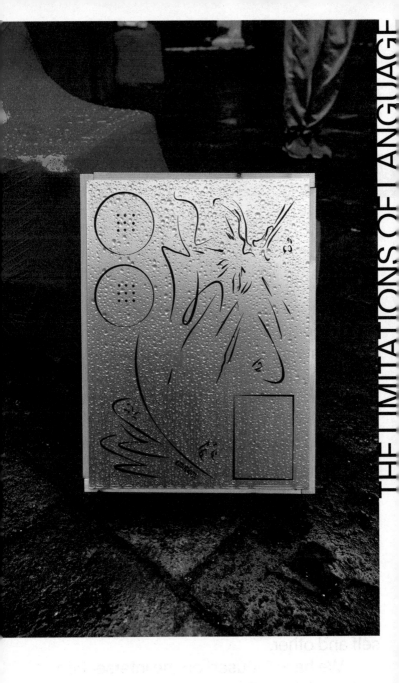

AN INDIFFERENT CONDUCT
Gamze Baray and Eurico Sá Fernandes

Our project addresses the current level of (in)distinguishability between humans and machines. It aims to expand on and design a different version of the original Turing test. Guided by the psychological measures that are normally used for humans, such as alexithymia (emotional blindness), depression and self-awareness, this project speculates on our current ability to tell the difference between humans and machines.

We tried to fuse our knowledge of systems of reason and interaction that come from the technification of life with the ways in which ideologies shape the definition of self and other.

We have focused on the intersection of Artificial Intelligence (AI) and psychology. We think emotions are one of the crucial elements that demarcate the difference between humans and machines.

Emotions have evolved to inform humans and even other species about what is happening inside the mind, what occurred before, and what is likely to occur next.

Early in our research we discovered that current applications of AI have been deeply influenced by the functioning and structure of the human brain. We got interested in the mechanics of emotions: for example, the complex emotion 'outrage' is a combination of disgust, anger, and surprise. Complex emotions are often the combination of two or more basic emotions. The expression of basic emotions, such as fear, disgust, anger, sadness, surprise, trust, anticipation and joy, are universal. Most humans and animals are able to recognize the expression of these emotions in others.

By analysing how emotions can be measured in psychology and their possibility to be coded into a type of a programming language, we became interested in finding the humanity behind these systems. We are also interested in questioning whether machines can experience emotions that are completely unfamiliar to us.

Gamze Baray and Eurico Sá Fernandes

Most of the time it is straightforward for humans to read others' emotions. We can observe the facial expression or observe physiological changes such as the change in body temperature. However, for an emotion to be communicated accurately, the facial and physical expression should correspond to the emotion. If, for instance, a person is joyful but they have a sad expression, we would assume that the person is sad. We believe that in AI the algorithm could be blind to this discrepancy between what is observed and what is experienced. We started to question if machines could be diagnosed with psychological and neurological conditions such as emotional blindness or alexithymia, a condition that is marked by the difficulty in identifying and describing emotions. Alexithymic people are often confused and unsure about what emotions they are feeling. For instance, when they are upset they don't know if they are sad, frightened or angry. They live in a one- or two-dimensional world, deprived of the fullness of feelings. They also have difficulty in identifying emotional expressions of others. With the help of a variety of techniques, they are able to learn how to identify their emotions and give the appropriate response. We are interested in this example because in mainstream culture, AI is often portrayed as emotionally blind. We are currently working with a specific focus on emotions and the ways in which they function in humans and how they may function in machines.

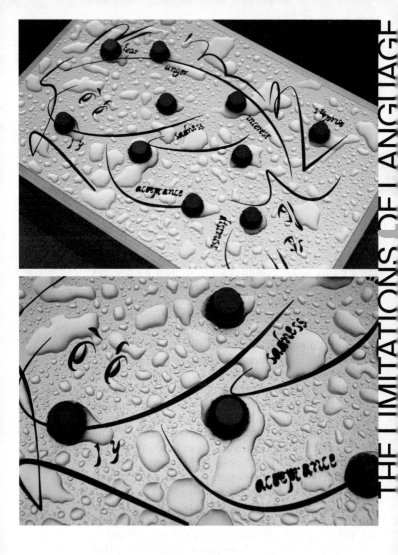

Gamze Baray and Eurico Sá Fernandes

LISTEN, LOOK, AND LEARN
Matthew Longo

The limits of your language are the limits of your world. Ludwig Wittgenstein tells us this. He is making a point about human cognition, how we process the world around us and make meaning out of it. But the plight is familiar. Every day we come to the edge of what we understand; of the things we feel but can't express. In such cases, we cannot resort to the language we know—the words and idioms that structure our lives. We have to create something new. But how?

In my work, I think a lot about politics as a spatial construct, with places and territories cut up by various logics of division: religion, nation, ideology, and so forth. Some of these demarcations are familiar; just think of the borders separating one state from another, clear black lines that tear across the map. But as frequently, the interesting divisions are not so visible—neighbourhoods where some people feel welcome and others don't; places with good schools and hospitals versus those where the police don't come when called. Such demarcations are no less meaningful, yet we often lack the verbal or visual idioms to describe them. To take these invisible lines and bring them to light.

The artists assembled here grapple in different ways with this same challenge—expanding the scope of our language to (re)capture meaning; translating one kind of idiom into another. Manon Bachelier (*Ariadne and the Inflammatory Choir*) reconceives the Greek heroine Ariadne. In the classic telling, Ariadne is a secondary figure in the myth of Theseus and the Minotaur, an accomplice to Theseus, ultimately abandoned by him. In the mythological construct, Ariadne's agency is subsidiary, derivative, dismissed. How can she escape these bonds? Through experimental writing and editing techniques, Bachelier breathes new life into Ariadne, scripting adventures that break free from

the classic telling. By changing the idiom, she transcends its limitations.

These themes of language and gender also find expression in Ellen Ogawa's (*Girls' Night Out*) project, where language-transcendence takes a discretely physical form as she communicates the complexity of emotions that inhere in the feminist struggle. She does so by juxtaposing two physical forms: carved foam sculptures that embody the expression of softness, intertwined with hard and unforgiving clay. This interplay of visual and textual expressions—itself a statement of the predicament of women in our contemporary political environment—was set beside mirror spaces, inviting viewers to find their own place in this dialogic struggle.

Rebekka Fries (*Did Not Take Place*) draws this political message out further, into the context of contemporary migration and the untranslatability of experience. How can we empathize with migrants when we cannot understand what they have lived through? Simply seeing images of suffering won't help. This only reifies otherness—allowing us to temporarily stand in their shoes from a convenient emotional and physical distance after which we can return to our (comparatively) non-precarious lives. Instead, Fries makes the experience of refugee vulnerability appreciable to the viewer by using the shared medium of the mobile phone, giving insight into the disparate worlds we each hold in our hands.

These artists used their platform to bridge disparate experiences and replace delimiting idioms with new ones—reminiscent of French philosopher Gaston Bachelard's remark that art gives us a fresh start, that it 'stimulates our consciousness and keeps it from being somnolent'. Although academics pursue a different path, in many ways the mandate is the same. As a political theorist, in my work I look critically at the world around me aiming to destabilize conventional understandings, and to cast them in a new light. The fact that it seems as though artists and academics speak different languages is a failure on our part. It is a product of stove-piping and navel gazing, of using language as a tool to obfuscate, rather than communicate. The artists here have given us a prompt to think differently. It's time we listen.

Matthew Longo is Assistant Professor of Political Science at Leiden University and author of *The Politics of Borders: Sovereignty, Security, and the Citizen after 9/11* (Cambridge, UK: Cambridge University Press, 2018).

www.universiteitleiden.nl; @matthewblongo

WORLD · DISINFORMATION

We're In the Middle of a Global Information War. Here's What We Need to Do to Win

RELATED STORIES

WORLD
New Zealand's Health Minister Resigns After Virus Blunders

WORLD
24 Shot to Death in Attack on Drug Rehab Center in Mexico

PAID PARTNER CONTENT
The Future of Healthcare
BY KAISER PERMANENTE

'If the Russians had tried to find a more inhospitable space for our meeting, I don't know how they could have succeeded. I was led into a narrow trapezoidal room. It was 10 days before the 2016 presidential election. I had been Under Secretary of State for Public Diplomacy for almost three years, and a big part of my job had been trying to counter the deluge of Russian disinformation that we saw beginning with the invasion of Crimea in 2014. But I was under strict orders from the National Security Council to not bring up interference in the U.S. election. No one wanted any hiccups.'

Illustration by Lincoln Agnew for TIME

BY **RICHARD STENGEL** SEPTEMBER 26, 2019 6:36 AM EDT

I f the Russians had tried to find a more inhospitable space for our meeting, I don't know how they could have succeeded. I was led into a narrow trapezoidal room with one grimy window in a faceless building of Russian bureaucracy. It was 10 days before the 2016 presidential election, and I was the assistant Secretary of State for Public Diplomacy for almost three years, and a big part of my job had been trying to counter the deluge of Russian disinformation that we saw beginning with the invasion of Crimea in 2014. But I was under strict orders from the National Security Council to not bring up Russian disinformation or interference in the U.S. election. No one wanted any hiccups.

The two Russian officials seemed to be channeling Putin: chilly, inhospitable, inflexible. They made no effort to be pleasant—or even diplomatic. I brought up Russian harassment of American diplomats. They shrugged. I brought up the

From: Richard Stenger, 'We're in the Middle of
a Global Information War: Here's What We Need
to Do to Win', *Time*, 26 September 2019

https://time.com/5686843/global-
information-war/

'The two Russian officials seemed to be channeling Putin: chilly, inhospitable, inflexible. They made no effort to be pleasant–or even diplomatic. I brought up Russian harassment of American diplomats. They shrugged. I brought up the forced closing of American cultural facilities. They shrugged. I did not bring up Russian interference in our election. I wish I had.

I had come to State after being a journalist for many years and the editor of *Time* for the previous seven. My job was to help shape America's image in the world–I thought of myself as the chief marketing officer for brand USA. But then a funny thing happened. Within a few weeks of my being on the job in 2014, the Russians invaded and then annexed Crimea, the southernmost peninsula of Ukraine. The largest violation of another nation's sovereignty since Iraq's invasion of Kuwait. And Vladimir Putin lied about it–over and over again.

President Obama and Secretary of State John Kerry condemned this willful act of aggression and called for sanctions against Russia. I shared their outrage, but I couldn't impose sanctions or call up troops. What I could do was, well, tweet about it. After all, I was the head of all of State's communications, and I could marshal department messaging against Russia and the invasion. So I decided to tweet on my own, hoping others would follow. Here's the first: "The unshakable principle guiding events must be that the people of #Ukraine determine their own future."

As I started tweeting, I noticed something odd. Within the first few minutes and then for months after, I started getting attacked, often by Russian-sounding Twitter handles. A single tweet would get dozens, sometimes hundreds of comments. I soon started getting hundreds of tweets calling me a fascist propagandist, a hypocrite and much, much worse. At the same time, we observed a wave of social media in the Russian periphery supporting the Russian line on Ukraine, accusing the West of being the source of instability, claiming Ukraine was a part of Russia. Who knew that the Russians were so good at this? We didn't realize or even suspect it at the time, but this tsunami of Russian propaganda and disinformation became a kind of test run for what they did here in the 2016 election.'

What happens when an object is presented within the context of a performance? Can it change what the object is?

WHERE THERE IS AN OBJECT
Kjersti Alm Eriksen

Objects are not actors. Objects cannot control how they appear. While a human being can alter his or her appearance and therefore fit (act) several roles, an object is stuck with the characteristics it was given when it was made—or has attained while being. This radically limits the range of roles an object can play, and this matter became relevant as the project was exploring the means and methods of theatre.

Based on traditional ways of making a theatre performance, the project came to be in the following order of actions:

1. Choosing a story.
2. Casting for this story, which meant making the right objects for this story, and creating scenography, sound, and light.
3. Rehearsing—a stage that also included making, since making (or physically changing) was how the objects could work with their character.
4. Performing.

All objects contain stories. The majority of these stories though, are never really being communicated, as neither the objects nor those who would potentially perceive them are giving the stories the attention they require to be told. *Where there is an object* is a search for new ways of presenting objects, and an exploration of the narrating powers that lie within them and the stories they hold.

In January 2016, I founded The Potential Object Theatre. In July of that year we put together our very first performance. *The Norwegian Oil Adventure* played nineteen times at the Gerrit Rietveld Academie graduation show. *Where there is an object* is the making of this performance and the installation it became between the shows.

The element of time (the defined beginning and end of the artwork) draws the audience's attention from the physicality of the objects to their actions—and, if you like, their agency. Character is a result of conduct (this is one of the pillars in theatre): we *are* what we *do*. And this deliberate way of shifting focus from aesthetics to behaviour is also an honest attempt to question on what basis we define what an object is. What do we look for when we read an object and what do we find?

This project's concern for action also reveals a fundamental dependency on human presence. Objects need a constant supply of energy in order to act. For this particular performance I wanted to keep the objects analogue and somehow transparent when it came to movement, and this structure would require my presence as a provider of energy during shows. This human presence raises questions about the motivation behind an action. Are the objects reacting to an impulse, or is the audience only watching a choreographed performance? Are the objects telling their own stories? As the audience was also invited to interact with the objects before and after the show, this search for motivated action could be further explored in a one-to-one meeting with an object.

What affects our perception of an object? *Where there is an object* is about the unnoticed potential of things. It brings attention to the details. It cherishes imagination and the notion of what could be or become. By placing objects in a temporary and fictive reality on stage, and giving them the possibility to perform, I aim to broaden the spectators' imagination. What was an unrecognized function might now make a lot of sense in another setting. I want to challenge the way we (choose to) look at physical things and enhance the possibilities we are able to see in them. Objects are not absolute and neither is how we perceive them.

Social media today and histor–ical tapestries have a lot in common, so how can a reading of both reveal the actual versus the exaggerated?

LEARNING FROM TAPESTRIES
175 Lisa Plaut

At one point in history, tapestries reflected current knowledge. They were luxury items, specific and elite, yet rarely shared with a general public. Today, the volume of images that circulate through social media is extreme.

In research I opt for a layered approach that fuses seriousness and wit. There is space for precision but also a democratic eye cast across what is perceived as high and low culture.

I based a lot of my research on the writings of German art historian and cultural theorist Aby Warburg about the persistence of pictures and the survival of the mythical. He describes Renaissance tapestries as 'democratic objects' and not 'aristocratic fossils'.

To create both the works in the project my research tools include paralleling the past and the future, visual story telling and object analysis, both in context and as a narrative tool.

I took two objects as my start point: an image of *The Lady and the Unicorn*, a medieval tapestry woven in Flanders around the beginning of the fifteenth century, and an orchid that was growing in my kitchen. Orchids were originally imported from the Far East as luxury goods but are now cultivated in the Netherlands for the European market. Similarly, the flora portrayed in the tapestry was the result of early colonial explorations by travellers and scientists.

To better understand the context of both a flower in an ancient tapestry and a flower in a contemporary kitchen, and to discover a potential link, I conducted historical research into colonialism and early capitalism via image analysis.

This work interrogates the contrast between the digital and the physical world and reflects on how the way we think is influenced by the way we see. It acts on the realization that the way we relate to our direct surroundings and its materiality, changes because of the omnipresence of screens today.

179 Lisa Plaut

For *Flower Mimicry*, I took pictures of flowers found in the tapestry like daffodils, roses and carnations, then downloaded them to plant.net, an app using image recognition to determine botanical species.

In the tapestry, the plants correspond to existing species, but their combination in the same space and season is not realistic.

This garden of information can only be semi-true, which I think relates to the internet today. Algorithms determine the information we can access as well as how subjects and topics are positioned and seen.

The culminating collage highlights the limitations of an algorithm that ultimately fails to embrace any socio-political perspective in its formulation of so-called knowledge.

The result of this part of the project was a digital print on silk, felted manually.

Flags of the Synthetic Self is a pair of wall hangings inspired by the flags seen in the tapestry. It is made out of plastic and dried fruit and comments on how images are used as social status enhancers to shape our digital synthetic self.

The commissioner of *The Lady and the Unicorn* was a rich merchant who aspired to nobility. He designed his own coat of arms with three moons on a diagonal, which according to the rules and norms of the day is fake. The colours do not follow heraldic rules.

This conclusion links to our own contemporary assemblage of pictures online and our staging of daily life on social media. Like the aspirational merchant, we are also busy building a digital synthetic self.

Today, fruits symbolize a healthy lifestyle and are easy tools for us to visually market ourselves online.

The fruit flags in my wall hangings are made from fresh fruits that have been processed, sliced, dried and transported, and then vacuum formed into giant plastic packaging. The mechanism driving the global fruit market reinforces corporate agricultural production. It's not sustainable despite its sleek image.

It is interesting to point out that as part of my research I accessed peels from the hipster restaurant in Amsterdam, The Avocado Show. This establishment served Instagram-friendly meals made from avocado in a space with healthy slogans that work as the ideal social media backdrop. The fetishization of avocados is part of a toxic trade network that indirectly fuels illegal deforestation. I used peels from the kitchen as a dye for the fabric in my project.

What are the prejudices and truths underlying conspiracy theories? What can they tell us about our societal condition?

he first stage was to prove the facts
[illegible] reality the conspiracies were wrote
[illegible] to establish the truth behind either
[illegible] which makes a point aimed [illegible] [illegible]
Special assignment feature, which [illegible] run
[illegible] conspiracy or secrecy.

The next [illegible] [illegible] was their presence
in the [illegible] media [illegible] where one
[illegible] theories exist [illegible] the [illegible] and
[illegible] and [illegible] a skeptical amount
of time engaging in conversations with those
[illegible]

CONSPIRATORIAL MYTHOLOGIES
183 Malena Arcucci

APPROACH

The methodological approach to answer the research question changed as the project developed.

The conspiracy theory I focused on was the notion that Finland does not exist, meaning that there is no actual land mass in the location where we believe this country to be, and that the country was invented after the Cold War by Russia and Japan to get access to fishing waters free of regulations.

The first stage was to prove the facts presented by the conspiracists were wrong. To accomplish this I worked in collaboration with institutions, such as the Finnish Geo-Spatial Research Institute, which measure the topology of the country.

The facts gathered were then presented in the social media groups where conspiracy theorists exchange their ideas and findings, and I spent a substantial amount of time engaging in conversations with them on reddit, Twitter, and Facebook.

As the project developed, it became clear that the research presented to the conspiracists was not deterring them from their notions and understandings of the world. On the contrary, it made them stick to their beliefs with even more conviction.

So the conversations became the starting point for the construction of characters in a Greek tragedy, and then their actual characterizations on stage.

The script was written using extracts from the conversations, news articles cited in the conversation threads, found material from radio and TV articles on conspiracy theories, as well as political speeches.

In times of post-truth, fake news and misinformation, it is increasingly challenging to discern fiction from reality. *Conspiratorial Mythologies* proposes alternative means to disseminating and deciphering conspiracy theories; likening their narratives to ancient Greek myths, as tragedies, rites, celebrations and crafts become the instruments through which their stories are being told.

In this work I tried to position the role of conspiracy theories as substitutes for religious and ancient myths. Both can be understood as a materialization of collective fears used by some to understand the complex power dynamics and structures surrounding our societies. How do conspiracy theories and their pervasive narratives shape worldviews? What truths, if any, do they contain? And most importantly, what can these stories tell us about the underlying fears that led to their creation?

Like any piece of narrative, conspiracy theories have actors, fictional characters informed by our perception of different agents around us. These actors play a key role in helping us, as readers and spectators, to understand societal structures. I analysed the inner mechanics of conspiracy theories from a narrative perspective, presenting a world governed by evil, whereby the powerful and wealthy few work to conceal the truth from those less privileged. A world in which our scepticism and distrust for political systems leads the actors in these fictions to find the truth for themselves.

I focused on the archetypal characters, meaning collective and stereotypical constructions of societal agents, present in all conspiracy theories: mass media communication, as a source of spectacle and non-factual information, controlled by their desire for wealth and popularity; the politician, as the source of all evil, a character blinded by his or her power; the corporation, as the politician's sidekick but also their facade; and the scientific community.

The purpose of this piece is to question the dissemination of conspiracy theories and explore the possibility of fiction providing a frame for us, as contemporary actors, to purge our fears while simultaneously reflecting the consequences of living in a constant state of distrust.

My project consisted of two segments: @*Raregan* and *Narrative Objects*.

@*Raregan* is a performance in five acts, which follows the structure of ancient Greek tragedies to tell the story of a contemporary hero. The plots revolve around a geographic conspiracy questioning the existence of Finland and follows @ *Raregan*, a reddit user, in their quest to uncover the truth.

Narrative Objects is a series of vases—a reinterpretation of the Greek amphora—exploring the possibility of rendering narratives through tangible means, therefore questioning the fleeting nature of online stories.

Can design methods be tools for creating a counter–archive to include marginalized per–spectives left out of the main–stream media narrative?

of citizen journalist material. It considers
methods that independently analyse found
footage to challenge prevailing official gov-
ernmental positions. In doing so, it seeks out
to enable new readings and undermine high-
ly stabilised media narratives.

The project is two-pronged: a multi-
project based on subject-relative, re-based
analysis of a series of incidents in ... Turkey
independently, therefore only to pro
mmunities ... encountered to the evasive
conflict ... freely pursued ... irtual
video ... from the Syrian Archives gather-
ing accounting to its website to Syrian-
led, collected collective of human rights
activists dedicated to creating virtual docu-
mentation ... relating
and the attacks

REAL-TIME HISTORY
Foundland Collective
189 (Lauren Alexander & Ghalia Elsrakbi)

By using the existing internet video archives of www.syrianarchive.org as a starting point, *Real-time History* looks at what is preserved of citizen journalist material. It considers methods that independently analyse found footage to challenge prevailing official governmental positions. In doing so, it sets out to enable new readings and understandings of established media narratives.

The project is an ongoing research project based on subjective, image-based analysis of a small selection of YouTube videos, which are thought to provide important future evidence related to the Syrian conflict. The primary source of YouTube videos are from the Syrian Archives platform, which according to its website is 'a Syrian-led and initiated collective of human rights activists dedicated to curating visual documentation relating to human rights violations and other crimes'.

Real-time History is shown as a video installation along with a publication. The project's actions and premise is to investigate how video material can be used as evidential material and how it can be read and interpreted.

The first video iteration of *Real-time History* was launched in September 2018 and looks at a particular attack on Douma earlier that year (7 April) as a starting point.

Directly after the April 2018 attack, both the Russian government and Western allies began to furiously speculate about whether the Douma attack involved poisonous chemical weapons or not. Russian authorities denied the Douma attack. But the United Kingdom, United States and France could not let supposed chemical weapons usage go unpunished, and eventually Western counter-attacks took place on 12 April 2018 aimed at the Syrian regime's chemical storage sites.

Foundland embarked on a hunt for the possible video evidence, which could have been used to justify truth claims on both sides of the story.

This video was uploaded by Yaser Aldoumani to his Youtube channel, and allegedly shows the aftermath of a chemical attack on Douma during the 7th of April 2018. He walks with cameraman into an abandoned building to reveal a heap of dead bodies.

Outdoor Shots	Indication of video edit
Indoor Shots	Environmental noises

P/26

P/27

Comments, video 1 on Youtube (21 total)

TheRamez99 / 4 months ago

Why only civilians (especially women and children) die??? What about men, rebels, White Helmets, activists etc... are they chlorine proof?? I think these poor people who died are the civilians from Adra which were kidnapped by "rebels" and now killed and used for propaganda.

7 Likes

Jirina S / 4 months ago

Because it is staged by the White Helmets.

2 Likes

Bassam Qutifani / 4 months ago

لعنة الله على القاتل المجرم بشار الكيباوي الحيوان ومن ساعده ومن والاه

4 Likes

قناة نبأ ظهور المهدي المنتظر ناصر محمد اليماني / 4 months ago

ممكن تشوف هاالفيديو و تعبود رأيك فيه .. هاد ممعل كيباوي ثم ضبطه

بالغوطة الشرقية .. هاد بس مثال .. لأن في كذا ممعل تم ضبطه.
https://www.youtube.com/attribution_link?a=axz19uv4O-ZU&u=%2Fwatch%3Fv%3Dv5_LH4GI42y%20feature%3Dshare

Mr. Hashim / 4 months ago

عدو واحد يجني يقتل هدول ارعبية

1 Like

taleb bassite / 4 months ago

هاى يا اهل دمشق هل هؤلاء ارهاب ام هم من الحاضنة للووووووه عليكم اجيبو يا اهل دمشق السنم تخشون من القصف من الارهابين اجيبو يا خونة

1 Like

taleb bassite / 4 months ago

لست من السعودية ولست من ال سعود ولست من اليهود ولست من الشيعة لعلمك انا انسان عربي مسلم اشهد ان لاالـه الا الله وان محمد رسول الله لست من اي فصيل ولا انتمي لاي حرب انا من المنادين للسلام في الشام لكن يا حسراه كل من يتكلم عن الحق يقولون انه اخواني داعشي وهاي شيمي

taleb bassite / 4 months ago

انا لست هنا لاناقشك انت سني ولا شيعي ولا علوي ولا درزي مل مسيحي يا رجل انا انسان مسلم لست لا للشيعة لا يهمني لى يهمني الاطفال الابرياء الذين يقتلون ليل نهار ولست لقول ارهابي دخل على ارضك وما قولك في الامريكي يا سيدي ما فولك بالفرنسي يا سوريا للقسم والجحش ايبو جعبل اطفالها يهجر نسائها واهلها الق الله يا رجل الق الله هذا الرجل الق لاضهم داهس عدو قتل الشعب يا رجل حرام لم حرام لا يعاب لسيء ارهاب والحديث يطول ف هذا لمجال هؤلاء المسلمو رجله منهم وفطر دعم الفصائل يا رجل هؤلاء نان ابرياء لا حول لهم ولا قوة حقيقة اليوم صارت الحق وكذبه لما اهل العاصمة اليوم بتلخذوق بقتل الابرياء ويقولون سوريا الاسد MIIIIIIIIIIIII سوريا لسوريين سوريا بلاد عربية مسلمة واهلها سنة يا رجل الق الله البلاد تدمرت بالكامل.

الثورة لم تعد ثورة اصبحت حرب علمية لم تعد شان السوريين وحدهم اصبحت اكثر من القضية الفلسطينية الق الله اهل دمشق العاصمة يفرحون ويمرحون لسقوط الغوطة اي غوطة الفيلم الفيلم قالها الوطني رحمه الله اما الثورة الق الله واما عقاب الاخي يا رجل الق الله الق الله هؤلاء اخوانكم اخوانكم اهل الغوطة اخوانكم واهل عفرين اخوانكم سوريا عم تقسم ولمعلوماتك السبب الجحش والغرب يوم من الايام راح تفيق لكن فات الاوان الغم تكلاب على سوريا تحدث عنه هؤلاء ناس يدافعو على ارضهم السلمو وعم عنهم بشرفك انت في واحد ارهابي وسارق عم يدخل لبيتك شو لسوي دافع على شرفك ومزلك واولادك ولا تقولو تعالى يا زلمي تصال انت من الجيش السوري انت زلم تحرر البلد ولـه انت قت بالجيش عملت جيش ولـه عم تحكي هيك على هيك يا رجل الق الله هذا الرجل الق لاضهم داهس

taleb bassite / 4 months ago

اخي الق الله العظيم نحكي من قلبي انا

03:20	03:25 A boy receives an oxygen mask
03:30 He is treated by the medical staff	03:35
03:40	03:45
03:50	03:55
04:00 Victims are recovering, on a drip	04:05

04:10 Boy uses his shirt as a face mask

04:12

The resulting video narrative is constructed using video fragments that are narrated by citizen journalists in multiple ways. In the editing of *Real-time History*, close attention is paid to keeping the real-time play back speed of the original found YouTube clips. However, the framing and fragmenting of the videos as an artistic intervention in the material, breaks down the images into isolated scenes, making it possible to look more closely at specific details.

Simultaneously an interview text, which is essentially a conversation about the videos, is used as commentary to interpret and also to translate what is happening within the visual frames.

Both the framing of visuals and the text offer access to the material, but the project's role is not to determine which story is correct or who is to be held responsible.

Real-time History is a start to an open discussion amongst us as artists, clearly demonstrating that identical video material can be used to tell multiple and conflicting truths. We do not aim to discern real-time true events, but wish to expose and deconstruct how and why narratives are designed, and how evidence can be used and potentially abused. In seeking justice for the overwhelming human rights abuses that have occurred since 2011, we are yet to discover what the future role of video material and existing archives such as the Syrian Archive will be.

THE CONSTRUCTION OF REALITIES
Lorand Bartels

Like all cognitive systems, law is based on facts and fictions. It describes persons, things and events, sometimes to establish their status, and sometimes to work out who is responsible for acts and their consequences. But it is not always clear how law relates to this 'reality', or even what this 'reality' might mean.

@*Raregan* focuses on the difficulty of pinning down even well-accepted realities. One of two segments in Malena Arcucci's *Conspiratorial Mythologies* project, here she spends time with conspiracy theorists, presenting them with 'real world' evidence that Finland, as a landmass, does in fact exist. But evidence itself means little without its own authority, which in turn depends upon an authority, and so on, endlessly. Herman Melville shows this with great irony in his masterpiece *The Confidence-Man* (1857); Arcucci approaches the matter in a tragic (and perhaps tragic-comic) mode.

Sometimes, 'reality' is cast into doubt because humans have an interest in distortion: the invention of Finland, we learn, was to enable Russia and Japan to carve up fishing rights. This is also the theme Lisa Plaut (*Learning from Tapestries*) focuses on in the use of images to establish identity and legal status. She takes as her inspiration a tapestry in which a merchant used an unrealistic grouping of exotic plants on a flag to shore up a claim to aristocratic status. This was not (and is still not) only a practice of individuals. The history of colonialization, in some senses an identity project of its own, is one of planted European flags, backed up by occupation and, if necessary, force—these being the methods approved by customary international law of 'manifesting' territorial sovereignty. Australia is a signal example, having been claimed by Britain as a *terra nullius*, owned by no nation, and hence able to be flagged and exploited without regard to the rights of

its indigenous inhabitants—a state of affairs that persisted until the High Court case *Mabo* in 1992.

Is 'reality' any more reliable when it is contested? Perhaps: this is the basis of the adversarial legal system in common law countries. But this does not always lead to 'truth'; indeed, the 'burden of proof' is an alternative to 'truth', not a means of establishing it with any absolute certainty. The Foundland Collective (*Real-time History*) looks at a 'reality' that is contested by two opposing sides: whether or not there was a gas attack on Syrian civilians in 2018. They take a hard look at evidence supplied by human rights activists, asking, for example, what the meaning might be of an image of a dangling gas mask? More generally, what can one ever make of video evidence? In 2003, US Secretary of State Colin Powell showed a video to the United Nations' Security Council purporting to show Iraqi weapons of mass destruction. Two years later, the video discredited, Powell called this episode 'painful' and a 'blot' on his record.

But even if something does occur, how does one know what it means? Arcucci (*Narrative Objects*) hints that tangible evidence, in the form of Grecian urns, might give concrete form to 'reality' in a way that intangible evidence might not. Perhaps not. After all, Keats concluded his *Ode on a Grecian Urn* (1819) with the subjectivist thought that 'Beauty is truth, truth beauty,—that is all/Ye know on earth, and all ye need to know.' Kjersti Alm Eriksen (*Where There is an Object*) picks up the theme, noting that 'Objects are not absolute and neither is how we perceive them.' Every lawyer would agree. Things may exist without humans, but it is we who imbue them with meaning. It took the seventeenth century Dutch jurist Hugo Grotius to settle a long-standing debate about whether the oceans could be owned by nations, or whether they must remain 'free'. The oceans might exist, but without a concept of the 'high seas' what it means for humanity would be radically different. The same can be said of 'human rights', a fiction according to which the raw fact of being a member of the human species entitles every human to a basic minimum of treatment.

'Reality' might be constructed, but so is everything that is human. That does not make it meaningless or unimportant.

Lorand Bartels is a Reader in International Law and Fellow of Trinity Hall at the University of Cambridge.

www.law.cam.ac.uk/people/academic/la-bartels/2137; @Lorand_Bartels

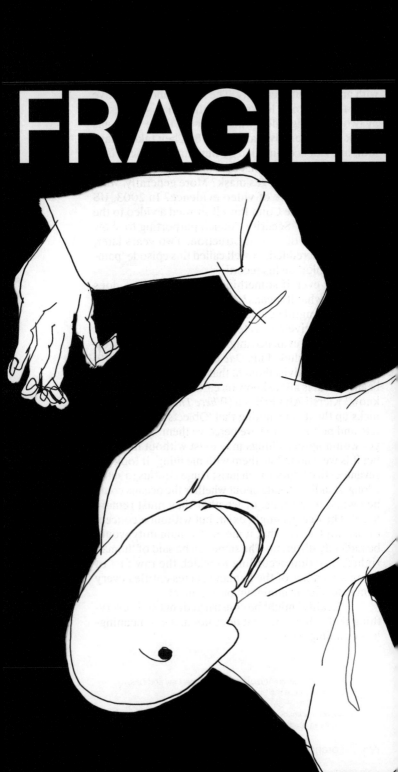

THE
HUMAN

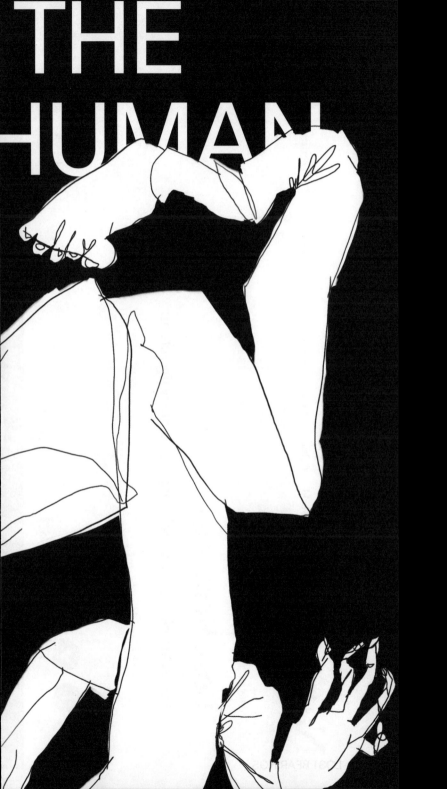

THE Nation.

Politics World Culture Events Shop Current Issue Newsletters Subscribe

GEORGE FLOYD PROTESTS CORONAVIRUS CLIMATE OPP-ART PODCASTS

Donate Log In

LIBERALISM BOOKS & THE ARTS JULY 1–8, 2019, ISSUE

Lost Bearings

Adam Gopnik and the search for a 21st-century liberalism.

By David A. Bell

JUNE 12, 2019

'In modern political history, few terms have had quite so slippery a career as "liberalism." It first appeared in early 19th-century Spain as a term of abuse: a system "founded upon ignorant, absurd, anti-social, anti-monarchic, anti-Catholic" ideas. Soon enough, self-proclaimed liberals claimed it as their own, but with amazingly little agreement as to its meaning. At the turn of the 20th century, the English economist John Hobson defined it as "practicable socialism," while across the channel, France's Liberal Republican Union insisted that "true liberalism" depended on a close alliance between church and state and a rejection of progressive social measures (...).'

Illustration by Ben Jones.

n modern political history, few terms have had quite so slippery a career as "liberalism." It first appeared in early 19th-century Spain as a term of abuse: a system "founded upon ignorant, absurd, anti-social, anti-monarchic, and Catholic" ideas or as such as

199 David A. Bell

From: David A. Bell, 'Lost Bearings. Adam Gopnik and the Search for a 21st-Century Liberalism', *The Nation*, 12 June 2019

www.thenation.com/article/adam-gopnik-a-thousand-small-sanities-book-review/

'Things have become no clearer in the present day. In Western Europe, "liberalism" generally designates what Americans view as free-market conservatism. In the United States, it has come to mean something similar to Western European–style social democracy. Even as many Democrats abandon the term, Republicans have done their best to again make it one of abuse. "What we call liberalism," Jonah Goldberg writes in his book *Liberal Fascism*, "is in fact a descendant and manifestation of fascism." In The *Lost History of Liberalism*, an excellent recent survey of the term, the historian Helena Rosenblatt states forthrightly that "we are muddled about what we mean by [it]."

Can liberalism be rescued from this lexical and political morass? Should it be? Adam Gopnik has no doubts on that score. In *A Thousand Small Sanities*, he sets out to offer both a definition of liberalism and a heartfelt defense of it. Gopnik does so in what has by now become his trademark style, honed over 30 years as a staff writer for *The New Yorker*: engaging, conversational prose; a wry sense of humor; a seasoned eye for the telling anecdote; and a great deal of learning, lightly worn. The book is nothing if not enjoyable to read, and it amply reflects the author's exquisitely good intentions. Despite the pleasures of the prose, *A Thousand Small Sanities* is a perfect illustration of the cul-de-sac in which mainstream American liberalism now finds itself. The book is worth reading, above all, because it exemplifies a seductive, well-meaning, but oddly apolitical outlook and language that still may have the power to tempt Democrats away from the progressive policies they need to embrace in 2020.

The vision that Gopnik offers of liberalism as sensible, skeptical, cautious, reformist, and moderate—a path to political safety between the Scylla and Charybdis of right and left extremes—will certainly appeal to many readers. But it is not a politics or a substitute for one; Gopnik himself defines it as a "temperament." The goals of liberalism, he writes, are to achieve, by incremental, nonviolent means, "(imperfectly) egalitarian social reform and ever greater (if not absolute) tolerance of human difference." But these are goals that many socialists and even conservatives have historically endorsed (...).

A Thousand Small Sanities suggests that if one has the proper constructive temperament, then a proper constructive politics will naturally follow. It is an attractive notion. But as our current, dire political moment shows with particularly cruel clarity, it has always been an illusion.'

How can we be more intensely understand our intimate and emotional relation to the objects we physically engage with?

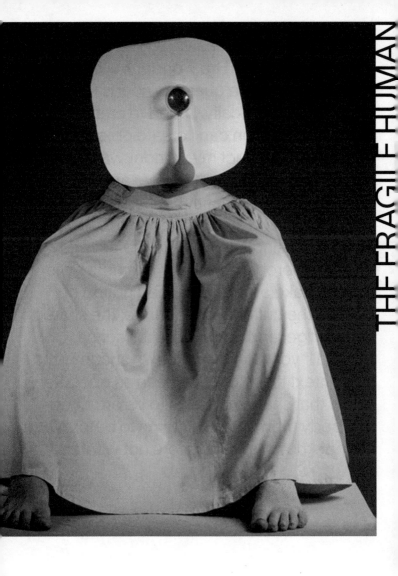

THE ACCEPTABLE SUCK
203 Cecilie Scoppa

I always start my research by wondering about something. The wonder builds into a question and the question needs to be manifested physically. I need to embody the answer. Only then can I create objects.

For this project my wonder was about how things are judged as pleasant and unpleasant, and what might be done to both understand and also challenge this. If you isolate any single thing—like the act and result of piercing an ear, for example—it is absurd. Take away the agreed notion of beauty, the cultural significance, the shared knowledge, and nothing makes sense.

So if you take an unknown shape with no context it can only be seen as obscure. And if that shape happens to be attached to a body then obscurity turns to deformity. It is not known and therefore not wanted.

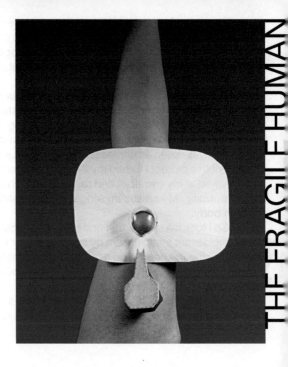

It is a copy!

And I knew it was a copy from the first time I saw it. To recognize a copy, one must also have the original to compare it to. Luckily for me, the original and the copy are side by side.

To carry around both at the same time and so close to each other is very strange. I never liked the closeness of the two. If they could only be seen apart, the issue might not have been so much of a problem.

But it is!

If only I had been aware in time, at the very start, then I could have stopped it. 'Sorry, no, I have no use for you!'

But it was too late. Looking down I fed the fire: my eyes only made the shape more severe by the extra attention. Not even the paint on my nails distracts. Now my feet are uneven and my extra lump is looking at me, asking why I appreciate the other foot more.

By wearing the shoes I did, I created this unnoticed extra lump. This made me realize how continuously we are formed by our surroundings, the designs we choose to wear or to sit on, and I came to wonder how society plays a part in these formations. In relation to the extra growth on my foot, I realize how little I appreciate it.

Why is the altered form less of a form and perceived negatively? When does a formation become a deformation?

These thoughts make me question the effects of objects we use in our daily routines. I want to press pause on our actions to look at how we physically adapt our bodies into specific positions because of the objects we engage with.

Who or what dictates the positions we assume as a result of these objects? Can we take control instead?

Because we look more deeply at anything generally deemed pleasant and strip away the context it can just as easily be seen as unpleasant or even absurd.

For this project I turned my thinking back on myself. I looked at my own foot and realized that it had its own 'deformity'. My artistic thinking was manifested on my own body.

So I took it a step further and challenged the border of unpleasant and pleasant by creating an aesthetic context for the unknown. The accepted space makes a viewer comfortable with what they might otherwise be repulsed by.

I see the role of the artist as someone who should be creating these contexts for broader and more diversified surroundings.

Cecilie Scoppa

How to flow with dreams?

RESIDING DAY RESIDUES
209 Tsai Mong Husan

1. Read and take notes.
2. Some notes are just 'ha, ha, ha.'
3. I think, too.

I am not the first person to be fascinated by dreams. Not until I realized that the way I make stuff kind of matches the way dreams are formed. It is a process of editing from collected materials consciously as well as unconsciously, which results in sequential images that could be seen.

Dreaming is a rather automatic and relaxing process. I am the only audience who can never fully remember what I have seen. On the other hand, me making stuff relies more on manipulation and control, which in the end I am able to share with others. It's the same brain at work, but dreams do not follow any usual logic or definable principle, while I am trained to think and talk in ways that are favoured by society.

Or probably dreams simply follow a language that is beyond our known language or knowledge—especially the so-called 'scientific method', which has been gaining power and control for the past four hundred years as 'the invincible truth'. According to the idea of Tao, opposites motivate each other to nurture a whole. A sleep and awake state are opposites that form a day. The tangible and the intangible form the perceivable universe. If science is on one end, what is on the other end to support it?

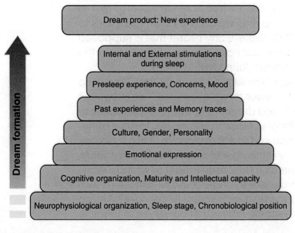

THE FRAGILE HUMAN

Jung (1933) took dreams as creative representations of the 'subjective state' of the dreamer. And Freud's use of dreams in psychoanalysis is defined as the 'royal road to the unconscious'. Dalí paints from what he saw in his dreams. David Foulkes (1985) proposed that dreams constitute 'a creative recombination of memory and knowledge', which echoes Aristotle's reflection on how dreams are a distorted fashion of past experience and external and internal bodily sensations. In figure 1, Joseph De Koninck (2012) illustrates what the sources of dreams are, which suggest that the lower-level factors are predominant and more difficult to influence, while the higher ones shape dreams with less influence. But how are all these materials edited or directed? Ernest Hartmann (2008) suggests each dream starts with a central image that expresses the dominant emotion of the dreamer and guides the creation of connections to existing memories that result in new associations that have an adaptive value.

Since most scientific research on dreams applies autobiographical writing or content reporting from right after waking, it has restricted our understanding of dreams to those that are vivid and recallable. Little is known about dreams in Non-Rapid Eye Movement (NREM) sleep, including by the dreamers themselves. People waking from NREM sleep can only provide thoughts and reflections, rather than the common understanding of dreams which consists of imagery sequences with characters, interactions, and emotions. Also, dreams arising from NREM sleep contain more leftovers from the day, or 'day residues' according to Foulkes, than dreams from Rapid Eye Movement (REM) sleep (Foulkes, 1962). This is interesting. When we are in the deep part of sleep, which is during NREM, what kind of leftovers enter the mind or are left in the bottom of the mind? Why do our brains restrict us from remembering them? Is it simply because we need to rest in that period of sleep thus we don't allocate resources to remembering? Or is there any secret that is supposed to be hidden from our consciousness that lies in the dreams experienced during NREM sleep?

The Threat Simulation Theory by Antti Revonsuo (2000) tries to answer these questions.* He proposes that unremembered dreams are imagery rehearsals to help us face dangers faced in waking life, to have better threat perception and threat avoidance. It is not necessary to explicitly remember to realize its adaptive value. However, no matter if Revonsuo is right or wrong, I wonder if it is appropriate to understand NREM sleep with a functional approach, or a scientific manner? As Tao teaches us, we should not restrict ourselves to tangible

experiences or specific perspectives; otherwise we are easily stuck in the search of truth. Is it the reason why we still cannot reveal the mystery of dreams in NREM sleep by fixating on a formulated direction of understanding, the scientific method? Or do two opposites generate a whole, the accessible REM and the untouchable NREM forms of sleep?

A lazy assumption here may be that our brain actually makes sequential images spontaneously when we are awake, not only in sleep. Thus we are actually 'dreaming' all the time, at work and in sleep. Because the NREM sleep is a continuous state of the brain, which is immune to the brutal touch of constructed knowledge, an over-educated mind can never be aware of it. The brain simply generates sequential images anytime then saves them. Only during sleep, when we are not equipped with the invented tools, like scientific and analysing methods to investigate them, are we finally able to read those image sequences in ourselves. The references of these images are either from those according to figure 1, or any other inspiration that may be hard to put into words. Consequently, the intuitive dreams are flourishing in parallel to cognitive learning and thinking processes without the restriction of time. By elevating the presentation of intuition at night to an equal status of the construction of knowledge in daytime, we are finally a natural and complete human because we are constituted by two opposites.

So, how to flow with dreams? What about: making stuff in the way of making dreams. Simple as it is, as it was, as it will be. We exist on the level Lao-Zi described: with no specific purpose, manipulated ideas, or selfish hopes.

* The works of all authors referenced feature in *The Oxford Handbook of Sleep and Sleep Disorder*, edited by Charles M. Morin and Colin A. Espie (Oxford and New York: Oxford Handbooks, 2012).

THE FRAGILE HUMAN

When facing reason, how does the human mind manage to create alternative and creative realities, and inject meaning into irrationality?

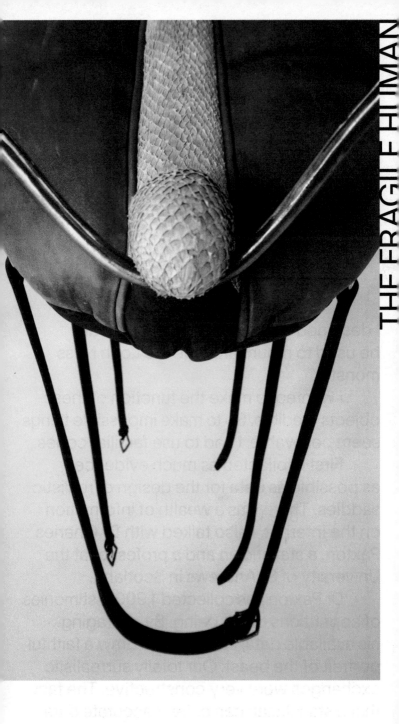

RIDING GHOSTS
215 Pauline Rip

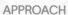

APPROACH

I designed a series of saddles that can be used to mount and ride the Loch Ness monster.

I wanted to make the function of these objects credible. So to make impossible things seem believable, I had to use familiar codes.

First I collected as much evidence as possible as data for the design of realistic saddles. There was a wealth of information on the internet. I also talked with Dr Charles Paxton, a statistician and a professor at the University of St Andrews in Scotland.

Dr Paxton has collected 1,900 testimonies of apparitions of the being. By averaging his available data, I was able to draw a faithful portrait of the beast. Our totally surrealistic exchanges were very constructive. The fact that a statistician can collect accurate data on such an unreasonable subject strongly supported my point and amused me a lot.

Today science has the ability to unravel many truths, yet it does not seem to have the power to be heard by all. Science can still be a gateway to the mystical, and magic remains irresistible to even the most rational minds.

Science can be romantic, meaning that it can speak to and touch ones' sensitivity.

Cryptozoology is the study of imaginary creatures–studying it can only lead to irrational results. Cryptozoology comes from three Greek words: kryptos (hidden), zoon (animal), and logos (discourse, science). It therefore refers to the science of hidden animals, those that have not yet been discovered or those that are part of legends and traditions.

Dedicated to uncovering evidence of hidden or ignored animals, cryptozoologists accumulate a lot of evidence and testimonies about appearances, footprints, hair—convinced that the being they covet is alive but undiscovered.

After the creation of a precise databank on the Loch Ness monster, I started making imaginary saddles using a traditional technique, presented on proper wooden bases.

A saddle is actually a seat, so I went to Willemien Werkplaats, an upholstery company in the De Pijp district in Amsterdam.

R I D E A G H O S T

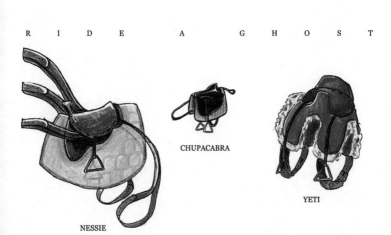

CHUPACABRA

YETI

NESSIE

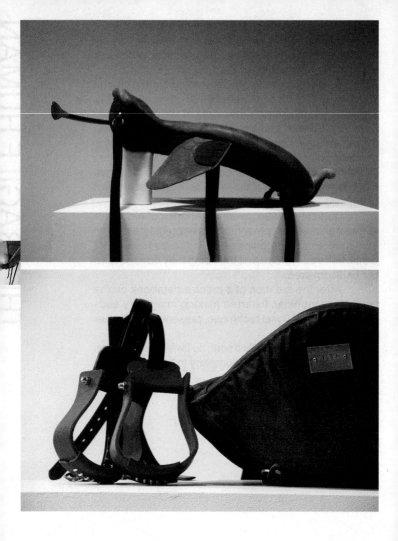

That this creature exists is highly questionable, we nevertheless have knowledge of its physical characteristics, such as the size of its tail, its neck, its speed, the number of bumps on its back, and its weight.

As a result, we are able to document what is actually inaccessible with an astonishing rationality.

Using all the available data and input from the statistician, I created a rational image of three cryptids: Nessie, the Yeti, and the Chupacabra.

For the seat that fits the Yeti's shoulders, I use fur suggesting a long trail in the cold mountains of the Himalayas. The one for the Loch Ness monster looks more fitted for speed, its colour reflects the rainy climate of the Scottish loch, and a fish skin on the top reinforces its underwater character.

No detail is random and every saddle fits the animal and its potential rider. The one for the Chupacabra is still under construction, but one can imagine the dangerousness of that being. The use of black goat leather emphasizes its destiny: to suck the blood of goats when the night falls. In my final installation there are also tools belonging to the maker and an office to work in.

In the presentation I include a messy notebook that includes all the gathered evidence, measurements, testimonies, and all the emails exchanged that lead to the manufacturing of the saddles. Surrounded by hundreds of archives, the maker seems passionate.

What can be disturbing for the visitor is the extremely logical way in which the research is undertaken, but also by the rationality of the saddles. In reality, these technical objects highlight our ability to theorize the invisible. In this sense, the work imagines the presence of these beasts amongst humans, who have historically proven to have a fundamental desire for control. Therefore, controlling the indiscernible would be the ultimate power we can have over things. And control is what we desire.

Riding Ghosts is an account of how the human mind can reason over unreasonable things, and how we strongly need to domesticate the unknown.

When extracted from a subject or physical body, can any 'core' truth or 'proof' answer who we are and where we belong?

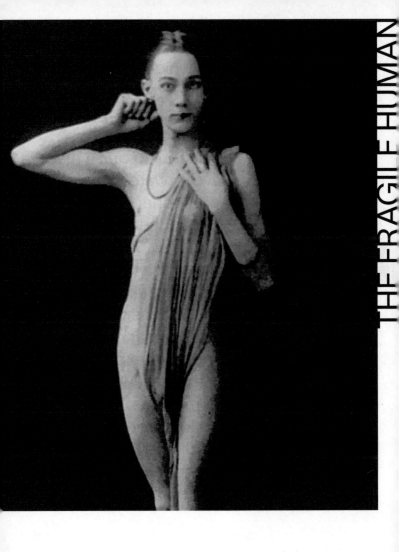

THE SECRET ORCHID
221 Levi de Kleer

My initial impulse was to start an archive of 'soothing' images from which to build a story. I started collecting images of portraits, figures with covered faces, bodies lying still, and pictures of medical procedures.

One picture kept standing out. It made me realize that to move forward I must report my own experiences, mirroring them with those I encountered along the way.

My most important text-based source material was the memoirs of a nineteenth-century hermaphrodite, Herculine Barbin. Moved by the tenderness of her writing and struck by the sometimes-uncanny parallels in our narratives I found an unexpected mirror and anchor in Herculine, who renamed herself 'Camille' in her memoirs.

Rather than trying to squeeze it into a formal structure I have allowed the text to find its own intuitive coherence, which is more in keeping with my own experience.

As I gathered images for the research I stumbled across an old photograph of an intersex child standing naked against a white wall with a ruler guide, arms outstretched, palms facing upwards, the face covered by a black censor bar. Standing there completely exposed, the image touched me profoundly, but at the same time everything about it infuriated me.

But I wanted to present my story without attacking the medical establishment or offering a story so personal it would fail to engage anyone other than the people immediately involved. My point was not to find answers, to clarify, to categorize, to define anything or anyone. Instead, I felt compelled to show the humanity and poetry of the bodies that have become sterile and detached through the incessant desire to describe them and understand them through dissection, through detaching them from their own sensuous pleasures and the world around them.

Most of all I wanted to gently challenge the notion that a refusal to make a choice, or a refusal to determine ones' self altogether, means that one is devoid of an identity. Being denied a place in society, or refusing to claim one within a rigid system that punishes anyone who displays a kind of variety, does not equal a denial of self nor a lack of it.

I want my story to close the gulf that exists between how society perceives the 'other' and what's actually going on in the other's inner self-sentient, self-reflection—a full existence that's well able to make sense of the world and a position in it.

This is a loving research, a series of delicate operations that attempt to uncover the subject without dissection. It is an exploration of a multitude of things: the act of sculpting as a means of trying to get a material grip on yourself; the desire to remake, redefine, and re-explain your own anatomy.

The act of writing and building an ongoing correspondence as a means of self-determination is powerful. All players or participants, the other, the reader, the correspondent, the audience, all relate to this and in doing so ultimately add shape to the edges of our self.

This can be an invisible process. It evolves slowly as we move forward, mirroring ourselves with others, making sense of whom we are, and how we can connect to the world around us.

My correspondences explore the multiplicity of 'self', of body, of identity, and how they can be best understood through experience, through mirroring, and through acts of self-determination such as writing a memoir and calling into being a non-existent 'you', an audience.

I believe Barbin used her writing to recreate a self she could give space to reflect on.

If there is any truth to be discovered about the human being, I believe that it is manifold and that it lives in every layer of our existence. And if there is anything that can be laid bare it needs to be done with delicacy using the utmost care—parts of it could easily be lost with every cut that digs too deeply. I have come to realize through this work that the hunt for the so-called core in which the 'truth' is perceived to be 'hiding' is much too crude and damaging for all of us.

All of us write and create multiple versions of ourselves; we write and integrate each new layer we uncover. We undress each other without ever hitting a core. For a core, I'd argue doesn't exist, our truths hide in every layer of our 'selves'.

Along with the research, I presented an installation with some of my most important personal belongings. The room was small and intimate and I included a series of sculptures, books, and leftovers from the research.

I called this installation *Camille's Room*. It's the carrier of an extensive correspondence; it is a reading room as well as a scattered universe of carefully organized comforting objects. It is a soothing space as much as a problematic one; a cushioning that attempts to support an encounter between reader and host, reader and space, reader and text, as well as an open invitation to simply immerse ones' self into a realm in which everything is both personal and multiple.

A BALANCING ACT
Jim van Os

Tsai Mong-Hsuan (*Residing Day Residues*): 'The way I make stuff kind of matches the way dreams are formed. It is a process of editing from collected materials consciously as well as unconsciously.... but dreams do not follow any usual logic or definable principle, while I am trained to think and talk in ways that are favoured by society.'

Levi de Kleer (*The Secret Orchid*): 'My point was not to find answers, to clarify, to categorize, to define anything or anyone.... I wanted to gently challenge the notion that a refusal to make a choice, or a refusal to determine ones' self altogether, means that one is devoid of an identity.'

Pauline Rip (*Riding Ghosts*): 'Science can still be a gateway to the mystical, and magic remains irresistible to even the most rational minds. Science can be romantic, meaning that it can speak to and touch ones' sensitivity.... As a result we are able to document what is actually inaccessible with an astonishing rationality.'

Cecilie Scoppa (*The Acceptable Suck*): 'If you take an unknown shape with no context it can only be seen as obscure. And if that shape happens to be attached to a body then obscurity turns to deformity.'

Although our mental fragility defines us, there is no primary science of mental experience. The main reason for this is the simple fact that mentation (feeling, thinking, perceiving, wanting) is not measurable in the physical domain. Science therefore has focused on the physical properties of the brain as the main explanatory factor underlying mental outcomes. Mental fragility thus has become the science of universal disease categories of mental illness, the root causes of which are to be found in the physically measurable environment of the brain. Even though there is broad epistemic and popular dissatisfaction with this model of science, it remains dominant given the perceived need for measurability and quantification, without which it is felt that a science of 'the mental' is not possible.

The ontogenesis of mental experience is essentially relational. It takes place in a life course sequence

of interactions in which the developing person learns to relate to the environment, the other, and the self. Mentation becomes a balancing act in which people constantly fluctuate in response to relational input, trying to maintain a dynamic system of equipoise. Existence is maintaining a sense of balance, in which the bodily and the mental domains are integrated in a dynamic body-mind unity, enabling the person to deal with daily challenges. In a process of continuous ups and downs we move around an individual set point that is predetermined by our earlier life experiences. Self-regulation is the experience of control over the direction, amplitude, and set point of the dynamic system underlying experience. Disruption of the balancing process brings challenges and sometimes experience of suffering, but also opportunities for development.

Within the relational model of mentation as a body-mind balancing act, science need not be defined by the 'measurability' in the physical realm. The artists contributing to this chapter, in different ways, are helpfully intuiting novel paradigms toward a primary science of the mental.

Rip provides a powerful model of progress once conventions are no longer there to hold one back. With an open eye and keen sense of humour, she uses non-linear scientific methods and data to arrive at fitting designs of saddles for creatures that can be willed into existence, like the Loch Ness monster.

Mong-Hsuan interestingly refers to the wisdom of philosophical Taoism, in which opposites motivate each other to nurture a whole, to raise the question that 'If science is on one end, what is on the other end to support it?'

De Kleer's attempt to 'gently challenge' identity without crudely damaging dissections or hunting a 'so-called core in which the truth is perceived to be hiding' facilitates a science in which non-determinedness is not seen as a burden.

Scoppa reminds us that mind-body experience is integrated—until it isn't, at which point it becomes open to scientific exploration.

In defining a more satisfactory primary science of the mental, a dialectical discourse between the linear and the non-linear has much to offer. Together, these projects show that transdisciplinary endeavours have a role to play.

Jim van Os is Professor of Psychiatry at UMC Utrecht and King's College London.

www.umcutrecht.nl; www.kcl.ac.uk; @JimvanOs1

THE INS

IDENTITY

RUMEN-TALISED

THE
POINT

ISSUE 16 | EXAMINED LIFE | APRIL 23, 2018

'In 1964, when Joseph Brodsky was 24, he was brought to trial for "social parasitism." In the view of the state, the young poet was a freeloader. His employment history was spotty at best. Being a writer didn't count as a job, and certainly not if you'd hardly published anything. In response to the charge, Brodsky leveled a straightforward defense: he'd been thinking about stuff, and writing. But there was a new order to build, and if you weren't actively contributing to society you were screwing it up.'

Joseph Brodsky and the moral responsibility to be useless

by Rachel Wiseman

This essay appears in a special symposium [intellectuals will want to] entirely composed of essays by the editors of The Post. Click here to read all of the essays from the symposium.

In 1964, when Joseph Brodsky was 24, he was brought to trial for 'social parasitism." In the view of the state, the young poet was a freeloader. His employment history was spotty at best: he was out of work for six months after losing his first factory job, and then for another four months after returning from a geological expedition. (Being a writer

From: Rachel Wiseman, 'Switching Off:
Joseph Brodsky and the Moral Responsibility
to Be Useless', *The Point*, 16 (23 April 2018)

https://thepointmag.com/examined-life/
switching-off/

'Over the course of the trial he stated his case repeatedly, insistently, with a guilelessness that annoyed the officials:

BRODSKY: I did work during the intervals. I did just what I am doing now. I wrote poems.

JUDGE: That is, you wrote your so-called poems? What was the purpose of your changing your place of work so often?

BRODSKY: I began working when I was fifteen. I found it all interesting. I changed work because I wanted to learn as much as possible about life and about people.

JUDGE: How were you useful to the motherland?

BRODSKY: I wrote poems. That's my work. I'm convinced … I believe that what I've written will be of use to people not only now, but also to future generations.

A VOICE FROM THE PUBLIC: Listen to that! What an imagination!

ANOTHER VOICE: He's a poet. He has to think like that.

JUDGE: That is, you think that your so-called poems are of use to people?

BRODSKY: Why do you say my poems are "so-called" poems?

JUDGE: We refer to your poems as "so-called" because we have no other impression of them.

Brodsky and the judge were (to put it mildly) talking past one another: Brodsky felt his calling had a value beyond political expediency, while the judge was tasked with reminding him that the state needn't subsidize his hobby if he wasn't going to say anything useful. But the incommensurability of these points of view runs much deeper than this one case.

Brodsky was born in Leningrad in 1940 and survived in infancy the brutal two-and-a-half-year siege that left over a million dead. Confronted with the accumulated traumas of revolution and world war, this "most abstract and intentional city" was thus violently thrust into modernity. Brodsky and his contemporaries came of age at a time when their experiences—and the squalid facts of life—were perpetually at odds with the vision of progress that was taught in schools, broadcast over radio and printed in newspapers. That this reality—of long lines and cramped communal apartments, where couples, children, in-laws and jealous neighbors all shared the same pre-revolutionary toilet —was right in front of their noses only made the official program all the more incongruous. (Brodsky later reflected on the contradictions of his upbringing: "You cannot cover a ruin with a page of *Pravda*.")'

How does identity shift if one's voice becomes damaged or altered? How easily can a voice be faked, or artificially generated?

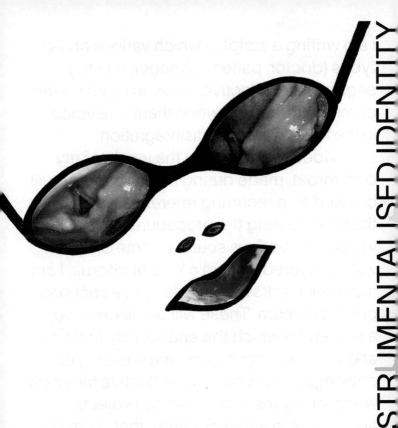

GLOTTAL STOP
237 Thom Driver

I am writing a script in which various arche-
types (doctor, patient, stranger, mystic)
engage in a collective tussle to redefine the
common thread between them, the voice,
in the face of internal disintegration.

Video footage from the inside of my
own throat, made during an endoscopy, will
be used as a recurring reference point in
the work. During the procedure I was asked
to vocalize various sounds, some of which
will be layered to form a kind of chorus. I am
also making drawings which have sections
cut out of them. These will be placed over
a screen on which the endoscopy footage
and various other images are shown. The
drawings are deliberately reductive faces on
which many meanings can be projected,
and they also serve as masks that allow only
small parts of the images below to be seen.

Following a throat endoscopy, I became fascinated by the relation between the hidden, corporeal sources of my voice, and its outer, disembodied manifestation. Seeing live images from inside one's own body is a very uncanny experience. I watch my larynx vibrate as it produces sounds requested by the doctor. Which sounds make the aperture expand or contract? Which ones change the shape of the glottal tissue? What affects the speed of the vibrations?

I had noticed my voice becoming more hoarse and more prone to cracking, and felt less sure of the sounds it was producing. Beyond the immediate medical issues (fortunately nothing too serious), I feared what a damaged voice would mean for my identity. Would it be fractured? Would its loss result in isolation?

Despite thousands of years of writing and over a century of recorded voice, it remains the case that to speak aloud in public is a gold standard of authoritative communication. At a basic level, if one becomes vocally compromised, or rendered mute, this primal means of personal authentication is threatened. Of course, a voice can be deliberately altered because a shift in identity is desired, for example if one is transitioning genders, or trying to move into a different class milieu. Of all bodily phenomena then, the voice is perhaps the most elastic. It allows us to project instant and endless reinventions of ourselves into the world.

As voice generation technologies such as Google's WaveNet become close to indistinguishable from real human voices, questions about the role of the voice as an identity marker become urgent. Convincing images of non-existent faces can now be algorithmically generated. Similarly, WaveNet is able to produce speech which more or less passes for human—if you don't listen too closely. If and when the majority of people can no longer distinguish, in any real-world situation, a generated voice from an authentic one, where will that leave us? The media landscape, already riddled with fake and/or unverifiable content, and the legal system which still takes the spoken word as basic evidence, are just two fields where the voice will surely be contested as never before. Our most ancient carrier of language may be at the point of losing its singular status, opening the way for potential chaos and injustice, but it could also allow for radically new kinds of performance and language.

In his 1973 book *Le Plaisir du texte* (*The Plaisure of the Text*), Roland Barthes writes of a 'language lined with flesh, a text where we can hear the grain of the throat, the patina of consonants, the voluptuousness of vowels, a whole carnal stereophony'. Barthes' potent imagery comes to mind if I think of possible damage to my larynx or about what will surely be a complex and contested future for the voice in general. This project engages with the innermost physical source of the voice, the 'flesh which lines language' and is never still, even when the voice is silent. Emerging from a fleshy apparatus, each voice exists in a stable of inevitable flux. As we face profound questions about what a voice is and who is allowed one, it feels appropriate to consider its point of origin and to think about how we might go forward without losing our voices.

What exactly is identity and what happens if a photograph of you travels and is found? Who becomes the owner?

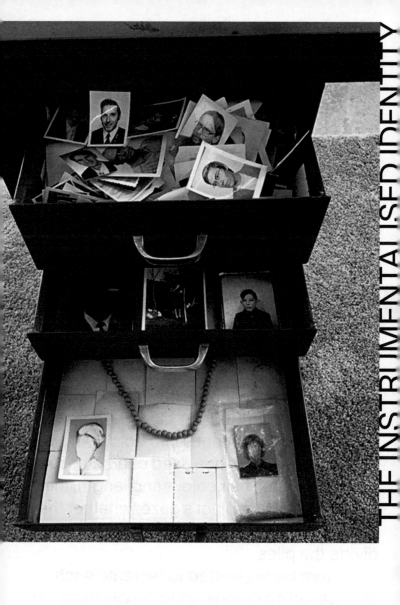

RES NULLIUS
(AN OWNERLESS IDENTITY)

Madelief Geus

In 2015, I became the 'owner' of a collection of three thousand black & white and coloured passport photographs taken in Berlin from the 1930s to the 1990s.

I divided the images into colour and black & white, and then used characteristics such as gender, hair colour and length, the direction of the subject's gaze, whether they wore eyeglasses or had facial hair, to further divide the piles

From there I started to recreate each face based on criteria using simple materials. Technically the aim was to transform the collection of passport photographs, but the dilemma was how to make art using any of my research. I didn't dare to cut anything so just kept sorting and re-sorting.

The legal term describing my ownership of the collection is *Res Nullius.**

To investigate the questions of identity and what happens when an identity travels the world, I wanted to manipulate the passport photographs into an artwork.

In my first technical experiments I tried to separate the colours from the paper by using water and peeling the photograph. This didn't work because the faces disappeared.

In the next experiment I employed sandpaper (grit 120) to scrape off the coloured layers of the photographs, separating hair colour, skin colour and other defining criteria, and following the contours of the mouth, nose, eyes, glasses, etc.

Scratching off somebody's face was not an aggressive gesture, but a delicate and precise act that gave a better insight into the identity of the subject. It was all separable. And even though in the end there was no face left, the identity of the subject was saved in a new form: a small amount of coloured dust as well as the silhouette on the original photograph.

I learned that one should not make art out of fear but out of bravery. My research led me to an empty space where I was free to make art. It was a space where I dared to do things for myself.

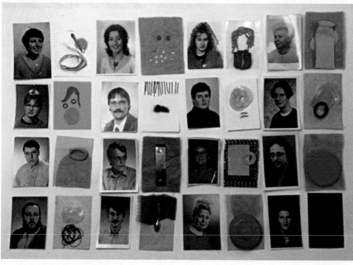

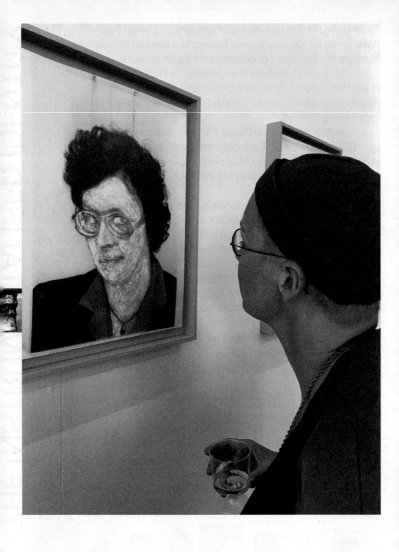

The project was shown in exhibition form at the Gerrit Rietveld Academie with six of the pictures shown as life-sized portraits. The collected dust from the scratching was exhibited in small heaps on a shelf under glass domes. Each heap had its own specific colour, emphasizing the unique identity of the characters. To me, the dust represented an identity.

In the exhibition, each chapter of my research was positioned separately: the portraits, the dust heaps, the soundscape of the scratching process, the video of me working, and an installation with a working desk filled with the passport portrait collection and a rug. In this space the visitors themselves were challenged to discover what had happened with the portraits.

The final results did not make me lose the humour I like so much in art. Because what are we for God's sake? Maybe only a bit of skin-coloured dust... And yet maybe just a little bit more?

> *Legally, Res Nullius is a thing belonging to no one whether because never appropriated or because abandoned by its owner but acquirable by appropriation.

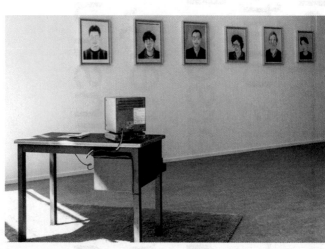

When a policeman changes into his uniform, how does his person become part of the machinery, his body acting as an instrument?

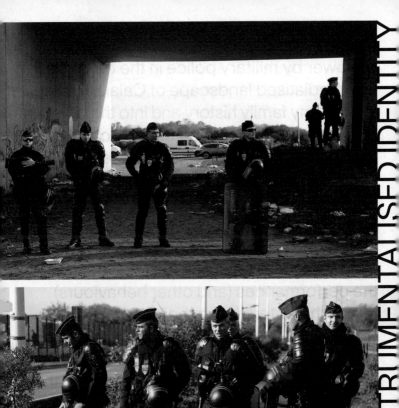

DEALING WITH CONTROL,
A PARALLEL FICTION
Neeltje ten Westenend

My research investigates the choreographies of power by military police in the controlled and mediatised landscape of Calais. It also looks at my family history and into the personal story of an ex-policeman turned actor.

I use observations and interviews as two basic strategies for ethnographic field-work and set the research in two locations, Calais and Amsterdam, for a non-scientific writing piece.

After this, I explored how one can read the performances (and other behaviours) of my characters using the language of film-making while combining individual perspectives with studies of group behaviour.

The 2016 fieldwork in Calais, during the dismantling of the refugee and migrant camp known at the 'Jungle', resulted in narrative texts and parallel scripts. This approach of departing from live situations and manipulating them into scripted situations plays with the interaction between truth and fiction.

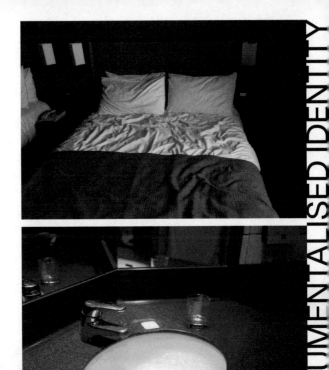

It was through studying films like Agnès Varda's *La Pointe courte* (1955), Peter Watkins' docudrama *Culloden* (1964), and Keren Cytter's videos and scripts that I came to better understand film-making as a language.* How to playfully dismantle cinema by using themes and techniques from television and theatrical cinema.

In Calais, I wanted to put myself in the shoes of the military police while sometimes entering the situation as a journalist or anthropologist. The point was to probe in different ways the appearances, workings and behaviour, of these uniformed officers.

After first visiting in 2016, I returned a second time staying in the same hotel the police had. Then I combined the previous research with the more individual perspectives and interviews I conducted with family members about my grandfather being a military policeman.

Back in Amsterdam I interviewed an ex-military policeman turned actor, to get a better understanding of this double perspective. He is usually cast as a soldier.

With these different positions I created a series of texts and scripts that blend truth and fiction. Every chapter is a reconstruction of the gathered material. My research ended with this collection, and from one script I created a film and video installation.

For this experiment, which I call parallel fiction, I extracted only two pages—a scripted dialogue—from the written research. The short film is based on a script that in turn is based on personal experience and memory.

In the short film there is a conflict between a man and a woman. I asked the actors to personalize and repeat the dialogue in different ways while they are driving through an empty military training village, Marnehuizen, in the Netherlands. I chose this place because it is a training facility where military personnel stage war scenes within an urban setting, a fictional copy of a real village.

I wanted the two actors to look like a familiar 'sitcom' couple. The setting inside the car offers an intimate sight. The couple (together with the spectator) looks out at the surrealistic environment. In the edit I've used the device of repetition—both the route and the conversation turn in loops. What has happened is not revealed.

The results of my research offer new ways of looking at the profession of military police. I found the subject of police rewarding, as this profession is permeated with numerous layers of role-playing. The encounters with text gave me new perspectives on how to work with this layered content. The film is a self-contained result. Both the texts and film are constructed in a way that makes for a more layered and complex story. These results provide more than journalism or imaginative fiction. There is a tension between the various methodologies, giving the story a more intricate understanding of generational difference, conflict, and our relationship to linear truths.

THE INSTRUMENTALISED IDENTITY

What follows are some excerpts of the observational texts I wrote from Calais.

Calais, Wednesday 26 October 2016

My hostess explains the television and the sound system. 'You want Indian music,' she asks me, while she toys around with the remote control. She turns on the local news and Calais presents itself with some world breaking news: 'Démantèlement de la "Jungle": Plus de 1000 migrants sont toujours à Calais,' reads the title on the screen. There are black clouds and lots of fire behind the news anchor's back. I reply to the question in very bad French: 'No music, non merci.' Then, in English, I try asking about the Jungle, where it is and whether I could walk there? How did she feel now that they have begun dismantling it? But she does not understand English and tries to tell me that today was a day full of smoke. She won't believe it is over yet and keeps saying: 'C'est un problème.' I try to ask if she also rents rooms to policemen. No, but she points out the hotels where the policemen stay. She also points out the Jungle, as situated within the dunes on a tourist map of Calais. Then she gives me the key and wishes me luck.

Calais, Thursday 27 October 2016

OK, this is the case. I was carrying my camera around that day. It is quite a heavy thing, without the belt with which to hang it around my neck. My hands were not able to make notes and to take photos at the same time. Taking pictures would be another way of being involved, another way of looking. But still I was not confident, daring to use my camera to shoot policemen.

Both to the left and right sides of the road groups of armoured policemen are strategically positioned. There is a half-open fence, a cameraman filming through the opening. A woman carrying a press card around her neck is on the phone. Behind the fence there are big tents and temporary toilets. It looks like the backstage area of a festival. Another camera crew is following a lady from the Catholic Church who walks and talks with three young black men towards the direction of the bridge. Cleaning teams are picking up all the remnants, putting them in garbage bags.

Slowly I'm reaching the end of the road and the bridge, where I cannot go any further. The bridge is used as the border. Behind it is the camp area. Policemen are lined up along the border. Eight of them are standing in line, half a metre apart from each other. Some of them are carrying rifles, others shields, and some are wearing sunglasses too.

A bit higher up, at the foot of the bridge's slope, one man is looking down at the group below. His gaze looks really concentrated...

Some immigrants have covered their heads with blankets, others pulled mouth masks over their faces, but most of these young black men wear hoodies to defend themselves against the media attack.

* Keren Cytter's films are described by London's Pilar Corrias gallery, as consisting 'of multiple layers of images; conversation; monologue, and narration systematically composed to undermine linguistic conventions and traditional interpretation schemata'.

ILLUSIONS OF IDENTITY
Fabrice Bourlez

Identity is a complex word. The three projects gathered in this chapter reveal several aspects of such complexity. Each proposal deals with different issues and applies a different method and could therefore appear unrelated to each other. One wonders, what is the link between the 'Jungle' of Calais, passport photos found in Germany, and medical exams taken at a phoniatrist? What is the relationship between a video research, a piece using iconographic materials, and a sound production? *A priori*, very little. However, studied together, these propositions situate identity at the crossroads of three of its fundamental determinants: power, body, and language.

It is fundamental to study identity not as a stable, established, clear and distinct concept, but as an open question. We must not freeze identity once and for all. On the contrary, we should show how it is constructed at a given moment, in the face of a specific issue, and in a specific context. Identity is never acquired: it is constantly being constructed from a theoretical, social or personal point of view. When Michel Foucault reflected on (homo)sexual identity, on friendship as a way of life between men, and on the possibility of constituting a culture specific to certain types of sexual identity, he insisted on the fact that 'the agenda must be empty'.

The research of Neeltje ten Westenend, Madelief Geus, and Thom Driver is grounded in a search for invention without the temptation to fill in emptiness. These artists are not interested in making programmes or setting agendas. On the contrary, they attempt to articulate the mainsprings on which to think about identity. Ten Westenend (*Dealing with Control, A Parallel Fiction*) reminds us that identity—who we are—is part of a set of political relationships: the most intimate aspects of our lives cannot be detached from the relationship to an otherness that constitutes as much as

it deconstructs us. The white man, bourgeois, urban dweller, heterosexual, tends to think of his identity as a private dimension of his existence. In a situation as terrible as that of the Calais 'Jungle', the choreography of the bodies that opposed policemen and migrants showed to what extent, depending on one's origin, the hazards of life, the costume that fate has given us, or depending on the economic-political stakes of one's situation and thus going far beyond any subjective choices, our identities are determined by implicit and explicit power relationships.

Res Nullius (*An Ownerless Identity*) shows how this inscription of power in the shaping of our identities comes through the image of our own bodies. To be someone, to have an identity, is to have an image recognizable by oneself and by the 'other'. We spend our lives redoing our identity photos. This image of the self is necessary to face daily life. It is nonetheless a fiction. In the project Geus highlights how the cliché, the freeze frame, imprints the unity of the self. Such images are illusions. Such unity only covers up the multiplicities, the infinite molecules that make up our becoming. Heraclitus already taught us that our bodies never bathe twice in the same river: we are one with the perpetual movements that take us beyond what we seem to be. It is therefore identity itself that becomes *res nullius*, that is to say: without an owner and nevertheless appropriable.

Driver (*Glottal Stop*) brings identity back on a fundamental axis: the one of language. In a subtle way, what is at stake here is the link between our voice and who we are. If identity implies power relations within the body, this encounter between political otherness and physical intimacy is established differently for each subject and affects each person's voice in a singular way. What uniquely distinguishes each human being and prevents it from closing in on itself are its accents, its formulations, the way it says how it feels cluttered by what it thinks it is and what it is told to be.

It is striking to observe how these three plastic experiments lead to a fiction of the self: as if the complexity of the concept of identity, in order to assert itself authentically, required recourse to speculative storytelling.

Fabrice Bourlez is a psychoanalyst in Paris and Professor of Philosophy at ESAD (School of Fine Arts) Reims. His latest publication is *Queer Psychoanalysis* (Paris: Éditions Hermann, 2018).

www.esad-reims.fr/fabrice-bourlez-2

GENDER

AND
OLENCE

Quillette

HOME ABOUT SUBSCRIBE DONATE QUILLETTE CIRCLE Q BOOK CLUB

Features Science / Tech Politics Review Podcast

Podcast
PODCAST 97: Professor Eric Kaufmann
on America's Maoist Moment

PODCAST

MEMOIR, RECENT

Published on November 10, 2019

Reflections on My Decision to Change Gender

written by **Deirdre McCloskey**

'It's been a long time now since, at age 53, I became a woman. Actually, I'm an old woman, who walks sometimes with a nice fold-up cane, and has had two hip-joint replacements, and lives in a loft in downtown Chicago with 8,000 books, delighting in her dogs, her birth family, her friends, her Episcopal church, her eating club near the Art Institute, and above all her teaching and writing as a professor. Or, as the Italians so charmingly say, as *una professoressa*. Oh, that–essa. She retired from teaching at age 73, twenty years after transitioning, "emerita." Not, you see, "emeritus."'

It's been a long time now since, at age 53, I became a woman. Actually, an old woman more than twenty years on, who walks sometimes with a nice fold-up cane, and has had two hip-joint replacements, and lives in a loft in downtown Chicago with 8,000 books, delighting in her dogs, her birth family, her friends scattered from Chile to China, her Episcopal church across the street, her eating club near the Art Institute, and above all her teaching and writing as a professor. Or, as the Italians so charmingly say, as *una professoressa*. Oh, that –essa. She retired from teaching, though not from scribbling, at age 73, twenty years after transitioning, "emerita." Not, you see, "emeritus."

But of course one can't "really" change gender, can one? The "really" comes up when an angry conservative man or an angry essentialist feminist writes in a blog

From: Deirdre McCloskey, 'Reflections on
My Decision to Change Gender', *Quillette*,
10 November 2019

https://quillette.com/2019/11/10/reflections-
on-my-decision-to-change-gender/

'But of course one can't "really" change gender, can one? The "really" comes up when an angry conservative man or an angry essentialist feminist writes in a blog or an editorial or a comment page. The angry folk are correct, biologically speaking. That's why their anger sounds to them like common sense. Every cell in my body shouts XY, XY, XY! I do wish they would shut up. Wretched little chromosomes. In some magical future I suppose we'll be able to change XYs into XXs. But not now.

And more importantly a gender changer age 53, as I was in 1995, can't have had the history of a born girl and woman. She cannot have had the good and the bad experiences of girlhood and motherhood and the rest. No science can change her life history. It's the same for a born female going the other way, to male– which by the way seems on recent evidence to be about as frequently desired as male to female. The singer and actress Cher's son, for example. Neither way is all that frequent–maybe one in every 400 or so births. It is much less frequent than, say, gayness, with which it is chronically confused. Yet the desire to change gender is in fact vastly more common than the crazy guess in the dark ages of the 1960s that psychiatrists confidently proffered, of one in every 20,000 births. Upshot? You yourself probably know a transgender person, whether she has transitioned or not. When I first went to my little progressive Episcopal church in Chicago, there was someone going the other way, female to male, and a few years later another one.

(...) But frequencies aside, a girl's life is not the same as a boy's, and I had a normal boy's life, and the advantage in a macho field like economics of being a man for half of my academic career. The question of what you are is qualitative, not quantitative. What sort? What life? What team? In late 1995, I chose to switch teams.

I do not want to sound unreasonably essentialist. Genders massively overlap. We're human or American or raised in Boston. People, whether male or female, born like me in the United States to white middle-class parents in 1942 share a great deal. It's what makes high school and college reunions so nice, a renewal of old friends with so many old experiences in common. My mother born in 1922, says that she prefers to hang out with "people who danced to Harry James," a 1940s bandleader.'

#*iwannamakerevolution* reacts to subjective, political and social oppression about sexuality, identity, and desire. It explores pussybilities beyond binaries.

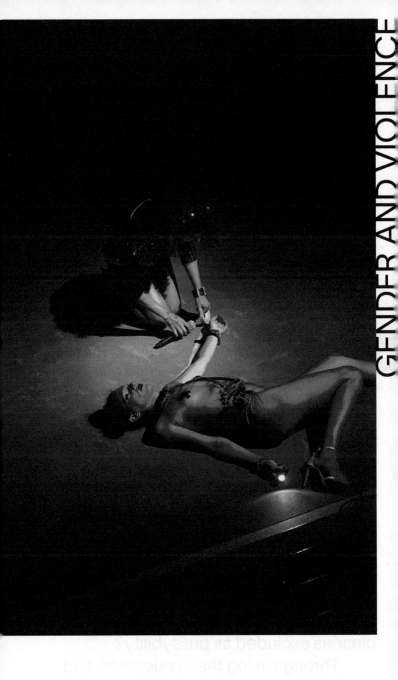

#IWANNAMAKEREVOLUTION

Mavi Veloso

APPROACH

Do differences in language, beliefs, laws and habitat, create segregation between European and non-European citizens? What generates marginalization of non-binary and trans* bodies? Why are female and transsexual bodies so over sexualized and objectified? What are the politics for trans-gender migrants in Europe? Why and what does it mean to have 'passability'? What are the regulations and rights to change documents? Should one adjust her voice to what is understood as a female voice? Can women with a deep voice fit into society? Do we need to judge only between male and female? Why are other colours and vocal tones that do not fit into male and female binaries excluded as pussybility?

Through living these questions and experiencing gender transformations as a foreigner in Europe, I wanted to capture the process using various tools of performance, music, photography, and workshops.

#*iwannamakerevolution* is a research on transits, transition, and mutation. An artistic investigation on conflicts around migration, gender discussions, and political and social transformations related to trans* and non-binary bodies.

Within #*iwannamakerevolution* I developed the trilogy *MUDA*, *Truque Trrrah* and *Trans* Opera*, with which I was striving to give a place and sense of belonging to trans* and non-binary voices.

MUDA

The first work in the trilogy, *MUDA*, is a sound and dance performance initiated between 2014 and 2015. It was a time when I had migrated from Brazil to Belgium and also started to self-medicate with female hormones.

The work is transpassed by poetic interpretations of a trans* Latin American body, living on the margins of the normatives of gender and binary identity standards, entering into and conflicting with European culture and the politics of a first world country.

In Brazil, *muda* means both change and to mute. *MUDA* performs the immigrant body that enters the new context/terrain, searching and experimenting from the perspective of a foreigner. She tries to assimilate and at the same time resists and renegotiates with the structures that have been ruling and colonizing her body.

MUDA also destabilizes the 'other' and their normatives; a hybrid persona going through mutations, using hormones, immersed into different identities, and gender technologies.

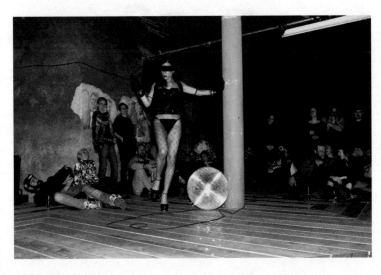

#IWANNAMAKEREVOLUTION

Truque Trrrah

This piece deals with voice experimentation and the physicality of sound, microphones, and amplifiers. During gender transition, for both trans men and trans women, many changes in the body and voice are important and conflicting topics. Over the decades, a series of body, voice strategies and gender technologies have been developed within trans* communities.

Dar o truque is an effective, smart, or quick way to do something. Do it right, do it tricky, do it magic. *Trrrah* is a *pajubá* among us girls: tra, *travesti*, *trava*, tranny. *Truque Trrrah* is a solo experimentation on voice, music, and performance. A happening where the politics and technologies of gender are all tucked up together. An appropriation of feminization and/or masculinization voice transition practices, using them as indefinite performance tools to slay, deconstruct standards, and build up different layers between the concepts established for male and female.

Trans* Opera

The last work in the trilogy orchestrates our personal experience as femme, non-binary, and trans* bodies: different performers telling herstories of marginalization, rejection, and resistance. The performance explores decolonization, the politics and technologies of gender as well as vocal and performative practices on the process of transitioning between gender identities. *Trans* Opera* is a manifesto built up by putting together different voices, multiple subjectivities, and the diverse repertoire that each performer generously brings to the piece.

Moving the crowds, scratching the floor with high heels, whipping bodies with microphones, singing songs about confrontation, trauma and love, we create a suspension in space and time, haunting the sound, performing violence—fierce empowerment.

GENDER AND VIOLENCE

Is it ever possible to leave the past behind and create new memories together? And if not, where do I belong?

ZONDER HOOP HEB IK GEEN DROMEN

Rowena Buur

This project is a non-binary feminist and artivist research into identity, sexuality, gender, and family.

Using interviews, video, photography and typography as a method to confront themself and others, Rowena Buur explored new ways to understand reality.

Taking a difficult reunion with their estranged father as a starting point, they document their reunion with him. Layering different perspectives and angles, they use tools including cameras, webcams, and archival footage.

This mixed angle destabilizes how the audience reads their relationship with their father. Love is an apple—the apple of knowledge, the poisoned apple, the Apple computer, the apple of discord.

This project is a non-binary feminist and artivist research into identity, sexuality, gender, and family.

Zonder hoop heb ik geen dromen [I have no dreams without hope] is an installation that consists of a forty-minute documentary, photographic works, and a wall of bricks. Eight years ago Buur broke contact with their father Renee, who had been, and continues to struggle with alcohol addiction, and does not have a stable place to live.

When they heard that their father had finally found some stability in a trailer park, they thought it was time to get back in touch with him again. The installation is an intimate family portrait told through Buur's eyes. The viewer becomes privy to their sometimes difficult, honest and sensitive process of building a new relationship, and their both coming to terms with the passage of time and acceptance.

Buur feels it is important in their research to create a balance between heavy subjects and something that is lighter. On images that depict difficult and deeply personal moments, for example, they include added layers to lighten the impact.

Another way to create balance is to work on and present contrasting projects at the same time; the differing mindsets of the emotional and physical can create a more dynamic and realistic reaction to the work.

The final installation includes work exploring sexuality and the heteronormative morals that society spits in our faces. Within the project, Buur starts to explore some of the daily and (in)visible aggressions that LGBTQ+ people confront daily. It is a protest against oppressive morality, a protest that reverses recurring comments and questions and opinions that are not asked for.

When did you become a heterosexual? Because you don't look like one.

The project aims to reflect the purpose of finding a more transformative response to the awkward and difficult conversation LGBTQ+ has with the wider community.

Two conversations between Buur and their father:

14 May 2018

+ When will you be in the neighbourhood again Roween?
- I don't know yet, but I can let you know when I'm around.
+ You should give me your phone number so we can call.
- I can give it to you, but I don't want you to drunk dial me.
+ I won't, I promise that.
- That's what you say now and then you'll forget when you've been drinking.
+ No I won't. I won't. I'll send a WhatsApp then.

29 July 2018

- So we both don't like digging up the past, let's not do that then.
+ You're starting it now Roween, I didn't start talking about it at all. Am I right or not?
- Yes because it got me stuck that you drunk dialled me last week. You were yelling at me without a reason.
- Telling me that you where always there for me. Where have you been the last eighteen years?
+ You know what, I'm bringing you home and you can call me in three months. And if not, then not.
- That's not what I want at all.
+ Tell me what you want then?!
- I don't want you to cross my limits, that's the whole point.
+ It's all fine to me.

What happens if emotional damage is understood as a sort of systemic debt perpet-rated by power structures we live under?

NATUREZA MORTA-VIVA
279 Vita Evangelista

I looked at the readily available technologies of representation provided by Google Maps and Google VR to investigate my body's geographical, political, and emotional positions in the world. *Natureza Morta-Viva* [Living-Dead Nature] is the umbrella title for the research project from which a series of works begun to arise, taking shape as film, performance, and installation.

Searching for the kinds of information that these images fail to or choose not to represent, I redirect Google's point of view while traveling through two settings that are mostly familiar to me: the cities of Rio de Janeiro and Amsterdam. Collected footage of my body's travels through Google technology is disrupted by the interventions of text sound recordings that are both found and post-produced, animations, and the presence of the performing body.

If emotional damage could become a micro lens, an intimate vantage point and a private way of knowing, what stories would it tell about the larger frameworks that delineate all forms of life?

Hegemonic narratives on both human and non-human life are instrumental in any Western imperialist and colonialist project. At levels ranging from the micro to the macro, they interweave and co-fabricate specific realities that are conditioned by top-down, dominant worldviews. For the sake of their perpetuation and to the advantage of its rulers, they prescribe the hoards of default binary ideals that either add or deny worth, access and mobility, to the categorized forms of life that they have produced. The embodied and lived experience of gendered, racialized, classed and disabled bodies are in turn contingent on the way beings, things, thoughts, and emotions are ordered. As the effects of global geopolitics demonstrate, such systems affect not only the human but also non-human forms of life.

Under the dominance of neoliberal capitalism's ways of thinking, all sorts of environments have been reduced to becoming sites of conquest and extraction for the benefit of the few. Environmental ordering, exploitation and destruction, reflect the social and political conditions that categorized bodies inherit and inhabit: that of being subjugated to preset contexts through which some can move freely while access is either restricted or refused to other(ed)s.

As an (possibly unintentional) illustration of this, technologies like Google Maps and Google VR create representations of reality, which are often regarded as accurate and to a certain extent neutral. By way of assembling its multidimensional data collection, satellite mapping, photographs taken by Google's staff and those provided by anonymous users, are curated into a sort of realistic picture of a world hypothesis, which tends to be taken for granted.

Top-down perspectives more often than not reflect the hegemonic discourses by which they come to exist. Specific worldviews inform the representation of worldviews that create the right circumstances needed for perpetuating the very worldviews of control that shaped its own representation in the first place. It is an autonomous device in a cycle of biased creations of hollow truths and surfaces that stretch beyond the point of abstraction.

But, as with most binaries, the seemingly rigid boundary parting the private and the public spheres of life crumbles.

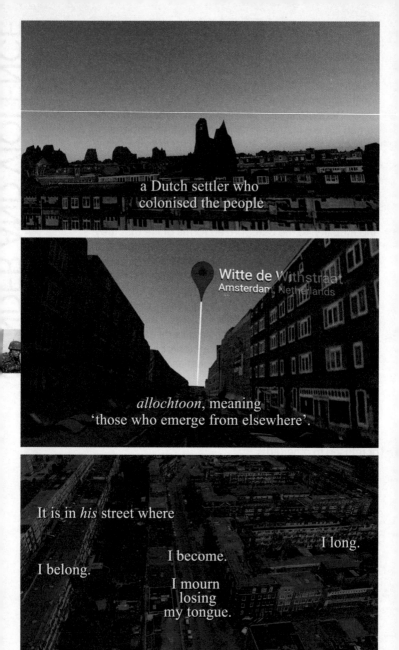

a Dutch settler who
colonised the people

Witte de Withstraat
Amsterdam, Netherlands

allochtoon, meaning
'those who emerge from elsewhere'.

It is in *his* street where

I long.

I belong.

I become.

I mourn
losing
my tongue.

Evidently, hegemonic narratives bring emotional effects to whoever is attempting to exist in the world under such dominance. Affect permeates and transforms embodied experience. Yet, it might tell different stories—stories of its own. If emotions precede the meanings that pertain to them, affect might self-enunciate despite thought and language. Affect, then, might be able to provide an alternative sort of language, before reason could attach specific meanings to the way one feels about the things and events they are struck by. Because of this, 'poethic' narrations of contextualized and lived experience could be useful in unveiling crucial information that might have been hidden or purposefully erased by hegemonic narratives.[1]

Between the headset and the goggles, blood powers a body. With all their specificities and pluralities, the organic technologies of the human body certainly do collaborate (and merge) with hardware in creating current world experiences. But one must not forget that specific corporations design technological devices, are owned by specific individuals, and made under specific terms of production for no less specific purposes. One must not forget to remain critically aware of what such collaborations might want to impose.

However, I try to use these readily available technologies of representation to re-experience familiar things (and self) with the perspective twist that is brought by a certain distance. Occupying the vague dimension that settles between one thing and its own prescribed image, the self is alienated.

By doing so, I notice that slightly alienating oneself can become a methodology that facilitates a more detached understanding of my own positionality, be that towards the self or the world.[2] It becomes a tool with which to try to look again; to unmake sense of what I believe to know; to challenge the produce of thought that is fed to sight. Consciously alienated, I attend to the representation of things and places which seem to lack the different or more nuanced sort of truth that my memory utters. Consciously alienated, I look for specific things that might be missing, misrepresented, lacking depth, as well as those that might perhaps have been deliberately erased from prescribed images.

1. American poet, critic, and multidisciplinary scholar Joan Retallack coined the term poethics as 'an attempt to note and value traditions in art exemplified by a linking of aesthetic registers to the fluid and rapidly changing experiences of everyday life'.

2. Positionality is the notion that personal values, views, and location in time and space influence how one understands the world.

FREE YOURSELF
Daan F. Oostveen

The recent intensification of the so-called 'culture wars' have put to the fore questions regarding identity, performativity, and the objective of cultural and artistic production. We could say this has caused art to lose its innocence. Did we only thirty years ago, when the cultural context was still undisputedly postmodern, find irony mostly on the side of the left; today the left has become all too serious and has left irony and creative performativity to the reactionary right.

This shift is, I believe, centred around the question of who dominates the critique of violence. A critique of violence is often afraid of itself. When this fear becomes productive, as we see in the 1921 essay *Zur Kritik der Gewalt* (*On the Critique of Violence*) by philosopher Walter Benjamin, the postmodern left can dominate it. When this fear becomes afraid of itself, the reactionary right can move itself into the postmodern discourse and acquire the hegemony over the definition of the critique of violence.

Before, in line with gender theorist Judith Butler, our bodies and identities were seen as fluid, performative, and in 'trans'. Now, the 'trans' and the 'queer' have become identities in themselves. The consequences of this shift should not be underestimated. The postmodern has become suspect, and as a result of this suspicion by the left, we have relinquished our hegemony on the critique of violence. This has enabled a new fascism to enter in the void. Gender has become re-essentialised. Where feminism first had succeeded in exposing the binary biological essentialisations that were the root cause of gender oppression, now the productive violence of the concept of 'identity' which had actively served the fascist right for so long, has become re-appropriated by a certain left. We see this in Rowena Buur's (*Zonder hoop heb ik geen dromen* [I have no dreams without hope]) personal retelling of how having to define their identity for their father caused not just pain but a destabilizing of the expected.

Benjamin emphasizes the mythical origin of all violence. The state has the monopoly on violence. Modernity has made us secular, but the origin of the violence of this secular state is mystical. The power of the constitution which cements our social contract has been granted by a religious source of power, a god, either an imaginary god, or a True God, a god of love, or a god of play. Maybe a god which has been killed, but who still haunts us. Vita Evangelista (*Natureza Morta-Viva* [Living-Dead Nature]) aptly talks about 'sites of conquest' revealing how the system works for some while marginalizing and perpetuating hegemonic views of control.

Why do we cling to identity? Do we have a nostalgia for the forgotten violence of 'being something'? We have forgotten the liberating playfulness of the postmodern performativity and have succumbed to the imperative to demand justice, to demand anger. Weren't justice and anger precisely the faculties that we had attempted to deconstruct?

Mavi Veloso's (#*iwannamakerevolution*) research experimented with voice and questioned whether a narrowly defined identity inevitably ends in oppression. This work reveals how post-colonial, the gender-deconstructed, and even the intersectional can be expressed in art best when it avoids being overtly political. Since when did the political, this misguided attempt to find justice, trump the aesthetic? The philosopher Jacques Derrida said that all philosophy is a matter of justice, but that justice is at the same time absolutely impossible. This opens up the possibility for art.

All the work in this chapter shows that identity is a trap, not a liberation. Let us stick to being whoever we want to be, not who we supposedly 'are'. This does not mean we have to negate the power relations which are inherent to living and dying together. The world is a messy place. Art is about getting dirty. It is in this artistic dirt that we can find new possibilities of belonging. We are neither connected to a larger unity nor are we part of identitarian communities. We are whatever our bodies afford us to be.

The artist has a responsibility to play and be joyful, but does not have a responsibility for politics and justice. Forgetting this is the only possible sin.

Daan F. Oostveen is a philosopher. Currently he is a postdoctoral researcher at the Institute for Cultural Inquiry at Universiteit Utrecht, where he works on the New Humanities in Europe project.

www.uu.nl/staff/dfoostveen; www.ineffable.live

Circuit Judge, held
on basis of

Plaintiff, a black female, brought
Court for the Central Distr
for involuntary dismissal,
that: (1) district court did

The intersectionality wars

When Kimberlé Crenshaw coined the term 30 years ago, she was writing about a relatively obscure legal concept. Then it went viral.

By Jane Coaston | jane.coaston@vox...

f y SHARE

The Highlight BY *Vox*

'There may not be a word in American conservatism more hated right now than "intersectionality." On the right, intersectionality is seen as "the new caste system" placing nonwhite, non-heterosexual people on top. To many conservatives, intersectionality mean "because you're a minority, you get special standards, special treatment in the eyes of some." It "promotes solipsism at the personal level and division at the social level." It represents a form of feminism that "puts a label on you. It tells you how oppressed you are. It tells you what you're allowed to think." Intersectionality is thus "really dangerous" or a "conspiracy theory of victimization."'

system" placing nonwhite, non-heterosexual people on top.

To many conservatives, intersectionality means "because you're a minority, you get special standards, special treatment in the eyes of some." It "promotes solipsism at the personal level and division at the social level." It represents a form of feminism that "puts a label on you. It tells you how oppressed you are. It tells you what you're allowed to think." Intersectionality is thus "**really dangerous**" or a "**conspiracy theory of victimization.**"

This is a highly unusual level of disdain for a word that until several years ago was a legal term in relative obscurity outside academic circles. It was coined in 1989 by professor Kimberlé

From: Jane Coaston, 'The Intersectionality Wars', *Vox*, 28 May 2019

www.vox.com/the-highlight/2019/5/20/18542843/intersectionality-conservatism-law-race-gender-discrimination

'This is a highly unusual level of disdain for a word that until several years ago was a legal term in relative obscurity outside academic circles. It was coined in 1989 by professor Kimberlé Crenshaw to describe how race, class, gender, and other individual characteristics "intersect" with one another and overlap. "Intersectionality" has, in a sense, gone viral over the past half-decade, resulting in a backlash from the right.

In my conversations with right-wing critics of intersectionality, I've found that what upsets them isn't the theory itself. Indeed, they largely agree that it accurately describes the way people from different backgrounds encounter the world. The lived experiences—and experiences of discrimination—of a black woman will be different from those of a white woman, or a black man, for example. They object to its implications, uses, and, most importantly, its consequences, what some conservatives view as the upending of racial and cultural hierarchies to create a new one.

(...)

But it's not just academic panels where the fight over what intersectionality is—or isn't—plays out. Intersectionality has become a dividing line between the left and the right. Sen. Kirsten Gillibrand (D-NY) tweets that "the future is female [and] intersectional." The Daily Wire's Ben Shapiro, meanwhile, posts videos with headlines like "Is intersectionality the biggest problem in America?"

The current debate over intersectionality is really three debates: one based on what academics like Crenshaw actually mean by the term, one based on how activists seeking to eliminate disparities between groups have interpreted the term, and a third on how some conservatives are responding to its use by those activists.

(...)

But Crenshaw isn't seeking to build a racial hierarchy with black women at the top. Through her work, she's attempting to demolish racial hierarchies altogether.

(...)

Crenshaw has watched all this with no small measure of surprise. "This is what happens when an idea travels beyond the context and the content," she said.'

Is Southern African singing a possible form of cathartic release from intergenerational trauma amongst Black people in the diaspora?

"When they sang the song, it literally shifted the energy in the room, it felt rousing, powerful and liberating."

BLACK WOMEN. TEARS, VULNERABILITY, AND SONGS

293 Sekai Makoni

APPROACH

It was important in the project to decentre 'rational', non-emotional, clinical, and depersonalized approaches to research. This was a conscious effort to assert that I did not want to continue with a colonial approach to thought and imperial academic research.

To centre the private sphere as also being valid was a conscious decision in the research and writing phases.

The main methodological approach of the text was the utilization of Black feminist theory, personal narrative, and interviews with Black women.

The thesis centred Black feminist theory using writers such as bell hooks, Brittney Cooper, Pumla Gqola, Taiwo Afuape, and Pumla Gobodo-Madikizela. It was very important to me to reference Black women writers, as I wanted to ensure the thesis had a theoretical underpinning that came from writers who were of similar backgrounds to me and the women I interviewed.

Group singing is positioned as a device that may hold trauma at bay, giving rise to a number of questions:

What is intergenerational trauma?

What are the ways in which Black women are denied spaces for vulnerability and crying?

What might the onset of tears demonstrate about the possible safety of certain spaces?

What are Black spaces and what might constitute safety within them?

Is there something particular about Southern African singing that allows for emotional release?

In exploring how Black women access healing via song, I used my own experiences.

My interviews with Black women asked when was the last time they cried, where they were, whether white people were present or not, and whether this might make it a safer space or not. Most importantly, respondents were asked about the possibility of a link between song, singing, and the onset of tears.

I tend to connect to theory written by Black women as it is often fused with lived experience, creating a critical praxis.

Misodzi is a Shona word from Zimbabwe; it means tears and is one of my great-grandmother's names. In Shona culture you name your child in relation to the context they are born into. Her name (Musodzi) is thought to be a reference to the many siblings she lost growing up. The name speaks to the sadness my great-great-grandmother must have felt. I would argue that crying isn't something we speak about enough, especially in relation to Black womanhood. The power of the Strong Black Woman stereotype means our pain is often not seen or heard. Through this project, I wanted to shift the ways in which Black women's pain is rendered invisible, and centre on Black women's experiences and healing approaches to that pain.

I began by conceptualizing tears as a form of cathartic release and considered what might happen if we were allowed space for tears and thought of them as a sign of possible collective mourning.

I had three experiences which made me take seriously Southern African singing and its connection to emotion.

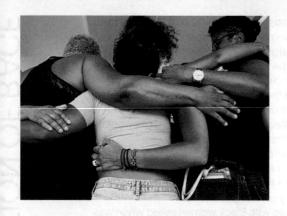

I was a part of the Sisters Uncut reclamation of London's Holloway Prison in June 2017. We reclaimed the visitors' centre to draw attention to the swift closure of the prison following the death of a young Black woman, Sarah Reed. There was a seeming desire to make use of the prime real estate the prison sat on and we wanted to draw attention to the fact that the land should be used to honour women and non-binary people, and the services they require, especially in relation to domestic violence. As part of the wellbeing team, I helped coordinate events like a singing workshop put on by singing leader Shilpa Shah. On that day, we sat in a large circle and were taught the harmonies to a Zulu/Xhosa song, *Thina Simunye* [We Are Together]. We learned the song by ear. This took a while, but when all the pieces came together, it sounded beautiful. As we settled into the song, I started to feel tearful. I was just about holding it together when we finished the song, but as I looked at a fellow sister, whose eyes were welling up, my tears began to flow. I felt awkward as I was meant to introduce the next workshop, but couldn't really speak. Shilpa took over and affirmed that we didn't need to speak, we could just be and feel, reminding us that these songs were powerful and had emotional impact.

The predicament that Black people often find themselves in, of speaking of your existence as a Black person within a white framework, has been an ongoing bind. It can be seen in what W.E.B. Du Bois describes in *The Souls of Black Folk* (1903) as double consciousness, the 'peculiar sensation' of 'always looking at one's self through the eyes of others, of measuring one's soul by the tape of a world that looks on in amused contempt and pity'. Du Bois spoke about the difference between how we view ourselves as Black people versus knowing how others view us. This two-ness can be extrapolated to other contexts. Frantz Fanon, for instance, wrote from his position in France, Algeria, and Martinique.

Analysis of two of the interviews:

A central theme that appeared in multiple responses was that singing provided access to emotions we might try to keep under the surface to get through everyday life. Singing itself seemed to give space to the release of emotions such as sadness. Ari says, 'Singing can move you, it can allow you to relax or to be open to emotion, it allows whatever's inside you to rise up.' The singing provided a form of emotional accessibility that 'shifts something'. Central to this sense of shifting was the consensus that there was less need for conversation. Ari explained that 'singing can allow people to be emotional and allow them to express themselves without having to talk about it'. Perhaps, in a Western world that often places emphasis on talking therapies, there may be an undervaluing of other ways of accessing and releasing emotion.

For Ari, there seemed to be real impact in not having to talk about what was behind her emotional expression. Often there seems to be a need to make tears more acceptable, bearable or less shameful; this often means that people suppress their tears in public and try to make them go away. But what would it mean to allow ourselves to stay with difficult emotions and fully feel them, even when we are with other people?

I strongly connected to Amina's notion of a convergence that happens when singing and crying together. 'It's painful, but it's beautiful to hold one another up in that moment.' She spoke of pain and beauty happening simultaneously, an almost bittersweet experience. This duality relates to my feelings towards theory and its history of eliciting pain in the ways it has been instrumentalised against Black people.

What makes us individuals?
What makes us part of a whole?
How can I belong? Can gar-
ments be spaces of interaction?

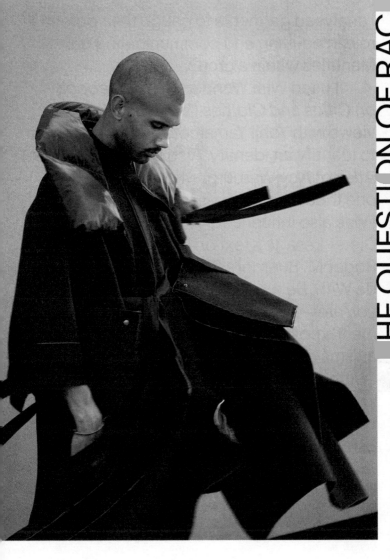

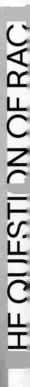

HOW TO LIVE TOGETHER
299 Karime Salame

I analysed garments to gauge their potential role in defining and communicating our identities within a group.

I used Wim Wenders' film *Notebook on Cities and Clothes* (1989) and its interviews with Yohji Yamamoto focusing on how to identify an identity. Also *the Mnemosyne Atlas* of Aby Warburg, who collected over one thousand pictures to re-read the world.[1] I was also influenced by Belgian philosopher Dieter Lesage's text on Ruth Noack and Roger M. Buergel's 2005 exhibition in Witte de With, *Be what you want but stay where you are*—a comment on the Dutch government's position on the 'other' and mechanisms of exclusion that emerge within the Dutch concept of tolerance.[2]

I incorporated Roland Barthes' series of lectures *How to Live Together: Novelistic Simulations of Everyday Spaces* from the 1970s, in which he questions and explores individual life in collective situations.[3]

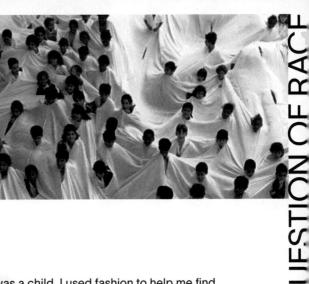

Ever since I was a child, I used fashion to help me find answers. I always loved the ritual of dressing up. But even back then, the division between my personal life and my school life felt like having two different identities.

I was born in Mexico City, and that's where my identity dilemma began. I was given an Arabic name that is normally given to boys. I was 50 cm taller than most people in my class. My father was Jewish, my mom Catholic, and we were never seen as belonging to either religion. Now, twenty years later, I have lived in four different countries, always getting new visas, or new identities, as I call them.

I have never really belonged anywhere. It was a struggle to study as a Hispanic person in European institutions where Eurocentric knowledge is seen as the pure and absolute truth. Therefore what I knew and showed was seen as the 'other', especially in a design and fashion context.

I grew up in Latin America, in a culture of good craftsmanship where knowledge is shared with family and community to keep traditions alive. This collectivistic culture has and still is something that I have difficulty finding in Europe. I am left wondering—how can one find that sort of harmony and cooperation rather than individualistic behaviour?

I might not have found an exact answer to my initial questions, but via my analysis of fashion and incorporating Barthes' principle of idiorrhythmic, I have come to realize that everything is connected with the environment. Idiorrhythmy is composed of idos (characteristic, particular) and rhuthmos (measured motion, rhythm), a productive form of living together in which one recognizes and respects the individual rhythms of the other.

This work focused on finding a rhythm amongst all the rhythms of everyone else in an attempt to create a community. And fashion is one major element in this realization. Fashion's fluidity can be used as a powerful tool, to show symbols of the personal, social, and cultural identity. It is an ongoing identity game. A mix or a montage.

In contemporary Dutch society, the other is not left alone and cannot be what he or she wants to be. When is tolerance only dealing with the other? What is the step towards allowing us to be what we want to be and to live wherever we want? Is it the way we behave that makes us part of a collective group?

I argue that the ideal way of living together would be a society in which everyone could live according to his or her own rhythm without solitude.

To position this, I designed a collection of coats with a dual functionality. Space providers and triggers of interaction, they can be worn, put flat on the floor and be joined together to create a communal sitting space. I want to encourage people to gather, to sit down, take a pause, and slow down.

Another way to look at this is to encourage people to step out of the virtual social space and create a real social space to meet actual people in the flesh, not via a screen.

1. Aby Warburg, *The Mnemosyne Atlas,* a series of over sixty panels that represented Warburg's attempt to map the 'afterlife of antiquity'.

2. Dieter Lesage, 'How to Become Dutch', *Afterall: A Journal of Art, Context and Enquiry 18* (2008).

3. Roland Barthes, *How to Live Together: Novelistic Simulations of Everyday Spaces,* trans. Kate Briggs (New York: Columbia University Press, 2012).

How can a makeshift approach, focused on self-reliance, creativity, improvisation and intuition, contribute to reframing global narratives from prede-fined, formulaic designations?

THE HANDS THAT FEED YOU
João Roxo

In *THE HANDS THAT FEED YOU* (*THTFY*), I investigate overlooked maps of economic, political, social and psychological dependency through present day affairs.

The project proposes speculative, hypothetical scenarios of emancipation and escape from a system in which visual hierarchies and generalized prejudice materialize in graphic codes and semiotic stimuli that enhance and perpetuate the distance between hemispheres, both geographic and subconscious.

In this imaginary world, intuition and resourcefulness are core values for reframing narratives and reinventing humankind. Intuition comes to represent a sort of surrender—within creative production—as a means of liberation, clearly opposing (or complementing) more formalized and controlled frameworks, and establishing a harsh contrast with the agenda of modernity and the colonial project.

Although I grew up as an African citizen, I was never recognized as Mozambican—because I am not of black descent, rather the result of a mixture of ethnicities. Along the way, I was repeatedly confronted with the question: 'How does the privileged white male approach Africa?' Or in other words, what legitimacy do I have to speak of African affairs and in which ways could I avoid being colonial or hypocritical. In some ways these are personal questions, but as the personal becomes public they do also feed into the prism of *THTFY* project.

Underlying *THTFY* is the Dependency Theory—the notion that resources flow from a 'periphery' of poor and underdeveloped states to a 'core' of wealthy states enriching the latter at the expense of the former—that works within the global North-South axis.

My work surrounds the dialogue that visual communication establishes with this dependency system and the final installation and peripheral media of the project proposes a passive form of protest through creativity. It reclaims the value of the craftsman's hand as a vehicle for liberation, laying bare the fact that your own hands are the real hands that feed you: self-sufficiency prevailing over dependency.

Dealing with contrasting and mutually contradictory realities enhances one's perception of the value of context. Immersing myself deeper in cognitive and epistemic research, I became aware of evidence of a certain perpetuation of hierarchies, feeding the growing gap between North and South, between rich and poor.

As an example, inflows of second-hand products arriving in the African continent (and other places) are a clear expression of both political and economic dependency, with large and deep-rooted consequences.

In an act best described as part of a pseudo-humanitarian aid campaign, most of the second-hand clothing donated from Northern countries is meant to minimize the effect of poverty. In downtown Maputo, Mozambique, *calamidades* is what people call the used clothing sold on the streets. Literally translated to 'calamities', it refers to the intent of helping people recover from natural catastrophes or other disasters that impact communities. In Portuguese, these big brick-shaped bales of compressed clothing are called *fardos*. It is ironic that the same word translates to both 'package' and 'burden'.

Somewhere in the North, someone purchases and accumulates goods. These same products, such as clothing, are thrown away and exported to a third-world country in what is usually called an act of charity, feeding a system of intermediaries who profit from it. Someone else on the other side of the world sells used clothing on a sidewalk instead of producing locally. Aid becomes trade.

Another important aspect to point out is that there is a general understanding that the persistence of capitalism (and subsequently of this state of dependency) relies on the dehumanization of the colonial subject. The portrayal of the African subject as 'primitive' and inferior justified the division of the land into territories and the assumption that an external entity was entitled to it. In 'development communication' the ubiquitous image of the impoverished, miserable youngster often comes superimposed with the image of a caring woman, reminiscent of another version of the feeling of lamentation. Mercifulness. This idea of a vulnerable, helpless child embodies the true corporate identity of the global aid agency.

In essence, it might be the time to question this image of the helping hand, amputating along with it this covert system of reliance. Contrary to the popular maxim, one 'better bite the hand that feeds us.'

At one point, I unintentionally arrived at the craft of wax printing (or batik), for it constitutes a metaphor, in itself containing the essential message of balance, of tension between the fabric (a microscopic grid structure), the application of colour, and the fluidity of wax. This constituted, in essence, a *flooding of the grid*. Picture a square grid. Acknowledge the structure and its clean and balanced lines. Now, I have come to realize how relevant and important that a kind of bindweed grows on the grid wall; how the unintended cracks bring

life and personality to the structure. I seek a bending of the grid, a flood of character, a certain uniqueness that comes with the unexpected, much in the same way the ink flows along the wax cracks on fabric.

This experience resulted in a series of screen prints and batik wax-prints on fabric, and I independently published a reader on the general themes of the project with content developed by ten different authors.

There is now a collective strand for *THTFY* and other projects. I met Russel Hlongwane, a cultural producer in South Africa, and after spending time researching and experimenting in each other's countries we exhibited our works in Durban at the end of 2019. Our shared interests led us to create the thirdspace as a collective movement, expressed in an online repository and a printed reader publication in which various thinkers propose both binary and non-binary approaches towards the African phenomenology.

RACE: OR THE POLITICS
OF A WILD OBJECT
Amade Aouatef M'charek

'Tell me, there is no biological race, is there?'

You won't believe how often I have to relate to this question. The person posing it seems to be looking for reassurance that there is nothing in nature, nothing deep down in our bodies, that supports the persistent racism in society.

This question is understandable, but each time I start answering it I stumble over my words. The question seems simple, yet is full of ambiguities—ambiguities that exist in two words: biology and race. Neither of these words can be reduced to one singular entity. For example, biology is not a matter of adding up genes, hormones, bones, and what have you. The biological is perhaps best viewed as *con-figurations* of scientific work to present a 'natural phenomenon'. This phenomenon is not less valid or less true. The point is that it is *irreducible* to one thing. The power of its truth-claim is precisely the fact that it is a con-figuration. I cannot convince you of the existence of the melamine gene by making you stare at your skin. As philosopher Bruno Latour and many others have shown, we need a laboratory to do that.

Are you noticing the detours I am taking? If the above offers space for manoeuvring and for navigating the biological differently, it is the juxtaposition of biology and race that takes my breath away. This juxtaposition is precisely suffocating because it has a long and crusted history.

Race had long been the prime working horse in studies of human diversity. Since the late nineteenth century the prospect of finding the racial type has driven a feverish collection of data. In the slipstream of colonial projects and equipped with novel statistical methods, scientists started to measure anything from skin colour, lip thickness, hair structure, and so on and so forth. More details, better methods and larger data sets would determine once and for all what the human racial types were, or so the story went. But as the data accumulated, it became clear: race was an illusion.

But the very idea of race was also doing work in society. Assumed hierarchies, where the white man figured as the crowning glory of evolution was mobilized to justify injustice. To justify colonial extractions, killings, slavery, humiliations… Some aspects of this violence have been in the open, others silenced. They might indeed, as Sekai Makoni (*Black Women. Tears, Vulnerability, and Songs*) is suggesting, require some collective singing and tear shedding to articulate them and bring them into view. For slavery or colonialism is not simply a history left behind, as some politicians might want to claim. Makoni moves away from linear narratives about historical events and seeks methods that elicit convoluted emotions and bring disparate experiences into proximity.

In 1951, UNESCO issued the Statement on Race indicating that there is no biological basis for race. But this was not the end of it. And while genetic research has produced evidence for the non-existence of race, race is definitely making a comeback. Most genetic research teaches that differences cannot be pinpointed, but social categories are mobilized to do precisely that. And given the persistence of social problems, it is assumed that life science research will finally provide us with the answers, contributing to the biologization of social categories.

So, how can I say that biological race does not exist, when it is always a nature-culture con-figuration? To be sure, the increasing production of grids and colonial matrixes make us needy of bindweed to flood the grid and crack the walls, as João Roxo (*The Hands That Feed You*) has beautifully suggested. His project problematizes the colonial and racist image of Africa, always vulnerable and in need of help from the West, and proposes speculative methods to imagine how this relation can be otherwise. Perhaps this is akin to the suggestion of looking for *rhythms* of living together by Karime Salame (*How to Live Together*). Salame's perspective on rhythms is mesmerizing as it prevents us from fixating others with whom we share the planet. The other does neither come in one version nor stay put within the lines of the grid. The other moves and might incite us to move together.

Amade M'charek is Professor of Anthropology of Science at the Universiteit van Amsterdam. Her research focuses on the interaction between science and society, with special attention to race and forensics.

www.uva.nl/profiel/m/~/a.a.mcharek/a.a.mcharek

ITICS OF

SPACE

VULTURE

KARA WALKER'S NEXT ACT

After the success of her sugar sphinx, the artist is a whole different kind of public figure — and figuring out a whole new

'At the time of the debut of her most recent public-art project, Kara Walker would clandestinely ride her bike from her home in Fort Greene to the then-defunct Williamsburg Domino Sugar factory. The sugar Sphinx was raised in the summer of 2014; crowds as big as 10,000 people gathered to visually consume, and to Instagram, the monumental sculpture. Back then, Walker had dyed the top of her cropped Afro blonde, and her vague purpose in visiting Domino, she tells me, involved evaluating the people who had come to evaluate her work: She wanted to see how the moment of encounter with the colossus could change their faces.'

At the time of the debut of her most recent public-art project, Kara Walker would clandestinely ride her bike from her home in Fort Greene to the then-defunct Williamsburg Domino Sugar factory, where the massive sculpture was housed. The sugar Sphinx was raised in the summer of 2014; crowds as big as 10,000 people gathered to visually consume, and to Instagram, the monumental sculpture. Back then, the Walker had dyed the top of her cropped Afro blonde, and her vague purpose in visiting Domino, she tells me, involved evaluating the people who had come to evaluate her work: She wanted to see how the moment of encounter with the colossus could change their faces. But Walker's presence disturbed things, she says — as soon as viewers noticed, their eyes turned from the idol onto her, then they flocked in her direction. She was slightly exhausted by that, she says, still seeming a bit surprised. "I don't know, I thought maybe people would be focused on the white-but-black gigantic labia!"

From: Doreen St. Félix, 'Kara Walker's Next Act',
Vulture, 17 April 2017

www.vulture.com/2017/04/kara-walker-after-
a-subtlety.html

'But Walker's presence disturbed things, she says—as soon as viewers noticed, their eyes turned from the idol onto her, then they flocked in her direction. She was slightly exhausted by that, she says, still seeming a bit surprised. "I don't know, I thought maybe people would be focused on the white-but-black gigantic labia!"

Commissioned by the downtown public-art fund Creative Time, *A Subtlety, or the Marvelous Sugar Baby* induced, like any Kara Walker work, an equivocal ceremony of lookin—who looks, at what, and how. The central sculpture—a Sphinx creature with the kerchiefed head of a mammy figure, her breasts naked, her vulva prominent—stood 35 feet by 75 feet, a chimera of unvarnished American desires, protected by an infantry of black-boy figurines carrying agricultural bounty, built from Walker's sketches by a team of nearly 20 fabricators, the 3-D sculpting and milling firm Digital Atelier, and Sculpture House Casting. A foam skeleton overlaid with 40 tons of sugar, water, and resin, the *Sugar Baby* was the largest single piece of public art ever erected in New York City. It was also one of the biggest in another sense: The show attracted 130,000 visitors, briefly lived a convoluted life as a coveted social-media geo-tag, and seemed, given the many pilgrims it enticed, to herald a new future for public art in the city. As Nato Thompson of Creative Time told me, "Kara immediately understood what a different form public art can be."

The Sphinx was not meant to be a crowd-pleaser; it was too challenging for that, with compressed politics that were the result of what Walker calls her "magical thinking." The *Sugar Baby*'s extended title referred to the workers who had been degraded, maimed, underpaid, and killed in factories like this one: "an Homage to the unpaid and overworked Artisans who have refined our Sweet tastes from the cane fields to the Kitchens of the New World on the Occasion of the demolition of the Domino Sugar Refining Plant." The sculpture was a feat of reengineering, its materials not only sugar but also the events running through it: the brutal repurposing of black human life for the rank, commercial lusts of white supremacy; the emphasis on black female biological potential over black female creativity; both the bygone and contemporary processes of gentrification that threaten to wipe all indications of these dark and abiding practices from the structures in which they occurred.'

POLITICS OF PUBLIC SPACE

Inside the sick and elderly community, what role can design play in challenging a health industry addicted to creating anonymous spaces?

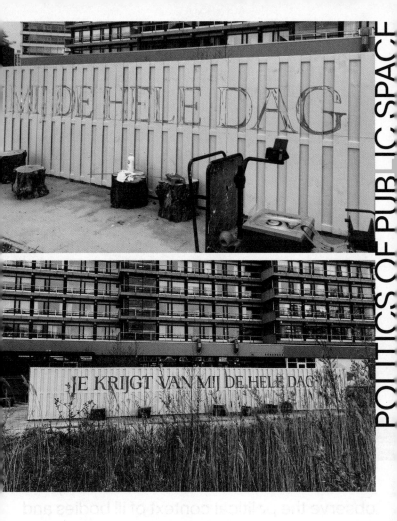

observe the political context of ill bodies and
the continuous narrative they are subjected
to as ill selfs.

I engaged in conversations on a one-on-one
way, in community, as close, in close proximity
to man, and aimed to do volunteer work at
the house, the knitting club.

Especially during my voluntary work,
I was able to move beyond the pity narrative.
I wanted to study this victimhood, which likens
illness to a person's identity and what parts
of a person's self are...

I'LL GIVE YOU THE ENTIRE DAY

Tessa Meeus

Initially I focused on experimenting with ways one can enter the bureaucratic system of 'being ill' to discover what challenges sufferers face.

Once inside, I wanted to research the (visual) gap between 'ill' and 'healthy' and kept a diary from the moment I entered the bureaucratic system.

From the inside I could more closely observe the political context of ill bodies and the victimesque narrative they are subjected to on a daily basis.

I engaged in conversations in the garden with the community, slept in close proximity to them, and started to do volunteer work at the in-house drawing club.

Especially during my volunteer work, I was able to move beyond the 'pity narrative'. I wanted to study this victimhood: what illness does to a person's identity and what parts of a personal identity illness doesn't influence.

The stigmatization of care facilities and the grouping of people based on their health presents a world of bias. Design can play a role in reshaping the image of illness, and therefore potentially expand the Western norm and definition of what is perceived as ill or piteous.

I think the skewed perception starts with the 'clean and standardized aesthetic' that comes with health facilities. This blind spot reproduces and reinforces a sterile, impersonal hospital-kind of design style that seems disconnected from what care is about.

To address this I present a series of design interventions in the personal space of an inclusive community. Those living there are not only the sick and elderly, or people needing round-the-clock care, but those who can live independently in the house. What they have in common is vulnerability, socially and/or economically. By creating work with residents, and incorporating their preferences and collective memory, I was able to create objects and spaces with personal value.

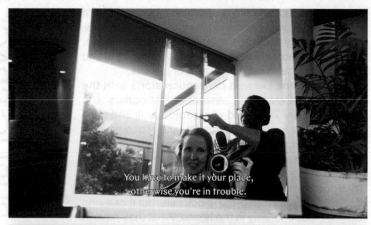

My results are not just about raising awareness; they are about transforming the actual living conditions of people. The work is not just a comment on ethical and theoretical perceptions.

I was surprised by how accustomed people are that the design of a home for the elderly feels like a public space. They don't seem to mind that the rooms have very little connection to their own identities, like someone's own house would. But not having much privacy or an intimate space when you are ill is somehow socially accepted.

Ill bodies, however, actually need more attention and security than healthy bodies do. Yet when you don't have the means to arrange for your own care space, the only alternative is to be in an anonymous space.

Why is holding onto your own identity when you are forced to live outside of your own house strictly available to the wealthy? Is the design of these places really related to means or is its origin rooted in something else?

How can we use computer vision techniques and machine learning to explore and analyse the aesthetical styles most often associated with gentrification?

POLITICS OF PUBLIC SPACE

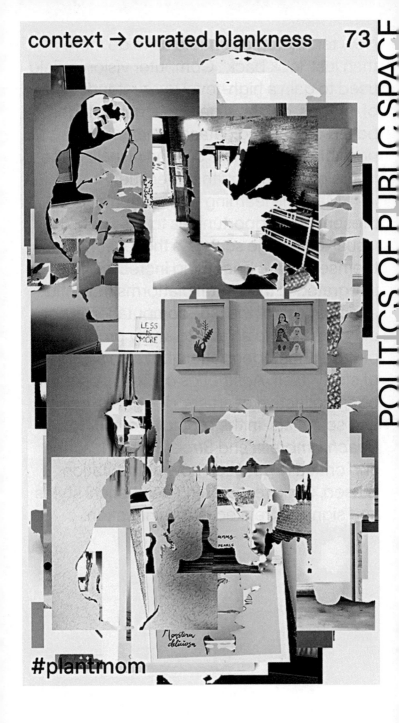

#plantmom

AESTHETICS OF EXCLUSION

New technologies enable us to do more than just 'look back'. Computer vision, a field used to gain a high-level understanding of images, can now generate new images based on existing datasets that make it possible to speculate on, and visualize, the future of urban growth or decline.

Machine learning and computation present new opportunities to research 'the visual' on a large scale. As these techniques themselves are becoming increasingly integrated in the digital platforms that influence our use of the city, computation is not only a means to an end to study processes of urban homogenization, but also an object of study itself. *Aesthetics of Exclusion* is an open collective of artists, designers, coders, and scientists. In the project, both 파라솔 *Beach Umbrella* and *StreetSwipe* describe and critically question how computation is used, while researching aesthetical styles and signifiers related to gentrification.

Today, digital mapping, Street View and machine learning technologies enable us to navigate cities over time. Seen in sequence, this makes clear the aesthetic changes common to so many cities across the globe. Since 2005, several companies such as Google, Microsoft, Baidu and Kakao (Daum), started to develop systems to digitally map urban and rural areas. Users can see how 'street views' have changed. Platforms such as Instagram, Uber and Airbnb not only supply an enormous amount of (visual) information about the city but also influence its use.

Aesthetics of Exclusion studies the visual signals and patterns of gentrification: an urban phenomenon that entails a decrease of diversity in classes, ethnicities, races, sexualities, languages, and points of view from central city neighbourhoods; and their replacement by more affluent and homogeneous groups. While a lot of research has focused on the socio-economic causes and effects of this process, we also view gentrification as a cultural phenomenon: its aesthetics are not only a reflection *of*, but also a central component *in* this sort of process.

파라솔*Beach Umbrella*

In the summer of 2018, Mark Jan van Tellingen (one of the collective's partners who I made the project with) and me physically walked through Seoul in South Korea with Street View, computer vision, and GPS tracking. When walking or navigating through a digital Street View archive of Seoul, street vendors, markets and *pojangmachas* [temporary food carts] fill the streets forming an integral part of the urban fabric. These specific typologies are linked to the informal economy, which has decreased significantly over the last decade and will continue to grow smaller. Several socio-economic processes, such as gentrification, strict law enforcement and rapid cultural change, make it hard for vendors to survive.[1] In the future will we only be able to remember Seoul's informal economy through the lens of visual archives?

Beach umbrellas provide shelter from rain, create shadow in Seoul's humid climate, and also operate as temporary spaces of exchange. We found them to be an interesting symbol of Seoul's informal economy, and a phenomenon often overlooked. We trained object recognition software to detect umbrellas across Seoul through images and Street View, making it possible to experience their movement and evolution through time. By tracing these peculiar objects with object recognition, the film *Beach Umbrella* questions how computer vision becomes a kind of fortune-teller, predicting the future of urban growth in the city.

GENTRIFIED / _NOT GENTRIFIED_

StreetSwipe

Which aesthetics do we associate with gentrification? *StreetSwipe* lets the audience determine if they think a photo of a storefront or bar should be classified as 'gentrified'. While swiping, different cities, streets, years and neighbourhoods will be compared on a live webpage that functions as a scoreboard. The subjective input of different groups of users will be used to train different computer models that can recognize and, using so-called Generative Adversarial Networks, generate images that are perceived as gentrified and non-gentrified.

Algorithms are generally presented and perceived as neutral decision makers. But what is classification? What and who is classified? Who is overlooked? Who or what is responsible for classifying? Do algorithms provide us with visual facts or do they generate visual meaning themselves? Can we teach machines, or can artificial intelligence teach itself, to identify highly subjective codes, which are heavily dependant on culture, ethnicity, gender, and so on?

StreetSwipe relates directly to similar research where Street View images were used together with computer vision to classify if a street was perceived as safe or unsafe. In these sorts of projects it often remains obscure how the computational models are trained: who gets to decide what is perceived as safe and how is this idea, which is presented as neutral and objective, projected into the future? With this, computation does not merely govern our actions in the present, but constructs a future that best fits its parameters.[2]

The aim of *StreetSwipe* is twofold: the generation of new knowledge that is aimed at researching a perceived state of gentrification through its aesthetics (colours, patterns, objects) and, in doing so, to increase our understanding of how computational systems are developed, function, implemented, and increasingly shape our lives.

A beta-version of *StreetSwipe* is already developed and functioning. In the coming year new functionalities will be added, more data will be acquired, different communities will be asked to participate in the project, and we will extend the research by adding different ways of describing and processes of gentrification.

1. Eun-Seon Park (Listen to the City collective). *Cheonggyecheon, Dongdaemun Gentrification: Artist's Note*, 2017, medium.com.

2. James Bridle, *New Dark Age: Technology and the End of the Future* (London: Verso, 2018).

POLITICS OF PUBLIC SPACE

How do arrangements between humans and things produce publicness?

THE FOUNTAIN OF PUBLICNESS

335 Frank Mueller & Curdin Tones

Working from a material and relational ontology, we investigate the emergence of publicness in dynamic relationships of matter, things, and audiences in different socio-material environments.* In our transdisciplinary collaboration, as urban geographer and artist, our method is to actively materialize and introduce participatory arrangements that generate scenes of relational publicness.

Artistic research as a tool of practical knowledge production enables us to work with ethnographic immersion. This brings us closer to leaving the usual laboratory situation of social science. Artistic research strategies allow us to immerse in complex socio-material environments: we can both actively materialize and study how intimate arrangements between humans and things produce publicness. In addition, since the method and the research tools themselves are subject to material change, our research becomes a process in which unforeseeable events, opinions, and ways of interacting continuously decentre us as researchers as well.

We understand publicness as an arrangement of all potentially interactive elements. As a process, publicness emerges out of and within encounters of humans and things. We converted a village fountain into a temporary bath, open to the general public, including villagers and tourists.

The fountains in the Swiss villages of the Lower Engadin valley have always been central sites for inner-communal social, political, and economic life. A warden supervised the fountains and a strict set of regulations applied to daily use. The guaranteed access to clean water, the surveillance of correct behaviour, and the effective functioning of a collective infrastructure were central to the historical emergence of publicness in Engadin's villages.

Our research aimed at both reviving and altering the picturesque and nostalgic role of the fountain. We transformed the largest fountain in the village of Tschlin into a temporary whirlpool, reactivating its social function. With a group of villagers, we developed objects to evoke this transformation: a woodstove to heat the water, a set of seats, a whirlpool pump, a filter system, a swimming pool handrail, wooden floor elements, and a public street sign. All elements were modular and could eventually be used in different fountains in the region.

The rearrangement of the fountain's environment and the staging of a different procedural publicness involved two connected sets of encounters in which we saw publicness emerge:

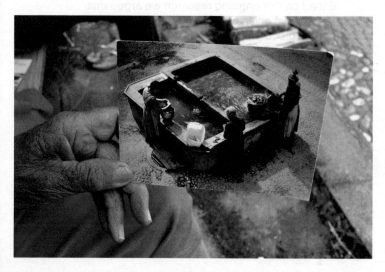

A first set of intimate publicness concerned the surfaces of the interacting bodies in and around the pool. Publicness emerged from the collective experience of intimacy in the engagement with neighbours, visiting tourists, artists, and material objects. Providing access to this intimacy, the step into the fountain became the minimal move from which the transformation of the decorative function of the fountain began. The bathers needed to expose themselves and to overcome their reluctance by stepping into a shared intimacy.

In blurring the social and bodily borders, the collective bath was an invitation to share and sense an emerging publicness within a modified environment.

The second set of intimate publicness was broader. The familiar yet modified environment of the square and fountain, provided the potential for a public debate of sometimes-antagonistic values. To realize and finance the project we collaborated with residents, local tourism and politicians who were involved in deciding shape, design, and procedures. By simulating the fashion of wellness as a form of consumer-adaptive tourism and by not commercializing it, the fountain triggered new imaginaries and expectations. Some people loved the project; others saw our intervention as sacrilege, or saw it as an opportunity to promote the village and hoped to sell more local products.

Modifying and confronting the traditional sociomaterial environment with new arrangements of objects and people, exposed and unsettled traditional understandings. We continuously had to discuss the social, cultural and economic value, which turned out to be key. The process amplified the effect of an emerging publicness.

Based on this ongoing research we argue that publicness is not a given condition for public life but a socio-material process that emerges from micro-spatial engagement with the 'other'.

* Publicness is usually defined to be the quality or state of being public or being owned by the public.

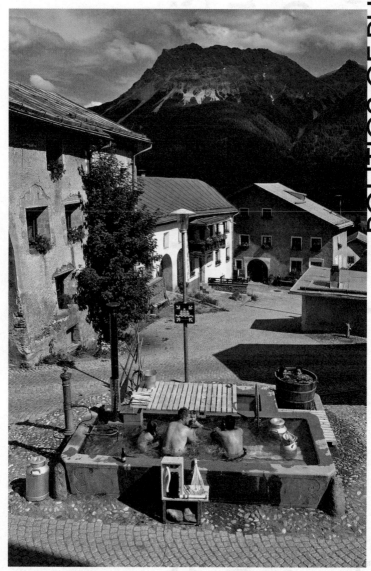

Frank Mueller & Curdin Tones

How can art and design diversify public space by exploring miscommunication around controversial memorials?

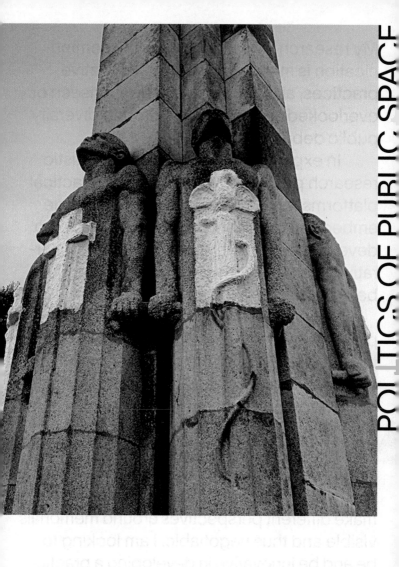

POLITICS OF PUBLIC SPACE

PUBLIC SPACE AS SITE
OF MISCOMMUNICATION
341 Barbara Neves Alves

My research investigates how miscommunication is made visible through creative practices, allowing us to consider unseen or overlooked accounts in an effort to diversify public debate.

In exploring memorials though artistic research processes, I aim to create practical platforms for exchange that can challenge embedded dominant narratives. But also, to develop speculative spaces where new narratives can take form by creating dialogues between reality and an imagined future.

I am looking to align my research approaches within the sociology field, exploring the performativity of the social through live and 'inventive' methods. I propose a speculative approach because expected outcomes are multi-perspective debates that can imagine new ways for reinscribing memorials in public space—activating new theoretical insights and methodologies. My aim is to make different perspectives around memorials visible and thus negotiable. I am looking to be and be innovative in developing a practice-based (performative/material) exploration of communication.

European colonialism erected memorials as symbols of imperial rule. Such symbols are today objects of fierce debate, undergoing processes of removal, dislocation and intervention that show they are not perceived in an uncontested form but generate conflicted feelings. Because memorials tell one version of history, the question remains how to deal with them, as leaving them unamended risks perpetuating stereotypes and removing them suggests taking a sanctioned side and erasing history.

But in my work, I want to suggest that social and cultural exchanges surrounding memorials produce misunderstandings that can become provocative sites for imagining new participatory practices and collective formations.

Miscommunications are often regarded as that which makes communication difficult, which interrupts, slows down, and misunderstands. However, when miscommunication is seen as an operative concept, and acknowledged in design practices, it becomes a transformative part of communication revealing many nuances and layers that are generally unaccounted for. As such, miscommunication is not about different understandings of a term but rather about how communication is inhabited in different ways, opening up the possibility of creating platforms for practical connections between different inhabitations of public space.

Thus, miscommunication is used as a central concept in a process where design and artistic research are not understood as problem solving but as sites that encourage exploration of new perspectives and new questions. Research activities are defined around particular contexts by adopting a design-led, mixed method approach. In these interactional and material aspects are designed to set up exchanges which allow for an openness where people can create (and share) their own meanings.

Currently, I have gathered work by artists and designers situating their work in public space within a post-colonial/decolonial framework, to initiate a first dialogue and moment of analysis.

Initial experimentation includes focusing (with support from the *Stimuleringsfonds*[1]) around the *Monumento ao Esforço Colonizador Português* [Monument to the Portuguese Colonializing Effort], which was created in 1934 for the first Portuguese Colonial Exhibition in Porto and later, in 1984, was re-erected and moved to the city's *Praça do Império* [Empire Square]. It still stands there today, six figures of the 'Portuguese colonializing effort' represented at its base: the doctor, the woman, the farmer, the warrior, the missionary, and the merchant.

I developed a practice that includes inhabiting the space of such a contested memorial for a period of time, in which rubber casts of symbolic parts of the granite monument have been created. These hollow spaces became the start of new symbolic appropriations, which will eventually resulting in a workshop, a self-published booklet and public debate, to unveil and work with the political stances of miscommunications emerging from the monument in its present location—when looking at its history and context—and how different perspectives are affected both by the monument's symbolism and physical presence.

1. Stimuleringsfonds [Creative Industries Funds NL] is a Dutch cultural fund for architecture, design, digital culture, and numerous crossovers.

THE PUBLIC MAZE
Rogier Brom

In the project *Innen Stadt Aussen* [*Inside City Outside*, 2010], artist Olafur Eliasson created situations in public space where exterior conditions and the internal sense of self of the viewer interact. In the accompanying catalogue, a quote by Ludwig Wittgenstein is included that offers an interesting perspective on the projects included in this chapter on the workings of public space: 'Language is a labyrinth of paths. You approach from one side and know your way about; you approach the same place from another side and no longer know your way around.'*

My interest for this quote in regard to the four contributions to this chapter lies in the fact that different perspectives on public space can have a great influence on how the policy surrounding it can be influenced. So often, public space is opposed to the private realm. It is a place where conditions are set for individuals to function within a setting that holds a group together through rules and regulations, recorded in policy. However, it can be a very sound idea to question the somewhat subordinate role the individual has to play within this setting. Tessa Meeus (*I'll Give You the Entire Day*) delves into the negative consequences of losing sight of individual needs when these are obfuscated by collectively reproduced assumptions of efficiency. By seeking out the right situation to test existing assumptions, she looks at whether or not these should or could be reshaped in order to better suit existing situations in society.

Frank Mueller and Curdin Tones (*The Fountain of Publicness*) follow a somewhat similar path. Instead of top-down assumptions on the design of public space, they really got into how intimate arrangements can develop into publicness. By seeing publicness as a process emerging 'out of and within encounters of humans and things', they test new arrangements of objects and people and how this affects how people see traditional engagements within their communities. The frequently underestimated role of objects in public space as actors is interestingly activated by Mueller and Tones by describing publicness as a socio-material process. Regardless of the interesting approach in this project and the insights it presents, it can be debated if

publicness is something that can emerge. I'd rather take the position that publicness and the public spaces in which it is active is constituted by the policy that enables its being.

Both these projects seem to focus more on how publicness comes into being rather than on what publicness does. Therefore, next to public versus private, another worthwhile perspective for looking at public space could be that of outcome versus function. One of the ways public space can be an active element in society is shown in the research of Barbara Neves Alves (*Public Space as Site of Miscommunication*). By operationalizing the concept of miscommunication, she seeks to use exchanges of different understandings in public space to offer ways of creating and sharing new understandings, thus using public space to strengthen itself. It would be interesting to see how this can be made into a tool that can be deployed into different situations and repeated.

As far as tools go, Sjoerd ter Borg (*Aesthetics of Exclusion*) describes his tool for exploring and analysing aesthetic styles most often associated with gentrification. While I hinted before that policy enables public space, Ter Borg convincingly makes a point for the growing role algorithms have in this respect. With his projects, he presents ways for design to use information on how changes in the outlook of our surroundings can be used for gauging how public space is seen, and how this information can inform policymaking. Using a combination of algorithms and human input, it offers public space the possibility to play a role in monitoring its own development.

As many of the projects illustrate, design has the possibility to not just introduce new perspectives on public space, it can offer ways to operationalize these new perspectives as well. By persistently trying on different perspectives for encountering questions surrounding public space, design can have a strong role in offering new directions for the function of the public domain.

* Ludwig Wittgenstein, *Philosophical Investigations*, ed. Rush Rhees and G.E.M. Anscombe, trans. G.E.M. Anscombe (Oxford: Basil Blackwell, 1953).

Rogier Brom has Master's degrees in Art History and the Sociology of Art and Culture and is working as a Research Coordinator at the Boekmanstichting Kenniscentrum, the Dutch institute for arts, culture, and related policy.

www.boekman.nl; @BromRogier

CAPITALI

NAKED
SM

Why Amartya Sen remains the century's great critic of capitalism

Tim Rogan is the author of *The Moral Economists: R H Tawney, Karl Polanyi, E P Thompson and the Critique of Capitalism* (2017). He lives in Sydney.

▶ Listen here

Brought to you by Curio, an Aeon partner

1,100 words

Edited by Sam Haselby

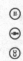

ⓒ ① ⊜

REPUBLISH FOR FREE

'Critiques of capitalism come in two varieties. First, there is the moral or spiritual critique. This critique rejects *Homo economicus* as the organising heuristic of human affairs. Human beings, it says, need more than material things to prosper. Calculating power is only a small part of what makes us who we are. Moral and spiritual relationships are first-order concerns. Material fixes such as a universal basic income will make no difference to societies in which the basic relationships are felt to be unjust.'

Critiques of capitalism come in two varieties. First, there is the moral or spiritual critique. This critique rejects *Homo economicus* as the organising heuristic of human affairs. Human beings, it says, need more than material things to prosper. Calculating power is only a small part of what makes us who we are. Moral and spiritual relationships are first-order concerns. Material fixes such as a universal basic income will make no difference to societies in which the basic relationships are felt to be unjust.

Then there is the materialist critique of capitalism. The materialist critique is the one we hear most these days, especially in discussions of inequality now. *Homo economicus* is the right starting point for social thought. We are calculators of our own advantage, single-minded, failing to see how prosperity is distributed across societies. But we are calculators. And the just society assures good material outcomes, thus the focus on material plenty, and a will to material plenty, thus the focus only on good material outcomes.

The first kind of argument for capitalism reform seems recessive now. The material critique predominates. Ideas emerge in numbers and figures. Talk of non-material values in political economy is muted. The Christians and Marxists who once made the moral critique of capitalism their own are marginal. Utilitarianism grows ubiquitous and compulsory.

'Then there is the material critique of capitalism. The economists who lead discussions of inequality now are its leading exponents. *Homo economicus* is the right starting point for social thought. We are poor calculators and single-minded, failing to see our advantage in the rational distribution of prosperity across societies. Hence inequality, the wages of ungoverned growth. But we are calculators all the same, and what we need above all is material plenty, thus the focus on the redress of material inequality. From good material outcomes, the rest follows.

The first kind of argument for capitalism's reform seems recessive now. The material critique predominates. Ideas emerge in numbers and figures. Talk of non-material values in political economy is muted. The Christians and Marxists who once made the moral critique of capitalism their own are marginal. Utilitarianism grows ubiquitous and compulsory.

But then there is Amartya Sen.

Every major work on material inequality in the 21st century owes a debt to Sen. But his own writings treat material inequality as though the moral frameworks and social relationships that mediate economic exchanges matter. Famine is the nadir of material deprivation. But it seldom occurs—Sen argues—for lack of food. To understand why a people goes hungry, look not for catastrophic crop failure; look rather for malfunctions of the moral economy that moderates competing demands upon a scarce commodity. Material inequality of the most egregious kind is the problem here. But piecemeal modifications to the machinery of production and distribution will not solve it. The relationships between different members of the economy must be put right. Only then will there be enough to go around.

In Sen's work, the two critiques of capitalism cooperate. We move from moral concerns to material outcomes and back again with no sense of a threshold separating the two. Sen disentangles moral and material issues without favouring one or the other, keeping both in focus. The separation between the two critiques of capitalism is real, but transcending the divide is possible, and not only at some esoteric remove. Sen's is a singular mind, but his work has a widespread following, not least in provinces of modern life where the predominance of utilitarian thinking is most pronounced. In economics curricula and in the schools of public policy, in internationalist secretariats and in humanitarian NGOs, there too Sen has created a niche for thinking that crosses boundaries otherwise rigidly observed.'

In the age of #homeinspo, capitalist desires reign. But why are people evidently seduced by residential property and home interiors?

HARDWOOD IN HEART WOOD
355 Harriet Foyster

To undertake this project I needed to collate examples of the relationship between desire and the interior. Drawing specifically from the arenas of advertising, selling, and entertainment, I amassed material from lyrics, films, social media posts, novels, and fashion.

I collaged vocabulary from interior decorating brands, mortgage advertisements and real estate marketing campaigns for the audio track, most of which employed sexualized or romantic wording, which was incredibly close to the language of dating. Besides the high-end and financial material, I also searched in self-published DIY blogs and budget homeware sales catalogues. As we saw in the last sub-prime mortgage crisis, loan companies frequently target low-income clients.

'Who among us, in his idle hours, has not taken a delicious pleasure in constructing for himself a model apartment, a dream house, a house of dreams?' asked Charles Baudelaire in 1852.[1]

My research materialized as an arrangement sitting somewhere between a fashion runway and a show home. The title, *Hardwood in Heart Wood* (a crude reference to both an erection and a material), borrows the name of paint brand Flexa's 2018 Colour of the Year, Heart Wood. The senior colour expert at Dulux (the UK version of the paint brand) says of the colour:

Providing the comfort and reassurance we're all seeking, [Heart Wood is] the perfect antidote to the mood of the moment—channelling a real sense of calm and warmth during such times of uncertainty. We can't wait to see homes across the globe transformed into true sanctuaries.

Compiling these fragmented pieces of text quickly began to act as 'evidence': sexual desire, romantic tropes, narratives of unity and guarantees of affirmation were frequently employed in descriptions of wall paint and three-piece suites. It became clear that 'the good life' is so commonly promised with property and that home improvement promises satisfaction. Instead of political action, then, widespread apathy is certainly no surprise.

On Instagram, #homeinspo has over four million posts, often with captions like 'I'm in love.'[2] Even IKEA's advertising often merges intimacy with homeware. But where does this romantic seduction come from, and why is it so perpetual? Moreover, what does it have to do with political apathy?

The research was primarily concerned with capitalism's *instrumentalisation* of desire and how central this is to the logic of property. I interrogated ways the system utilizes the domestic interior to forcefully instil itself and its values into emotional life, and how apathetic behaviour is propagated as a result. For me, this is an urgent political question: when we imagine the gargantuan suburbia of the United States or swathes of the European middle class it becomes less of an off-the-wall idea. Huge bodies of political voices are diverted away from action or community and towards Eames chairs, wicker love hearts, and plush headboards to find a good life.

I found a widespread conflation of personal fulfilment with property. Affirmation is promised with ownership, just as it is with romantic partnerships—both supposedly offer security, comfort, and pleasure. 'And if narratives of romance are "narratives of *wanting*...", to quote Teresa L. Ebert, then the 'fantasy of unity is essentially a fantasy of security.... [the] passion, sensuousness, and individual intimacy... associated with love are extended to commodities as tropes of property'.[3]

This conflation of desire, property and fulfilment rapidly reproduces neoliberal capitalism's own conditions by priming subjects to live aligned with its logic of relentless improvement and consumption. No wonder, then, that it's appealing to spend Sundays painting over the feature wall with Sweet Desire or Heart Wood, or to redesign the living room in the hopes of betterment. The violence of capital accumulation is naturalized behind already falsely naturalized love relations, conveniently covering up class differences. The fantasy of the loving home or the bachelor pad creates an illusion that the middle class is merely a reflection of natural social being.

1. English translation of Charles Baudelaire's French introduction to Edgar Allen Poe's 1940 essay *Philosophy of Furniture*.

2. Homeinspo is a Swedish company that describes itself as inspirational, 'sharing ideas from all around the world to make your house a home!'

3. 'Not Your Mother's Romance Novels', in Teresa L. Ebert, *The Task of Critical Critique* (Urbana: University of Illinois Press, 2009).

NAKED CAPITALISM

How can you you provide an 'artistic service' and go on to make a living as an artist?

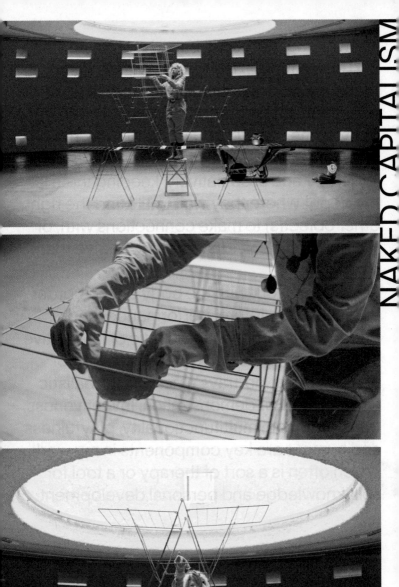

COMFORT ZONES

361 Maaike Fransen

My working method is based on transforming and combining existing as well as lost and found items. I re-evaluate and recycle all kinds of collected objects, materials, and clothing. They come from flea markets, friends, rubbish yards, and street-strolling. I gather them intuitively and associatively, keeping them in my depot where they wait until I find the right other object(s) to make connections with, or the right moment, idea, project, to give them a new life.

I often work with the body on the border of fashion, sculpture, performance, and photography/film. I make kinetic or interactive installations that involve a human being or character that portrays a certain surrealistic activity, ritual or demonstration. Inventiveness, transformation, multifunctionality, playfulness and humour are key components in my work, which often is a sort of therapy or a tool for self-knowledge and personal development.

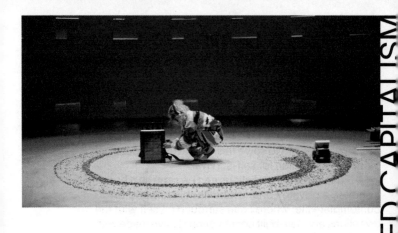

In a series of six 'self-portraits' I explored how to mirror and express inner processes, questions, challenges, and the sorts of ups and downs I faced when trying to study and make art while recovering from concussion. The portraits are utopian and dystopian mini-worlds, places of solitude, comfort and consolation, but also places of loneliness, confusion, and critique. They are proposals/suggestions/tryouts/attempts on inventing my own 'job', on creating solutions for my recurring struggle with the question of how to make a living from my work.

By making myself into a sculpture, a 'show', or placing myself in a circus-like setting, and by making a series of new unknown mini-worlds, I'm trying to find a suitable, safe, useful, and self-sufficient role for myself in this world.

Operating on the edge of design and art I often find myself in a difficult position, neither fitting the scenes of commercial industry nor serious art.

As a critique or an alternative to mainstream consumerism, I like to challenge myself to work with second-hand objects and waste. My motto is: 'One man's trash is another man's treasure.' Old, weird, abandoned, and often domestic items are combined to construct new personal habitats to disappear into. The results are poetic and concealing, as well as slightly absurd and even outrageous. The circle of light at the centre of the Art Chapel in Amsterdam provided the perfect stage for me to perform and document these six one-man tricks and rituals.

The images are screenshots of the documentation of the six 'acts', which in the future I will perform in multiple places and contexts as a nomadic showcase. This is the first step into devising an artistic solution for surviving in the art world. I am using a flexible, movable, and adaptable approach to enter the gaps left open by a flawed capitalistic and consumer society. So much of the modern system we exist in is floundering and many people find themselves in a precarious position. My research doesn't aim to solve this, but gives one possible modest intervention for self-survival.

Each of the installations can be seen as a home, a shelter, a private zone, where I publicly withdraw to contemplate life; where I can surround myself with the inventions and self-built constructions I have made with the leftovers of the material world.

I am as confused about capitalism as the next person and I am left wondering how I can ever make a living wage from my art. If in the end I discover that this is not possible, then what will be my role/function/contribution in society?

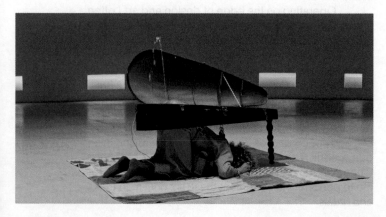

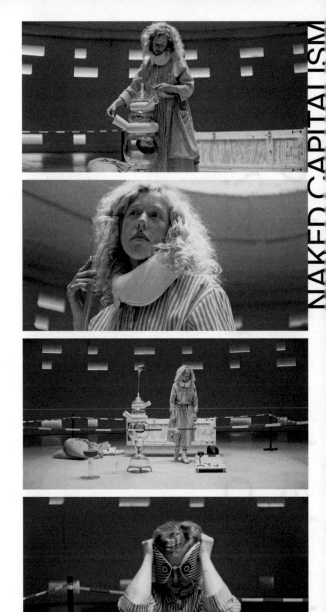

To what extent are products taking over our identities?

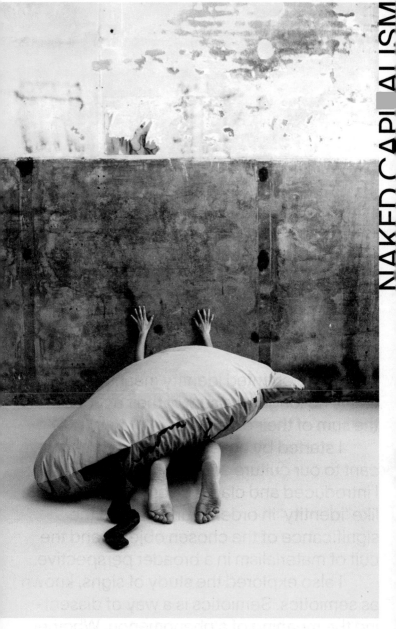

KILLING YOU SOFTLY
367 Zsofia Kollar

An object-oriented identity means that
one is no longer the sum of their actions but
the sum of their objects.

I started by collecting products signifi-
cant to our culture and our identities. Then
I introduced and clarified some key concepts
like 'identity' in order to understand the
significance of the chosen objects and the
cult of materialism in a broader perspective.

I also explored the study of signs, known
as semiotics. Semiotics is a way of dissect-
ing the meaning of a phenomenon. Whether
it be for a sneaker or a painting, semiotics
reveal the denotative and connotative mean-
ing of the analysed phenomenon, helping
us to understand the connotative associations
of a particular item.

Identity is not just how you define yourself but how you value yourself and your surroundings, which leads us to consumerism and advertising and how the global spread of capitalism has taken the material self to extremes.

An advertisement is a promotion of a product or a service in a public medium. Through advertisement, the underlying meaning of a product becomes understandable. Modern adverts do not only sell a product to us but also sell solutions to our selfish desires, creating a need to own more and more to embellish who we really are. Identity and the product-oriented culture in which we live cannot be discussed without taking a closer look at how social media has changed the way we create our identities on online platforms, and also how products have become popularized on these networks.

Based on these understandings, I selected and then dissected a series of products that I think become a part of what I am calling our 'Object-Oriented Identity.'

Object-oriented identity is a journey through a modern relationship between object and identity. This relationship says a lot about how product-oriented society now is. Individuals are no longer the sum of their actions but the sum of their owned objects.

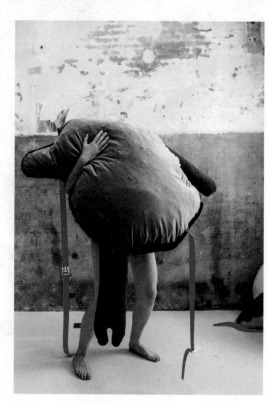

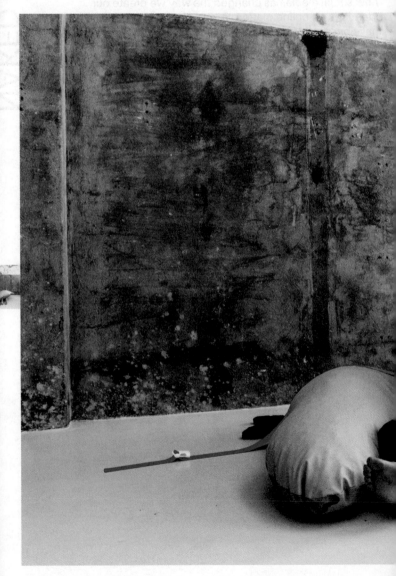

The products I selected reveal the nature of our consumption as well as some odd connections with cultural relevance and history. Seen alongside each other these products become objects that can and do transform or manipulate identity.

The line-up turned into a catalogue that is a journey from sneakers to household items, from iconic brands to low culture, and from high culture to the celebrities and advertisements that play an important role in empowering the objects that are embedded in our contemporary culture.

By the end of the catalogue a detox is necessary.

In the initial stages of my investigation, my main quest was to unravel the unspoken words of our material culture and to understand the transformative process from an ordinary object to a cultural symbol.

After the catalogue I present an installation, *Killing You Softly*, which is a reflection on our consumer culture. Although it comforts our needs, it also softly destroys us. Hyper-consumerism has spread globally; its tactics of persuasion have established a material culture where the hard-core whirlwind of information and the dense wilderness of materials have engaged a large part of most societies and cultures.

Killing You Softly encourages visitors to embrace themselves with the abstract and playful shapes. At first sight, the installation provides an impulsive and flirtatious encounter suggesting an innocent playground. While comforting the engaging, the installation slowly suffocates the ones who truly embrace themselves. However, the soft shapes provide comfort against the overwhelming power of the total volume. This represents the overpowering effects of consumer products we are surrounded by. Each shape within the installation comes with a strap, which can be used to attach them to each other or to visitors themselves. The attached volume and weight ought to represent the bond we create with our products, a bond that is hard to break.

Zsofia Kollar

What is the influence and contribution of 'aesthetics' on the construction of dangerous ideologies and their normalization?

LUXURY SURVIVAL FAIR

Mary Ponomareva

Initially a broad range of sources was studied, which included observing a thorough overview of recent popular culture examples to absorbing and applying critical and postmodern theory. Following this was a process of analysis, speculation, and documentation.

Graphic design, design, new media and visual art, were used as both research tools and as a means to share the project's conclusions. As the process evolved, research results fuelled the artistic practice and the other way around: outcomes of research were translated into artistic work, which in turn further fuelled the ongoing research.

The future is full of uncertainty, danger, and fear. At the Luxury Survival Fair, we expect 'the end of the world' to be fabulously glamorous! Get ready for the new millennium with high-end private security systems, state-of-the-art predator drones, luxurious survival condos, and encrusted gas masks from Raphael Universal, the world's provider of future-proof must-haves.

The *Luxury Survival Fair* is a fictional project that unravels the social and ethical duties of (graphic) designers. It wonders out loud and visually on the topic of how a designer's practice might regain a (more autonomous) socially engaged position within the current capitalist system.

The project looks closely at the defence industry and its marketing machinery: the commercials and visual language targeting defence and security procurers online. From this point it speculates on the future of survival.

The defence industry is but one of the dubious concepts that through visibility, visualization and decoration are normalized and presented as attractive commodities for civilians to consider.

The 'problematic' part has been removed, ensuring that the 'bad' has never looked that good.

The *Luxury Survival Fair* analyses the influence of aesthetics in the construction of this sort of 'acceptable ideology' and subsequently the consequences a certain aesthetic of design might entail for the socio-political context it is set in.

Sleek metallic surfaces and reflections play in the light. A mysterious dark void teases carbon close-up curves... Dramatic and powerful music builds and climaxes with the image of a full-size military bomber—in a spotlight as a masterpiece of design and engineering... Camera slowly pans around the bomber, making sure the viewer sees its desirable shapes from all angles.

In rendering militarization as normal and acceptable, a 'dark' phenomenon obtains an extra dimension: an aesthetic one. I call this the 'New Dark Aesthetic.' This I define as a scenario in which problematic concepts obtain an aesthetic dimension through the use of corporate symbolic clichés and generic visual codes.

In the *Luxury Survival Fair*, I use this New Dark Aesthetic to give a product tour via video that effectively 'flirts' with a view to 'seduce' the viewer with sleek and corporate aesthetics. The point is to provoke debate on the responsibility of a designer, the normalization of the arms race, militarization, and the role of aesthetics in constructing ideology.

The final result—a VR installation accompanied by appropriately dramatic and powerful music—crosses into a post-apocalyptic science fiction world and projects the viewer into a hyperreal future scenario. The viewer is confronted with ethical dilemmas while welcomed to explore luxury editions of survival and security products that are designed to help them survive the 'end-of-the-world' in spectacular style.

THE URGE TO CAPITALIZE
Bart Nooteboom

All four projects in this chapter are in the theme of 'commodification', going back to Karl Marx. To clarify this, use can be made of a view, in the literature on virtues (cf. Alasdair MacIntyre), that human activity has 'internal' and 'external' goods. External goods entail utility of outcomes, such as income, fame, power, convenience, while internal goods are intrinsic to the activity, in making a contribution to society, and in the satisfaction of taking the effort and risks of learning and exercising skill. Capitalism causes a shift from internal goods to external ones, and in doing so distracts from the good life. The internal, intrinsic is often varied, not amenable to standardization and efficiency of scale, and therefore is often 'inefficient' and stripped away. That loss engenders 'apathy', as is made clear by Harriet Foyster's project. People work for a wage, distracting from job satisfaction. Since the loss of religion and life after death, life on earth is the only life we have, and that scarce life has to be crammed full with things and excitement. The more efficient things are, the more we have. The effect of capitalism is alluring for its convenience, efficiency, safety, and protection from danger, effort, skill and pain. In other words it is soft and suffocating, 'killing you softly', as well expressed in the title and project of Zsofia Kollar. It binds you in ever more softness, ultimately killing you as a human being.

My main struggle with the projects of Mary Ponomareva (*Luxury Survival Fair*), Maaike Fransen (*Comfort Zones*) and Foyster (*Hardwood in Heart Wood*) is how the critique against capitalism can be distinguished from a natural urge for beauty and comfort.

In respect to Ponomareva, the beautifying of weapons is not new, and hardly a consequence of capitalism. Swords, armour and early guns were decorated with silver, arrows and bows with woodcarvings. That contributed to the intrinsic quality of being a warrior, enhancing rather than distracting from it, in the way that craftsmen decorated their utensils. Is there anything different here? On the other hand it does, I concede, make dangerous things comfortable, obfuscating risk and thereby is part of the distraction and avoidance coached by capitalism. Is it used to mollify the view of the weapons industry and stimulate it, make it more acceptable, as part of marketing?

The decoration of a habitat, to turn a house into a home, also seems natural and basic, not engineered by capitalism as suggested by Foyster. Here I admit that it can become excessive, a distraction from boredom and not having some other purpose; the perennial improvement and replacement of things—new curtains, furniture or colour of paint—a way to make sense of life. Perhaps the project shows that: the excess, artificiality, and pointlessness of it.

What I'd like to see more in the work of Foyster and Ponomareva is something more specific about capitalism versus what I see as a more natural urge, and what one does not like in it, what may be bad in it. What do you want the viewer or participant to take away from it?

Fransen is not looking for answers or solutions, but it is also vital that she make clear what her role 'in this world' is to be. I think it is problematic to say you operate neither in commerce nor art while at the same time admitting you embrace the systematic norms of neither. Her thinking was more convincing when she talked about materiality and I'd have liked the economic impact of that angle to be have been further explored.

But in all projects judgment greatly depends on execution: form, shape, colour, light and sound, which I think is shown most convincingly in Kollar's *Killing You Softly*.

Bart Nooteboom was the former Scientific Director at Erasmus University Rotterdam and later Professor of Innovation at several universities in the Netherlands.

www.bartnooteboom.nl

'In 2017, scientists at Carnegie Mellon University shocked the gaming world when they programmed a computer to beat experts in a poker game called no-limit hold 'em. People assumed a poker player's intuition and creative thinking would give him or her the competitive edge. Yet by playing 24 trillion hands of poker every second for two months, the computer "taught" itself an unbeatable strategy. Many people fear such events. It's not just the potential job losses. If artificial intelligence (AI) can do everything better than a human being can, then human endeavor is pointless and human beings are valueless.'

THE MORALITY OF A CYBORG

MIND OVER MATTER

Artificial Intelligence: Wars of Fear

RONALD W. DWORKIN

What should worry us most about artificial intelligence? Not the loss of our jobs to cheaper labor or losing our lives to killer robots, but a threat to our motivation: yet another danger: losing our motivation.

In 2017, scientists at Carnegie Mellon University shocked the gaming world when they programmed a computer to beat experts in a poker game called no-limit hold 'em. People assumed a poker player's intuition and creative thinking would give him or her the competitive edge. Yet by playing 24 trillion hands of poker every second for two months, the computer "taught" itself an unbeatable strategy.

Many people fear such events. It's not just the potential job losses. If artificial intelligence (AI) can do everything better than a human being can, then human endeavor is pointless and human beings are valueless.

Computers long ago surpassed humans in certain skills—for example, in the ability to calculate and catalog. Yet they have traditionally been unable to reproduce people's creative, imaginative, emotional, and intuitive skills. It is why personalized service workers such as coaches and physicians enjoy some of the sweetest sinecures in the economy. Their humanity, meaning their ability...

From: Ronald W. Dworkin, 'Artificial Intelligence: What's to Fear?', *The American Interest*, 8 October 2019

www.the-american-interest.com/2019/10/08/artificial-intelligence-whats-to-fear/

'Computers long ago surpassed humans in certain skills —for example, in the ability to calculate and catalog. Yet they have traditionally been unable to reproduce people's creative, imaginative, emotional, and intuitive skills. It is why personalized service workers such as coaches and physicians enjoy some of the sweetest sinecures in the economy. Their humanity, meaning their ability to individualize services and connect with others, which computers lack, adds value. Yet not only does AI win at cards now, it also creates art, writes poetry, and performs psychotherapy. Even lovemaking is at risk, as artificially intelligent robots stand poised to enter the market and provide sexual services and romantic intimacy. With the rise of AI, today's human beings seem to be as vulnerable as yesterday's apes, occupying a more primitive stage of evolution.

But not so fast. AI is not quite the threat it is made out to be. Take, for example, the computer's victory in poker. The computer did not win because it had more intuition; it won because it played a strategy called "game theory optimal" (GTO). The computer simply calculated the optimal frequency for raising, betting, and folding using special equations, independent of whatever cards the other players held. People call what the computer displayed during the game "intelligence," but it was not intelligence as we traditionally understand it.

Such a misinterpretation of AI seems subtle and unimportant. But over time, spread out over different areas of life, misinterpretations of this type launch a cascade of effects that have serious psychosocial consequences. People are right to fear AI robots taking their jobs. They may be right to fear AI killer robots. But AI presents other, smaller dangers that are less exciting but more corrosive in the long run.'

What strategies can be employed by Users to gain more agency in an augmented city, organized by the logic of platform capitalism?

1

model

2

model

3

model

city

USER-AGENT: IF EVERYTHING IS
SO SMOOTH, WHY AM I SO SAD?

Anastasia Kubrak

APPROACH

The project investigates what it means to be a human User in today's technological infrastructures. Reflecting on the impossibility of addressing a complex structural problem from a singular vantage point or field of expertise, the publication draws on interviews with practitioners including policy researchers, user-experience designers, software developers, architects, journalists, social activists, and media theorists. By bringing together sometimes opposing perspectives, the project puts forth possible strategies to contest the regime of platform capitalism.*

Inspired by cybernetic thinking and the values of the American 1970's counter-culture movement, such as self-sufficiency and 'access to tools', the research circulates as a PDF and a printed publication, given away on the basis of voluntary donation. The relations between interviews, texts and diagrams are presented as feedback loops, providing examples of what cybernetic publishing could look like in the age of ubiquitous computation.

Today, any inhabitant of a city is treated as a computational User by default. Smooth interfaces and real-time feedback loops augment our urban experiences making us feel empowered, while subjecting us to processes of profiling, quantification, optimization, and isolation. However, the sense of comfort and personal freedom (of a User) that is gained comes at the cost of political agency and autonomy (of a Citizen).

A citizen cannot traverse urban space without encountering any of its ubiquitous sensing technology. Pervasive sensors and trackers, Wi-Fi networks, Bluetooth and GPS signals enhance our streets, enabling the operation of geolocation-based platforms. Digital applications, provided by tech giants such as Google, Facebook, Amazon, Uber and Airbnb, have become the main (and sometimes the only) prism through which we encounter and understand urban space. Locate, like, review, rank up, vote down, follow, swipe. When cities are augmented by friendly and easily digestible interfaces, a smooth User Experience mediates and frames—and eventually replaces—our experience of urban dwelling, turning any participation in civic life into a service. Inhabitants of a city today are addressed as computational Users on a daily basis.

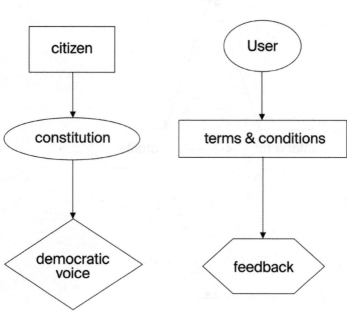

In fact, citizens interact with privately owned digital platforms more often and more intimately than they do with the platforms of the state. The algorithms behind geolocative software have introduced a new model of governance into the urban environment that is omnipresent, ambient and almost invisible to the naked eye, yet the impact they have on the lives of their users can be tremendous, not any less than the impact state governance has on the life of its citizens. To live in a city today means to be in a state of constant transition between being a citizen and being a User, augmented by networked technologies. But who or what is a *User*?

User is not a body. In computation, User is traditionally defined as a person who uses software, but this is less true in today's reality, when bots account for 48 million, or 15 per cent, of all Twitter accounts. Rather than being a human, User is a profile, an avatar, a body double, and a virtual stand-in for somebody on the platform. As formulated by the design theorist Benjamin Bratton, being a User is a question of authentication: anyone or anything can become a User, as long as they have a username and a password, be that a piece of software, a bot, an illegal immigrant, or a smart object connected to the network. The same cannot be said for a citizen. In order to be qualified as one, a citizen needs to fit within a strict set of requirements. If I wish to become a citizen of the Netherlands, I need to prove my qualifications. The obvious benefits of being a User over being a citizen are easy access and the ability to use convenient services regardless of citizen status. But when exactly does a citizen become a User, and what does it gain and lose in the process of this transition? And if everything is so *smooth* in the augmented city, why am I still feeling so *sad*?

* Platform capitalism refers to new business forms that involve recruiting large numbers of flexible workers through often monopolistic corporate platforms, such as Airbnb, Uber, and Deliveroo. It also refers to extractive business models employed by these platforms, based on collection and monetization of personal data.

In the context of a broader discussion on technology, I ask whether coloniality is a core component of tech development?

DESIGN FOR DECOLONIAL FUTURES

Flavia Dzodan

In this ongoing research into how seven-
teenth century taxonomies continue shaping
our technologies, I start by tracing the
genealogy of technology and how it was
used as part of the colonial project in the
fifteenth century Americas.

I also explore traditional and broader
definitions of key words such as colonialism.

I incorporate source materials such as
Edward Said's 1978 book *Orientalism*, whose
definition of colonialism extended to include
the coloniser with his self-perception as
someone improving 'the social order to reign
in the chaos of the vast lands and "disor-
ganized" peoples'. And also Italian Marxist
philosopher Antonio Gramsci, who in his
cultural hegemony concept wrote about the
living legacy of colonialism 'in the form
of social discrimination that outlived formal
colonialism and became integrated in suc-
ceeding social orders'.

Non-consensual exchange has been foundational to everything that came after colonialism, from the hierarchies of gender and sexual politics to the way we are now subject to non-consensual surveillance by the state or the non-consensual data collections done in the name of 'marketing'.

I want to trace the lack of consent of this genealogy to the foundational moment of European empires. Because colonialism is based on a relationship of unequals it creates a distinct class of individuals: the subaltern.

Coloniality then, is an ongoing project rather than a historical moment that remains in the past. Coloniality is the active, living legacy of colonialism. Coloniality is 'a way of being', a political project with no end in sight.

It was these rigid systems of classification and hierarchical formations that constituted an episteme, or a system of knowledge that formed the justification for the maintenance of both racial and gender classifications. Soon after these taxonomies were set in motion, they became the cornerstone for early forms of databases, or proto big data projects before there were digital means of archiving data.

The census is one of the early big data projects to classify and divide humans into rigid racial and gender categories, separating whiteness from everything else. As the census data became more important as a tool of policymaking and economic development, the racial categories acquired more granularity and specificity.

The Dutch have their big data archives courtesy of the Dutch East India Company. Established at the beginning of the seventeenth century, it was an early multinational/transnational corporation simultaneously considered a trading company, a shipping company and a proto-conglomerate company, diversifying into multiple commercial and industrial activities such as international trade (especially intra-Asian trade), shipbuilding, production and trade of East Indian spices, Formosan sugarcane, and South African wine. It is considered by many historians to be the first capitalist enterprise in the modern sense. It also traded in enslaved human beings. The archives of the Dutch East India Company are also one of the earliest examples of corporate-owned big data. Every piece of cargo that was transported or traded was painstakingly recorded. It is through its archives that we encounter slavery as data taxonomy: the enslaved subject, counted as a piece of cargo alongside 600 lbs of honey and 375 lbs of sandalwood.

And ever since, these taxonomies have been extended to every sphere aggregating data for political or administrative purposes.

POLICE RACIAL PROFILING OVERWHELMINGLY APPROVED BY DUTCH PUBLIC

By Janene Pieters on June 6, 2016 - 09:02

Typhoon (Glen de Randamie) (Source: Twitter/@jazzartorcht)

A massive 64 percent of Dutch voters think that ethnic profiling by the police is acceptable if it is done to fight crime, according to the latest poll by Maurice de Hond.

Demographic data, such as poverty levels in a community combined with surveys pertaining to white fears of people of colour, can result in strict and often violent policing under the claim that these communities present 'structural problems'.

Real estate brokers still evaluate the racial demographics of neighbourhoods to determine the value of property. Non-white and/or poor neighbourhoods can see their property values plummet if they fall within the 'unacceptable' percentile of certain measurements. These real estate valuations, based on data collected by the state, can even have an effect on intergenerational wealth. Healthcare providers can determine the average cost of certain demographics based on data, such as eating habits, ethnic predisposition for certain diseases, and eventual health predictions. Data from census and surveys is used to allocate funds for government programmes. City councils can regulate educational resource investments on students based on parents' incomes and predictive models of performance.

This same sort of taxonomical project remains firmly rooted in the culture of the Netherlands, informing government decisions and state policy. In late 2016, the country's Central Bureau of Statistics declared that it would stop dividing people into *allochtonen* [immigrants] and *autochtonen* [natives] because those words were too divisive. Up to that point, an allochtoon, defined as someone who was born outside the Netherlands or someone who had at least one parent born outside the Netherlands, was used in a derogatory manner against migrants and/or non-white people.

The obvious problem here is that we are repeatedly told that much of this data is 'neutral', not biased or political despite how much of it came to be. They say it is what we do with this data that matters. But I want to argue that this is simply not true. In machine learning, for example, machines learn how to make decisions from data sets. This means they are making decisions based on statistics that are anything but neutral.

The result is that the latest artificial intelligence and machine learning technologies are serving to sustain systems of oppression.

What can we expect from Augmented Reality in the future and what are the possible threats for society?

First I have to understand my topic: digital human rights issues. For this I look at opinionated channels—the news, social media, other popular media, and cultural references—sometimes combined with academic literature.

Then I define my artistic goals. Why do I think it's important to create work about this topic? How do I communicate this idea? Who is my audience? And most importantly, what do I want to give my audience?

Art is political by nature, but scientific research is *supposed* to be more truthful or neutral, with defined and tested methods to ensure reliability. A scientist cannot just 'claim' something or try something out without having a valid reason for it, whereas I have the ability to speculate about scenarios.

In 2018, I was invited by SETUP, a platform for media-critical research and design in Utrecht, for an artist-in-residency programme at the Rathenau Instituut, an independent Dutch research institute that conducts research on socially relevant aspects of science and technology.

The idea was to bring knowledge institutes and art/design closer together. This is based on the belief that design-based practice leads to new insights, concepts and prototypes, but often, the knowledge and will are lacking to bring these institutes and designers together. This residency was a pilot to see how these disciplines can benefit from each other.

My work looks at how scientific research benefits from artistic research and vice versa. It revolves around the social aspects of privacy, information filters, and digital human rights issues. It is about people being affected by surveillance capitalism, and not the technology itself. Topics like privacy are not physical, and their abstractness makes them more about emotion and power. What do we feel when our privacy is being breached, and how do we define our boundaries? To really define what these abstract issues mean to you, it is necessary to translate them into tangible, physical forms.

0:39

IT'S YOUR TURN!

RETAKE?

SEND

0:59

IT'S PLAYERNAME'S TURN!

PLAYERNAME IS CURRENTLY TAKING A PICTURE. WHEN YOU RECEIVE THE PICTURE, YOU AND THE OTHER PLAYERS WILL HAVE TO SEARCH THE AREA, FIND ITS LOCATION AND TAKE A SIMILAR PICTURE!

0:10

PLAYERNAME SEND YOU A PICTURE!

SEARCH YOUR AREA AND FIND ITS LOCATION!

ROUND FINISHED LEADERBOARD

Name	Score	
Arran	3	+1
Roos	2	+1
Remco	2	+0
Example text	1	+1
Example text	1	+0
Example text	0	+0

NEXT ROUND IN 10

EXIT

My projects end up being immersive game-like installations where viewers are forced to take a position regarding the topic. I've made passports for people with their Google ad-profiles for example, and I've built an entire casino where you don't play with money but with your personal information.

For the residency I joined the research group focusing on Augmented Reality (AR). This work was connected to how Extended Reality (XR) technologies are growing faster than ever. This year alone, multiple new tools—with affordable pricing—were presented at big tech conventions.

In 2016, AR-based smartphone game Pokémon GO showed the world how potentially disruptive this technology can be. How should society prepare itself for XR? How should civilians be prepared and protected against upcoming infrastructural, privacy, and social issues?

The institute recalled issues they were having with forming willpower and understanding on issues that in all likelihood will not arrive for a long time. How can we make these long-worded, abstract reports more immersive so that politicians and policymakers act upon them? Something tangible, like a speculative scenario, could help. And especially with a topic that is so involved with visual representation, the research could surely benefit from immersive speculation. During our meetings design and art were often mentioned, from haptic VR-glove prototypes to *Black Mirror* episodes. They formed an inspirational basis for new hypotheses and underlined the need for further tangible scenarios.

We decided on building a smartphone game for this project, *Mirror Worlds*. The game activates players to run and play around in public spaces. It is a digital 'I Spy' game: players take turns in taking pictures of objects and people that the others have to find. With the game we wanted to see how easily players are motivated and what disruptions the gameplay might cause within the public space. Afterwards we interviewed the players about possible moral and social issues in an open discussion. Not only did the art project become a conversation starter, it was also used as a new measuring tool for the research.

What does vivisection say about humans? Specifically, what does our treatment of non-humans reveal about our treatment of each other?

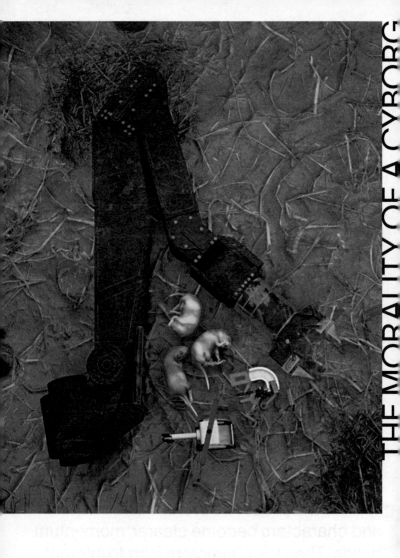

and characters become clearer, momentum
builds. That the innocents start to unravel
the mystery is perfect. Then, unexpected, late
interruption — a plot twist.

Having this to provide me an interest in
all the drama is no bad thing. It also affects
how I see androids; their drives and robots.
Now at least my reaction is unknown.

I do I mak many reaction as well all by people
everywhere, to invent in the this space are
have no understanding.

CLOSED CIRCUIT
Philip Ullman

To explore unknown territory I use a mental medley technique. I scour videos and imagery and start adding a layer of fictional narrative. From here I construct a digital 3D set and animated actors.

The goal of this approach is to parallel part fiction, part fact, in a space that lies somewhere between existing and non-existing.

As the process develops and scenes and characters become clearer, momentum builds. Then the characters start to interact with the environment. Then I enter almost like an independent participant.

Using fiction avoids me being forced into a linear storytelling technique. It also reflects the understanding non-humans and robots may have of testing spaces. An unknown force that is only heard or seen on the periphery constantly interrupts them in a space they have no understanding of, or control over.

Bundled up as a 'non-human research group', robots are also manipulated, tested, and studied in austere environments.

There is a video available online of a tour of Boston Dynamics, a facility used to test the navigation systems and movement abilities of its robots. The robots run around in small closed-off spaces that often consist of just one route on which they travel back and forth all day. Sometimes the spaces consist of two potential routes. In the video I saw, there were no visible humans except for the person giving the tour. The environment contains certain obstacles—a left turn, a right turn, a set of stairs. It's a non-house built only as a reference.

I see a correlation here with 3D animated film. The animated characters that we see on screen are not really alive. They may have been modelled after an existing living creature, but the particular one viewed on screen is not alive and are nothing more than a reference to the living world. This makes them seem more alive, especially because a living human is behind the captured movements, voices, music, and feelings portrayed.

In regards to animal testing this works the other way around. Tests that are recorded on non-humans such as lab mice are later applied and tested on humans. According to PETA there are up to 100 million lab mice in the United States alone. They are tested for diseases and medicine, their reactions recorded to implement later in the human world.

I find this relationship between lab mice and humans very interesting. Feminist scholar and philosopher of science Donna Haraway sums this relation up as 'We inhabit their narratives and they inhabit us' in her essay, *When Man Is on the Menu*.* Through medical testing we inhabit each other's bodies, but in the hierarchy upheld by humans we are far away from each other.

In the case of robots, either non-human animals or humans often inspire their shape and movements. Just like lab mice they are experimented on in the name of human innovation. After they are created, they start walking the Earth in patches of a culture inherent to their makers—closed-off spaces simulating the world outside.

The way Pixar films and robots are created are eerily similar. Seemingly sentient beings are designed to move around autonomously. In this project I started playing around with these mechanisms to see how I could affect this discourse. Alterations in tone and size can portray a very different character type.

In my video I captured and reused my own body movements on the mouse, which talks to its owner or simulator, asking next time to be simulated in a different environment. The mouse is aware of what's happening and is asking its caretaker to use their power in another way.

During the Gerrit Rietveld Academie graduation show, a woman approached me crying. She had once worked with lab mice and the film brought back all the memories. It felt incredible to have left someone who had actual experience of the spaces that I had only seen bits of online in tears. Unlike me, who had mostly fictionalized them, she actually knew the narratives of these mice.

When Man Is on the Menu in *Interpretations,* ed. Jonathan Crary and Sanford Kwinter (New York: Zone Books, 1992).

CYBORGS, UTOPIAS, AND OTHER SCIENCE FICTIONS
Christopher L. Robinson

In a 1960 article on manned space exploration, Manfred E. Clynes and Nathan S. Kline coined 'cyborg' from 'cybernetics' and 'organism.' The figure of the cyborg caught on quickly in science fiction, and acquired new significance in the social sciences with the publication of Donna Haraway's *A Cyborg Manifesto* in 1986.

The concept of the cyborg has proven attractive to people who roam across disciplinary boundaries. Clynes, for example, was a neurophysiologist and concert pianist who made significant contributions in musicology. Roos Groothuizen (*Mirror Worlds*) likewise bridges the arts and sciences. Although cybernetics was widely popularized by Norbert Weiner's study of feedback loops in the late 1940s, the word itself has a long and varied usage in philosophy, political science, economics, mathematics, engineering, and other disciplines. Inspired by utopian currents of cybernetics in the 1970s, the work of Anastasia Kubrak (*User-Agent: If everything is so smooth, why am I so sad?*) is similarly transdisciplinary.

Haraway argues that the cyborg effaces the binary distinctions between human and animal, organism and machine, male and female. The correlations that Philip Ullman (*Closed Circuit*) makes between industrial robots, lab mice and the characters in 3D animated films likewise blurs such distinctions, even as it raises an important ethical question. To many people, experimentation on animals is justified on the basis of a moral distinction between the human and non-human. When he superimposes anthropomorphic features on a mouse, does Ullman suggest the mouse deserves moral standing because it embodies human features? Or is its non-human status shown to be of value in and of itself?

For Haraway, the cyborg offers an alternative to patriarchal models of subjectivity. This utopian vision, however, is undermined by the gendered representations in arts, media, and advertising. Drawing an analogy with gender, Flavia Dzodan (*Design for Decolonial Futures*) shows how the colonial relations of native and immigrant have been reconfigured into taxonomies used for the purposes of the national census in the Netherlands. The theoretical deconstruction of binary categories of identity promised by the cyborg thus remains largely unfulfilled in practice.

The transgression of boundaries itself, moreover, raises further issues. As Dzodan, Groothuizen and Kubrak each insist, the collection and processing of personal data has increased in our era of surveillance and platform capitalism, breaching the boundaries between public and private, user and citizen, in ways that sound more dystopian than utopian. Dzodan concludes that AI and machine learning technologies reproduce a system of oppression informed by colonial logic. Does this mean we should limit or even prohibit the research and development of machine intelligence? Why not reprogramme the human mind itself, as Haraway suggests, and then reinvent thinking machines that might turn out to be less inhumane than we ourselves have been? Or is this prospect too 'utopian' in the negative sense of a fantasy or delusion?

Some of the projects are equally critical concerning the impact of new technologies, but less categorical in their rejection of the technologies themselves. Ullman and Groothuizen both harness the potential of new technologies for aesthetic purposes, without abandoning a critical perspective. Kubrak seems more ambivalent. Her project brings to mind the research of Erik Stolterman and Anna Croon Fors, who observe that people tend to believe information technology fosters prosperity and development, and yet fear it will transform society in ways that are contrary to a good life.

Noting the current popularity of apocalyptic narratives in both fiction and the daily news, Fredric Jameson observes that it is easier to imagine the end of the world than the end of capitalism. Consumer society 'feels so massively in place and its reification so overwhelming and impenetrable' that it has become nearly impossible to imagine a different way of life. This is why it has become the vocation of science fiction to give us 'alternative visions of a world that elsewhere seem[s] to resist even imagined change'. While they are not works of science fiction in the literary sense, a similar desire is at work in the projects of Ullman, Kubrak, Dzodan, and Groothuizen. Even as they express poignancy and melancholy, anxiety and indignation, their work is driven by a utopian impulse that gives their visions both a critical edge and the thrill of a creative challenge.

Christopher L. Robinson is Assistant Professor of English at the École Polytechnique / IP-Paris and frequent collaborator with the Chair of Arts and Sciences (École Polytechnique, ENSAD, Fondation Daniel et Nina Carasso).

www.ip-paris.fr

INDEX

Z

COLOPHON

This publication was initiated by Gerrit Rietveld Academie / Sandberg Instituut, Amsterdam to provide an overview of research practices at the academy.

EDITOR
Gabrielle Kennedy

EDITORIAL ADVICE
Emma Firmin, Eva Hoonhout, Astrid Vorstermans

TEXT EDITING
Emma Firmin

PROOFREADING
Els Brinkman

INDEX
Elke Stevens

IMAGE EDITING
Contributors, Gabrielle Kennedy, Sonja Haller & Pascal Brun

ILLUSTRATIONS
Sunjoo Lee

DESIGN
Haller Brun

TYPEFACE
Lausanne 300, Suisse Works

PAPER
Inside: Arcoprint Milk 85 gr 1.5
Cover: Natural Strongboard 265 gr

PRINTING AND BINDING
Wilco Art Books, Amersfoort

PUBLISHER
Valiz, Amsterdam,
Astrid Vorstermans & Pia Pol,
www.valiz.nl

IN COOPERATION WITH
Gerrit Rietveld Academie, Amsterdam,
www.rietveldacademie.nl /
Sandberg Instituut, Amsterdam,
www.sandberg.nl

ISBN 978-94-92095-80-0
Printed and bound in the EU

DISTRIBUTION
NL/BE/LU
Centraal Boekhuis, www.cb.nl
GB/IE
Anagram Books, www.anagrambooks.com
Europe (except GB/IE), Asia
Idea Books, www.ideabooks.nl
USA, Latin-America
D.A.P., www.artbook.com
Australia
Perimeter, www.perimeterdistribution.com
Individual orders
Valiz, www.valiz.nl